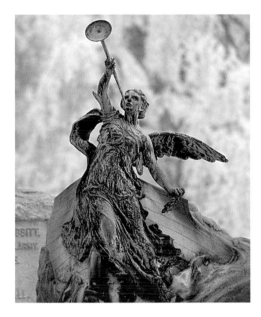

Behold yon sea of isles, boy,

Behold yon sea of isles,

Where every shore

Is sparkling o'er

With Beauty's richest smiles.

For us hath Freedom claimed, boy,

For us hath Freedom claimed

Those ocean-nests

Where Valor rests

His eagle wing untamed.

from "Trio" in The Summer Fete
by Thomas Moore

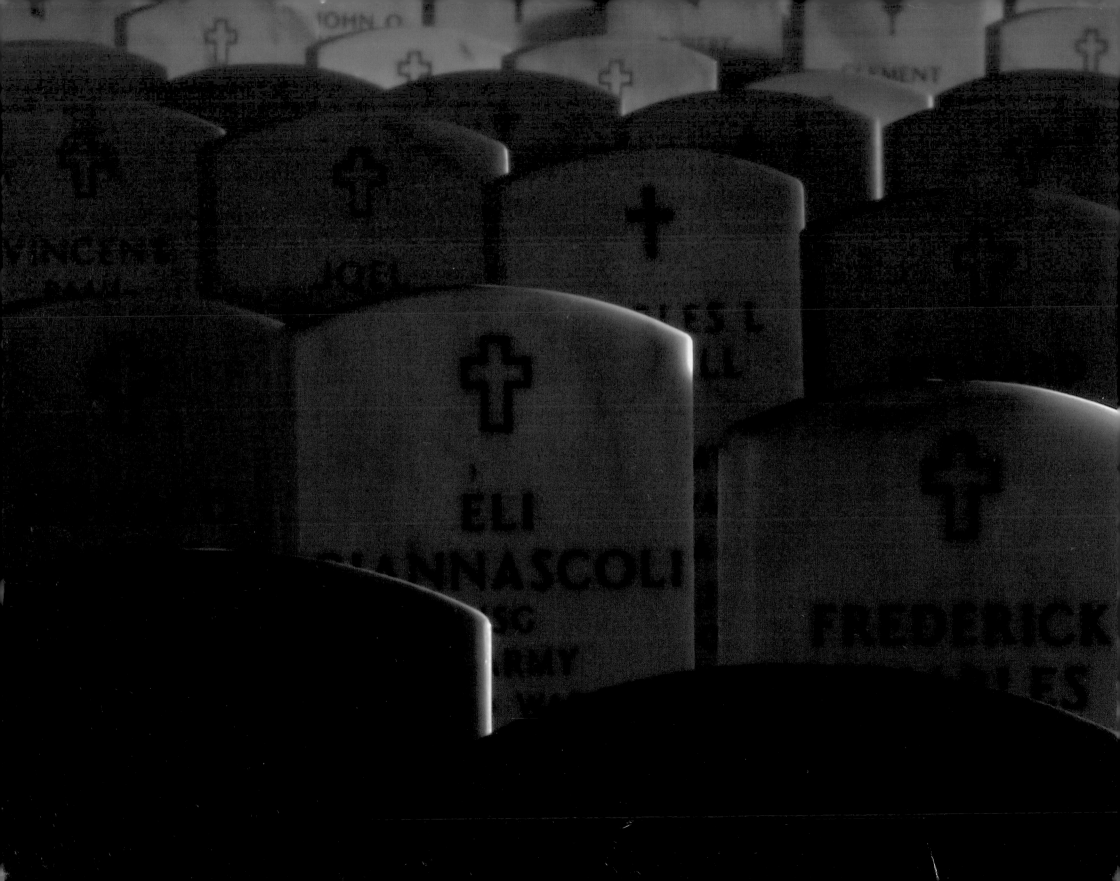

WHERE VALOR RESTS
Arlington National Cemetery

NATIONAL GEOGRAPHIC

Washington, D.C.

Essay RICK ATKINSON
Afterword JOHN C. METZLER, JR.

ESSAYISTS
JAMES BALOG
DAVE BLACK
DAVID BURNETT
BRUCE DALE
DAVID ALAN HARVEY
BRIAN LANKER

PHOTOGRAPHERS
SUSAN BIDDLE
CHIEF PHOTOGRAPHER'S MATE JOHNNY BIVERA, NAVY
MICHEL DU CILLE
LIEUTENANT COLONEL MICHAEL EDRINGTON, ARMY
WENDY GALIETTA
SERGEANT HARAZ GHANBARI, ARMY
TECHNICAL SERGEANT STACI MCKEE, AIR FORCE
SERGEANT FERDINAND THOMAS II, ARMY
MASTER SERGEANT JIM VARHEGYI, AIR FORCE

Page 1: A triumphal angel statue atop the grave of Navy Capt. Nathan Sargent in Section 1 of Arlington National Cemetery. Pages 2 and 3: Headstones from Section 54. Page 4: The Eternal Flame at the President John F. Kennedy Memorial. Page 5: On guard at the Tomb of the Unknowns.

CONTENTS

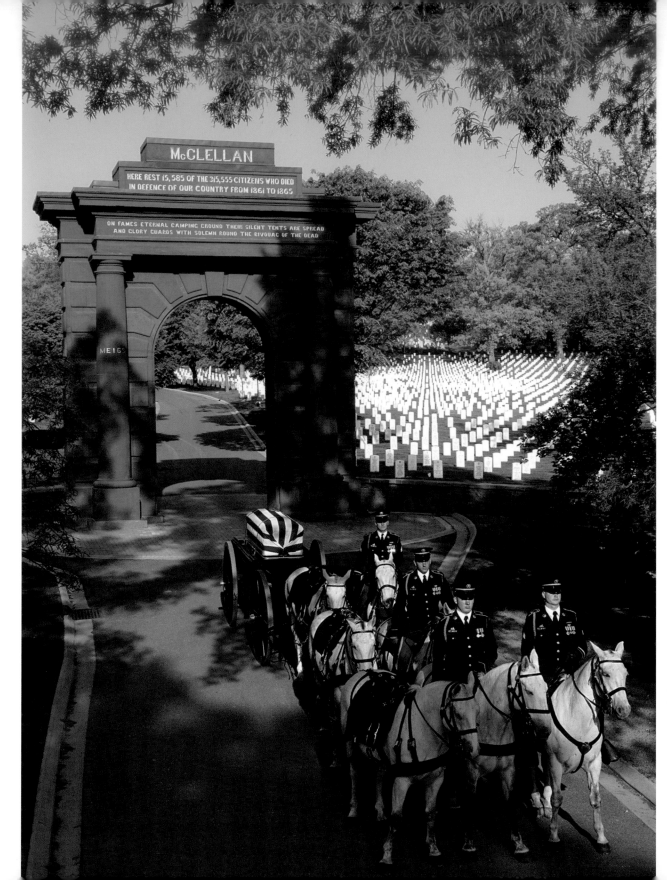

A team of horses ridden postillion style draws a caisson through McClellan Gate, the original entrance to Arlington National Cemetery, during a full honors Army funeral.

A TRIBUTE TO THE PAST, PRESENT, AND FUTURE

LIKE ARLINGTON NATIONAL CEMETERY itself, this book arose from a desire to memorialize the valiant heroes who died in service to the nation. In addition to presenting the next of kin with a folded flag after an interment, Arlington Superintendent John C. Metzler, Jr., wanted family members to leave with something from Arlington that reminded them of their loved one and the hallowed place where he or she will rest eternally. Thus came the challenge of creating a book that was every bit as elegant, tasteful, and relevant as a military honors funeral and worthy of the most sacred square mile in America.

Meeting this challenge required heavy artillery: writers and photographers with more than ten Pulitzer Prizes among them as well as a phalanx of accomplished military photojournalists. Their orders: bring their own vision to what they discovered at Arlington. The result: their different personalities, perspectives, and techniques created some of the most singular and moving impressions of the cemetery ever published. And to a person, even the most hardboiled war photographers, everyone became emotionally involved.

How could they not? From every point of view—aesthetic, patriotic, historic—Arlington brims with emotion. The grounds are simultaneously sad and beautiful, "undulating, handsomely adorned, and in every respect admirably fitted for the sacred purpose to which they have been dedicated," according to a 1864 newspaper report, the year the cemetery officially opened. Nearly a century and a half later, these elysian fields continue to inspire—whether it's the photographer who captures the ethereal tranquility of Section 2 at sunset, the workers who dote over every grave and blade of grass, the 300-plus service members who every day give honors to the fallen, the sentinels who guard the Tomb of the Unknowns, the tourist who marvels at the seemingly infinite rows of marble tributes to eternity, or the grieving mourner who weeps at the grave of a loved one.

Even though Arlington belongs to the nation, it belongs above all to the valorous men and women—and to their families—who have sacrificed everything for their country. They are the ones who inspired this book and in whose debt the nation will forever remain.

Some have asked, Why Arlington? Why now? To which our response is, Why not Arlington? Why not now? Whatever our opinions about war, there is never a time when the values consecrated at Arlington are irrelevant, when the lives of those who died in defense of this country are not "marketable."

This is not a political book but a patriotic one. As you leaf through the pages, we think you'll agree in our age of "new media," nothing expresses itself quite like finely crafted "old media." Everyone who worked on this book went into the same kind of loving detail that goes into everything at Arlington. Our express goal was to do justice to this hallowed, timeless monument and to let those who visit it carry it forever with them.

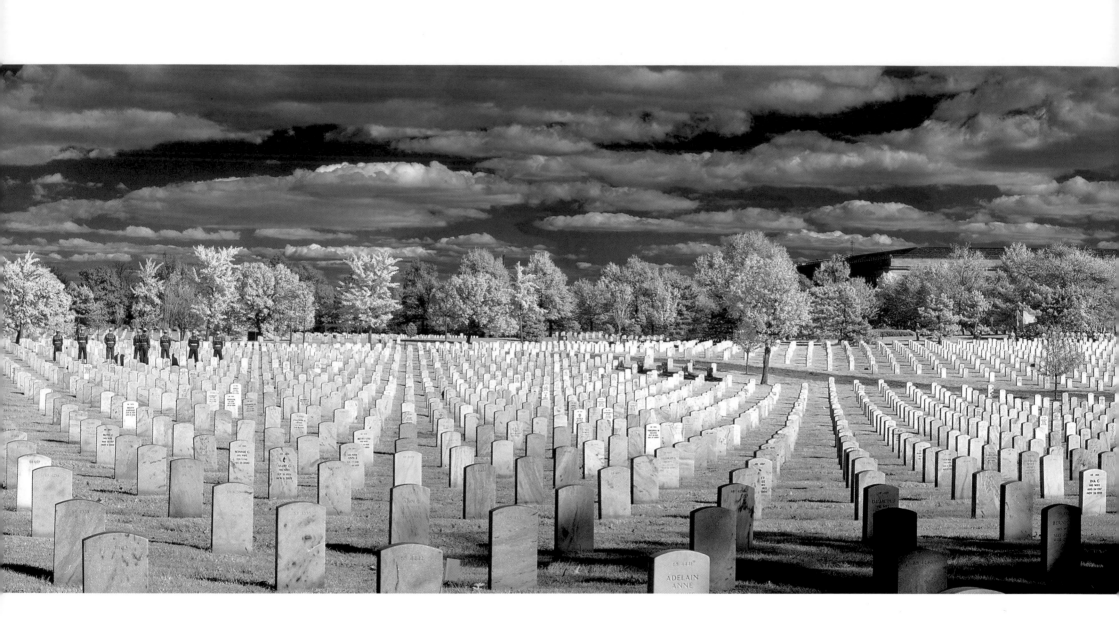

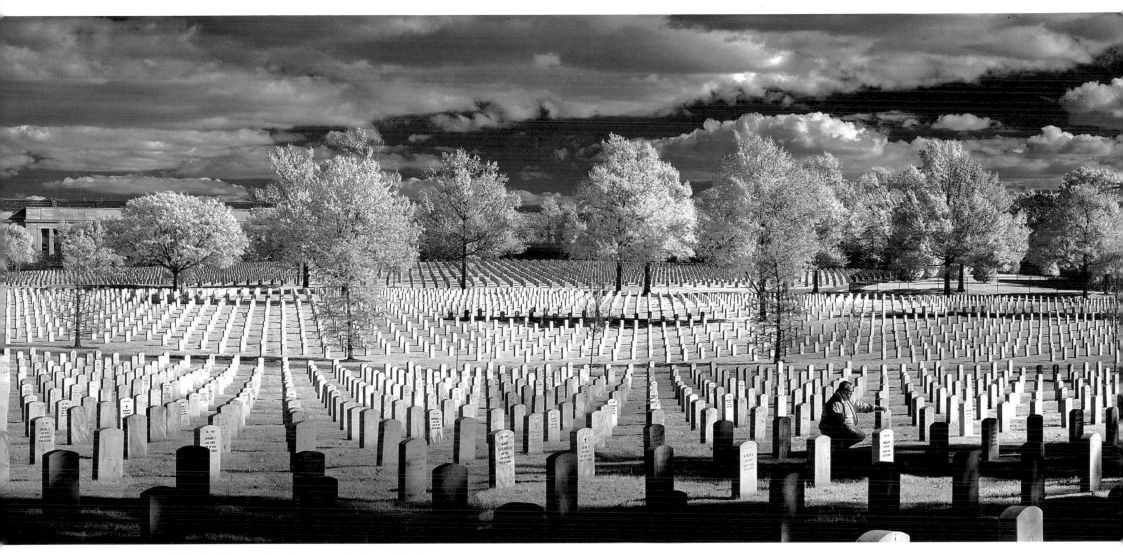

*Captured by infrared photography, a lone mourner kneels amid the columns
of grave markers that stretch infinitely across Arlington's spectral landscape.*

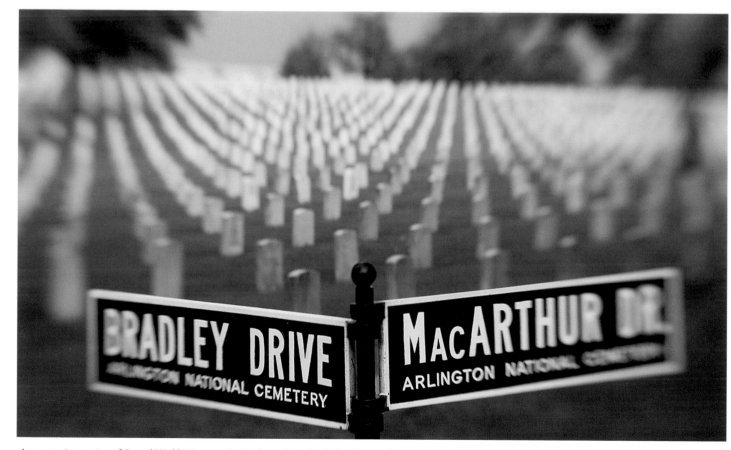

A ten-star intersection of Second World War generals. No form of weather halts the eternal guarding (right) of the Tomb of the Unknowns, where, every Christmas, wreaths adorn the marble slabs commemorating unidentified remains from World War II, Korea, and Vietnam.

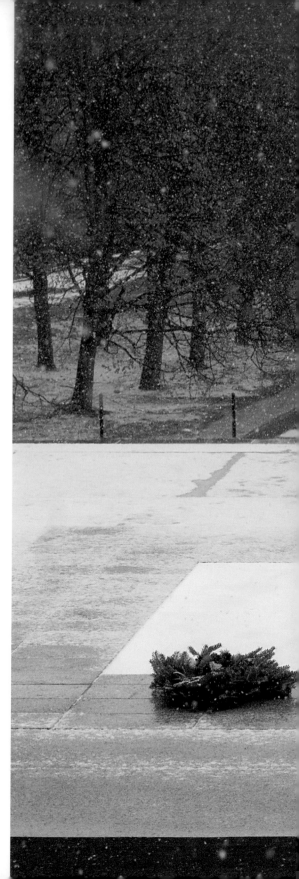

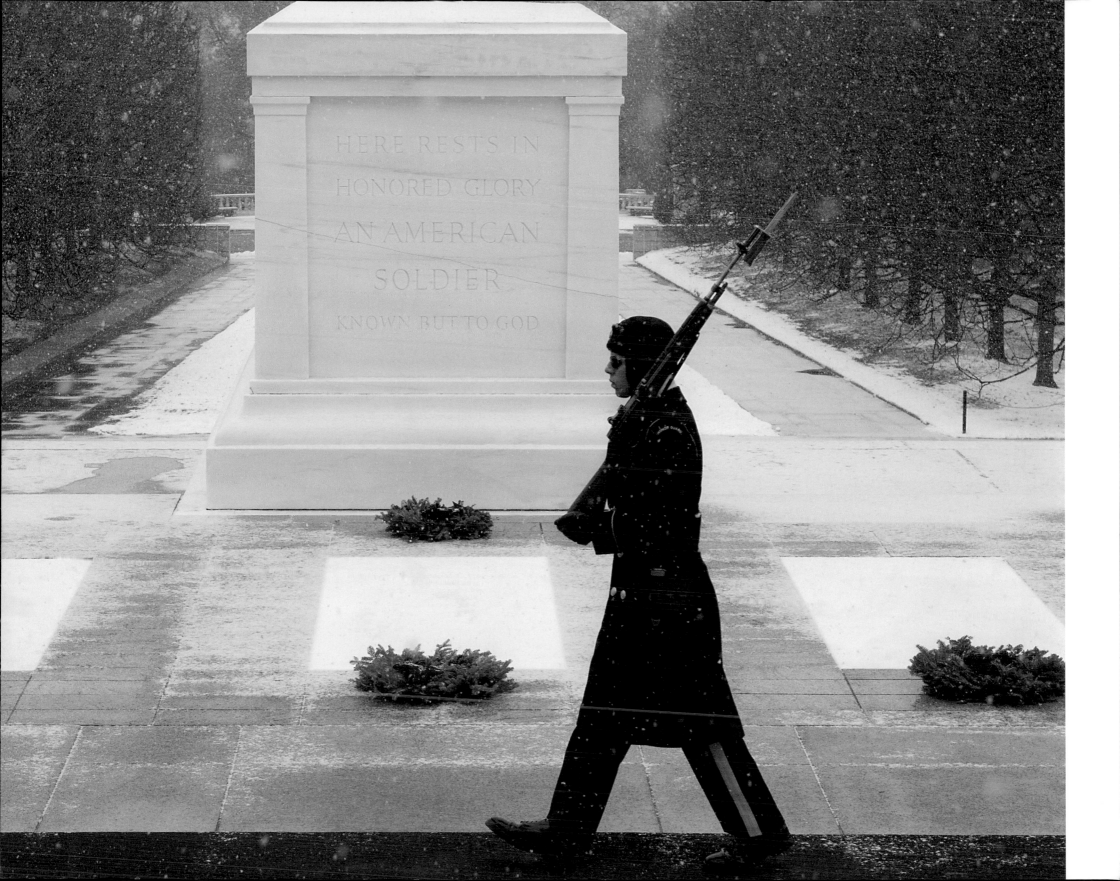

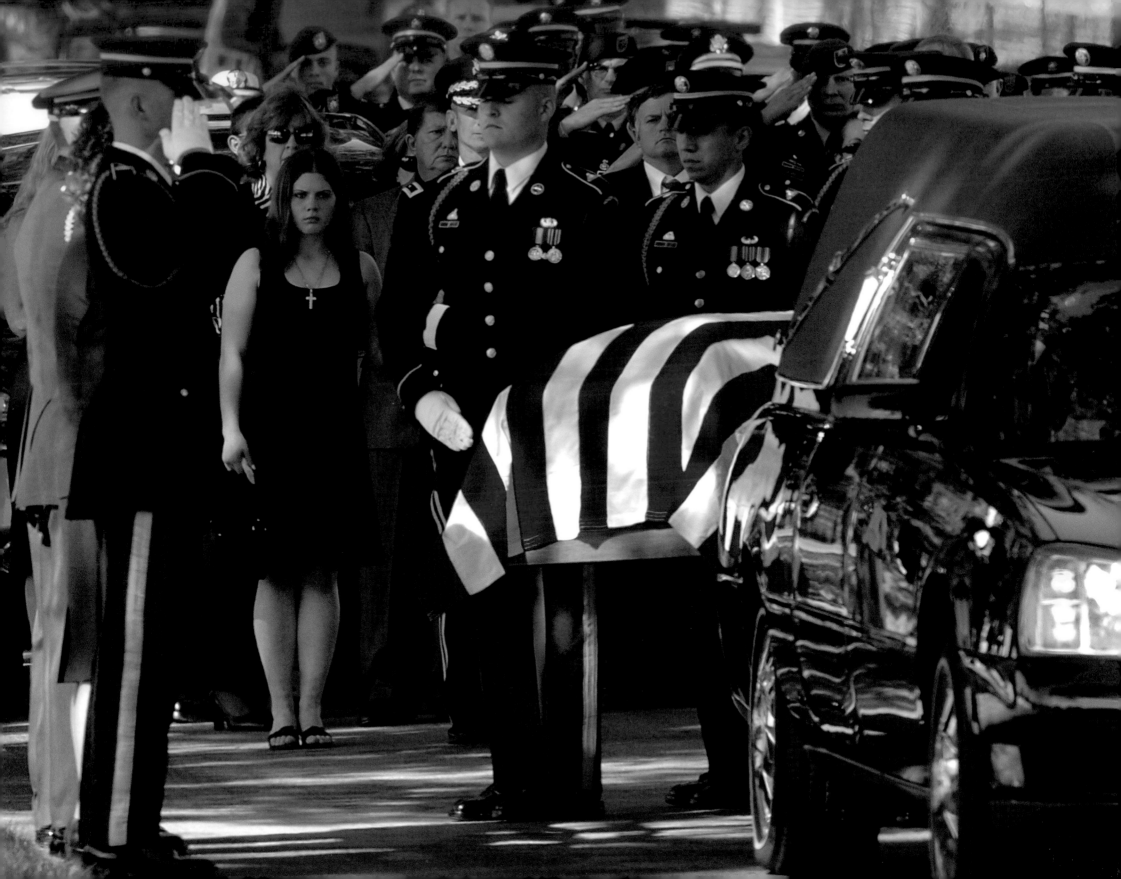

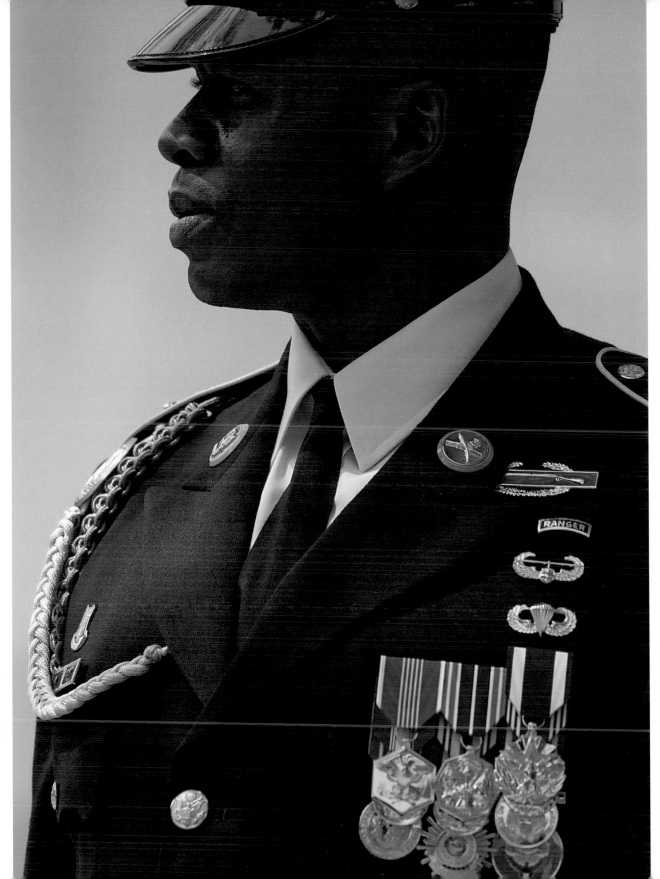

Specialist Maddison Campbell, 19, attends the funeral (left) of her husband, Sgt. Jeremy Campbell, 22, who died while both served in Iraq. First Sergeant Richard Thomas of Honor Guard Company, 3rd U.S. Infantry, Old Guard, proudly endures the heat during a summer funeral.

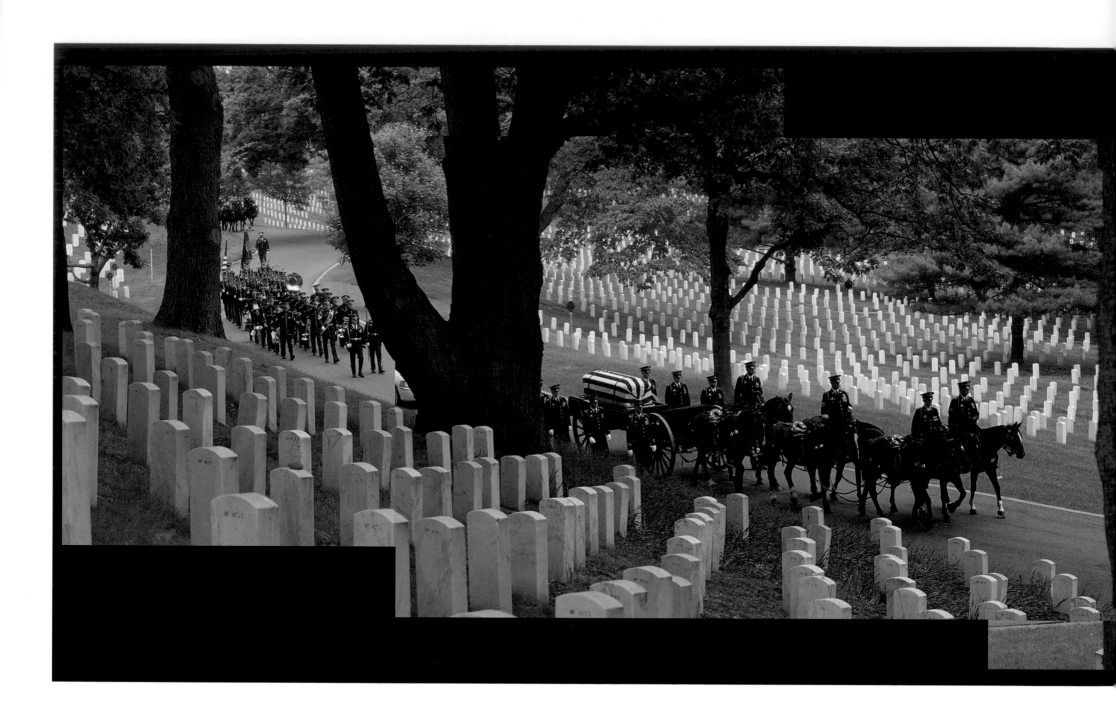

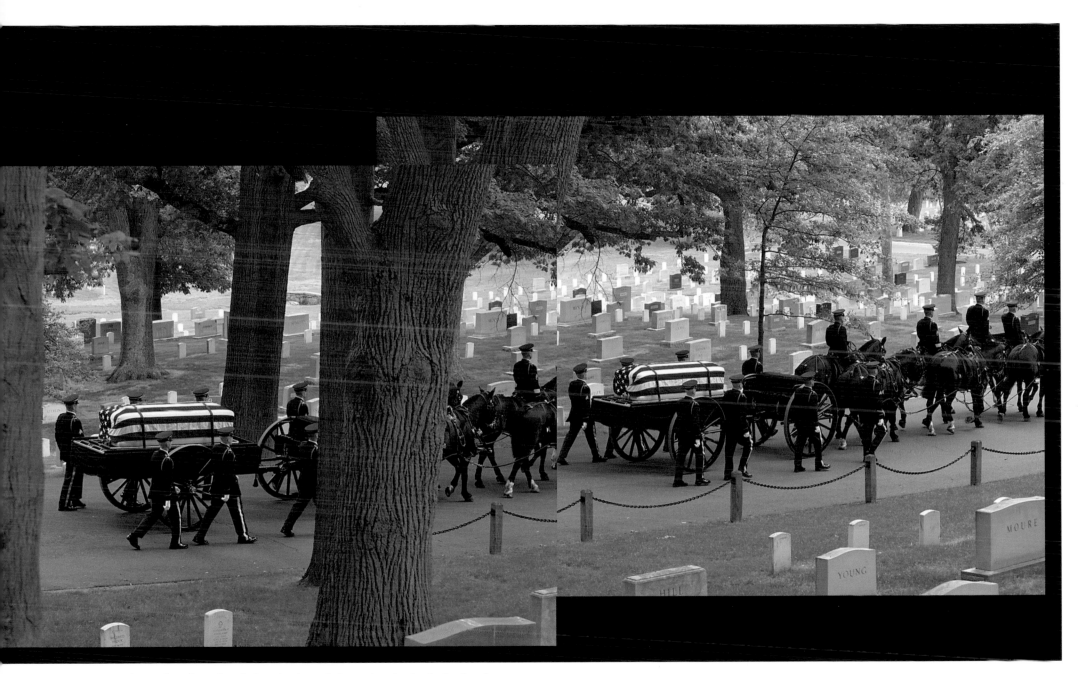

At one of two dozen funerals that take place each day, a caisson bearing the flag-draped casket of retired Army 1st Lt. Walter P. Kuzmuk rolls through Arlington's winding roads.

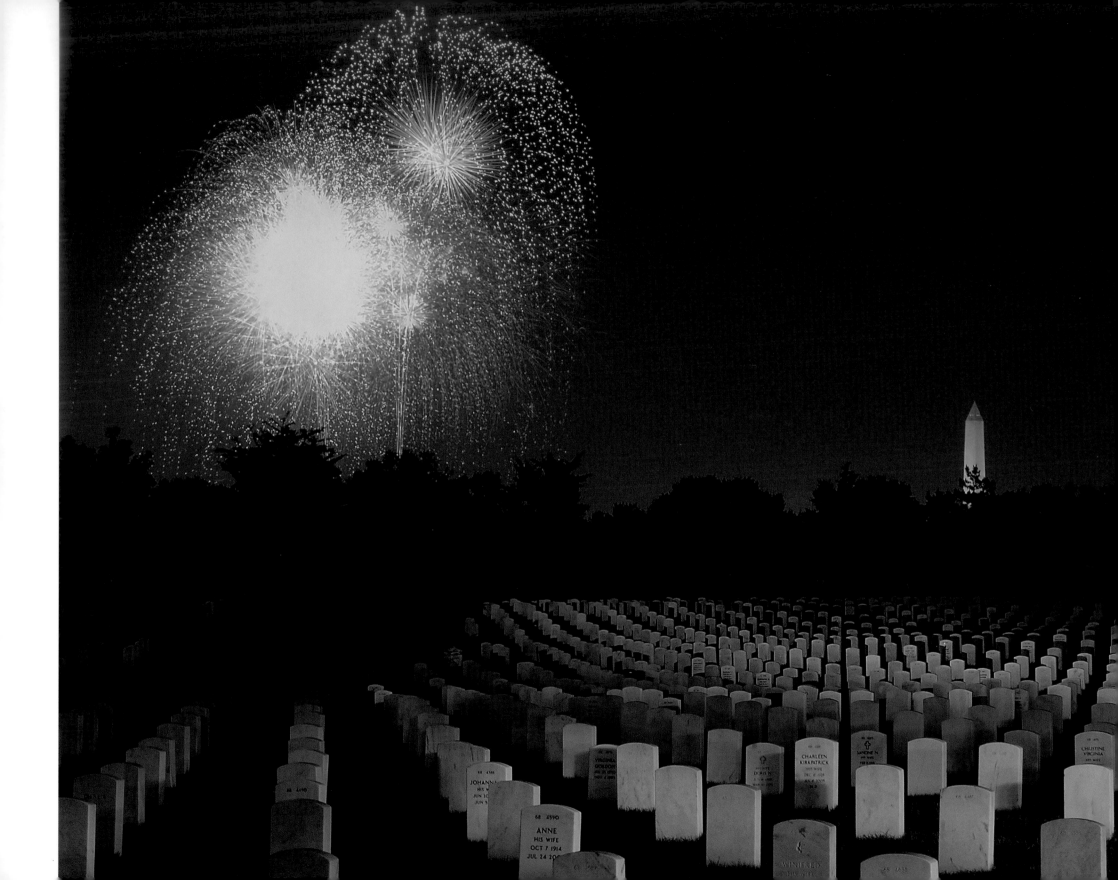

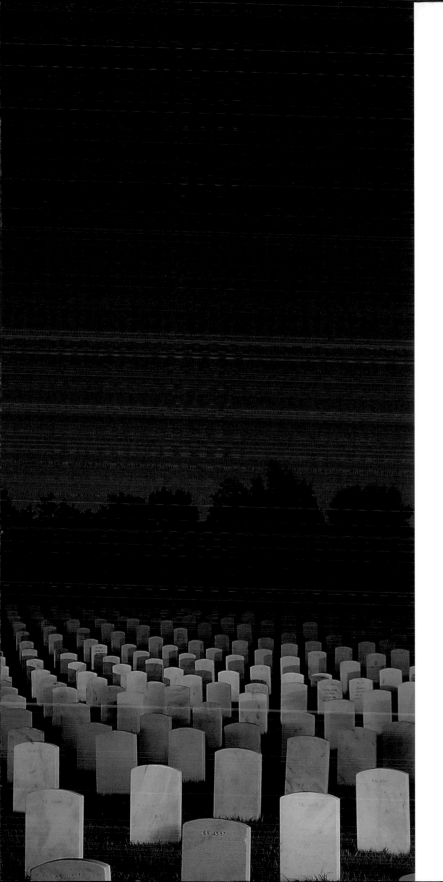

Colorful explosions of July 4th fireworks (left) and fall foliage fill the skies above Arlington.

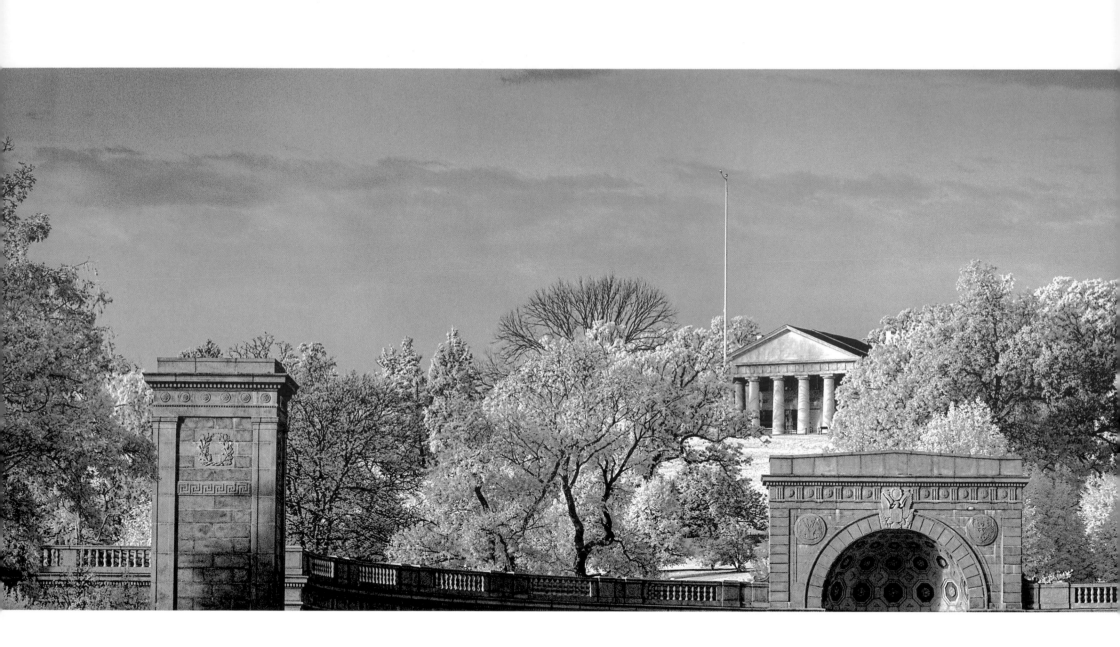

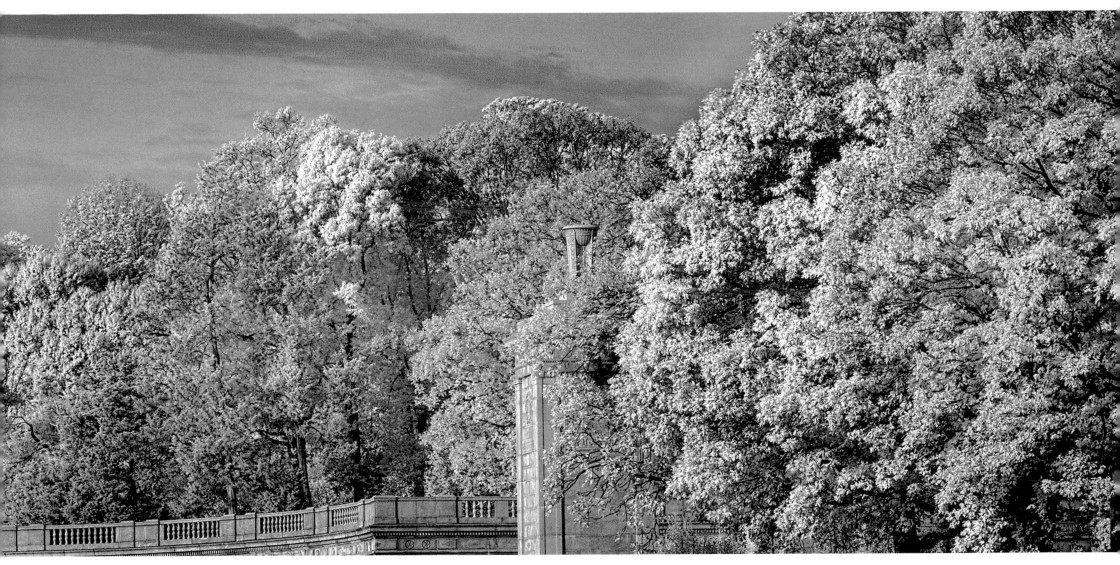

Framed by the colonnades of trees and Arlington House, the Women's Memorial creates a glorious panorama.

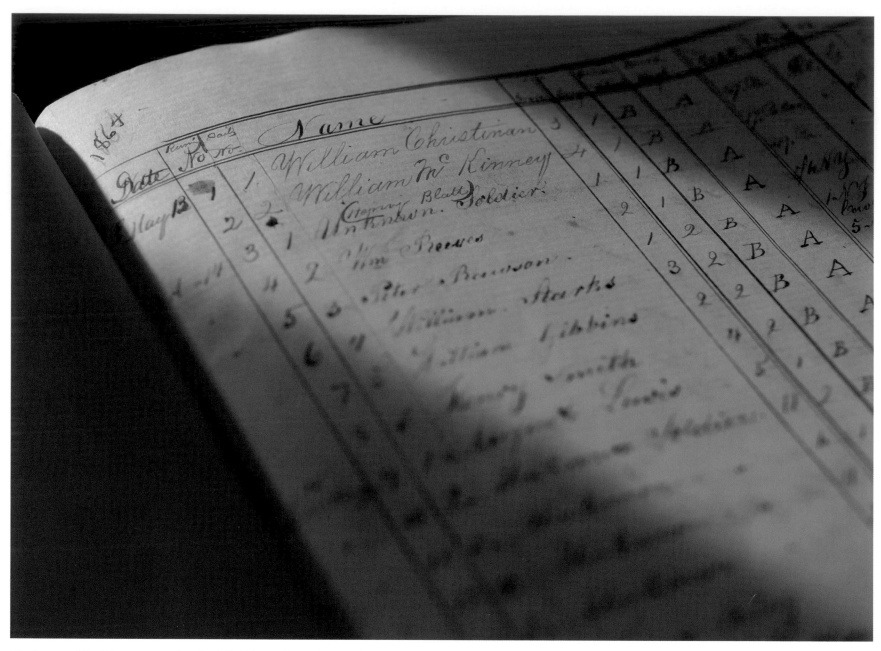

The first page of the Arlington grave register, dated 1864, lists William Christman (spelled incorrectly) as the cemetery's first burial.

Essay RICK ATKINSON

A PLACE OF REVERENCE AND REMEMBRANCE

NOTHING IN WILLIAM HENRY CHRISTMAN'S brief life suggested that in death he would become a singular figure in American history. A laborer from Lehigh County, Pennsylvania, Christman enlisted in the U.S. Army on March 25, 1864, for a $60 cash bounty and a $300 promissory note from his government. The muster rolls of the 67th Pennsylvania Infantry Regiment recorded that he was 5' 7½" tall, with sandy hair, gray eyes, and a florid complexion. Twenty-one years old and unmarried, he bore a scar on the left side of his neck and three prominent moles on his back. "I em well at the preasant time ant hope that my few lines will find you the same," he wrote his parents from Philadelphia on April 3, 1864. Military life suited him, he added. "I like it very good. We have enuph to eat and drink."

Three weeks later young Christman was hospitalized for measles. He grew sicker, and on May 1 was admitted to Lincoln General Hospital, a mile east of the Capitol in Washington, D.C. There, in Ward 19 on Wednesday, May 11, he died of peritonitis, a toxic inflammation of the membrane lining the abdominal cavity. An inventory of Christman's effects listed his modest legacy, including a hat, two flannel shirts, a pair of trousers, a blanket, a haversack, a canteen.

With the Civil War now in its fourth sanguinary year, Christman's body was among all too many bodies overwhelming the nation's capital. Every steamer up the Potomac River carried dead soldiers from Virginia battlefields, sheeted forms laid across the bows. Hospitals—often converted churches, public halls, or private mansions—ran out of burial space; more than 5,000 graves filled the Soldiers' Home cemetery alone. In desperate need of an expedient solution, Army quartermasters on May 13, 1864, trundled William Christman's mortal remains to a new burial ground that had been identified above the south bank of the Potomac on the confiscated estate of the Confederate commander, Robert E. Lee. The place was called Arlington.

Another Union soldier would be buried on the gentle slope near Christman later that Friday, with six more the next day, and an additional seven on May 15. By the time the war ended 11 months later, some 16,000 graves stippled the rolling greensward at Arlington as part of a deliberate plan to ensure that the Lee family could never reoccupy the estate, and to purify land ostensibly dishonored by General Lee's treason. With 600,000 dead in the Civil War, passions ran high.

In the 143 years since William Christman's burial those passions have cooled, but the veneration of Arlington as a place of reverence and remembrance has only increased. From the muddy potter's field of 1864, Arlington has grown to a vast necropolis of more than 300,000 dead in a leafy tract that has more than tripled in size from the original 200 acres. Of the 3.8 million square miles composing the United States of America, none is more sacred than the square mile of Arlington National Cemetery.

Here are buried Presidents and privates, five-star generals and anonymous souls known but to God. Here too are buried more than 370 recipients of the Medal of Honor, and ten times that many Civil War "contrabands"—fugitive or liberated slaves—whose headstones are chiseled with the simple epitaph "citizen" or "civilian." Arlington today holds dead veterans from every American war since the Revolution, including several hundred from the conflicts in Iraq and Afghanistan who are buried in Section 60, perhaps the saddest acre in America today.

Four and a half million visitors a year stroll beneath the white oaks and red maples, deciphering the nation's martial contours in the endless ranks of headstones that sweep from the ridgeline to the river flats below. Two dozen or more funeral corteges also roll through the cemetery each weekday, and

"Wash" Custis was a painter and built Arlington as a
memorial to his stepgrandfather, George Washington. His
depiction of the general at the Battle of Monmouth stands
in the Morning Room at Arlington House.

the sounds of another service member going to his or her grave—the clop of caisson horses, the crack of rifles, the drear blare of "Taps"—carry on the soughing wind from early morning until late afternoon.

This has long been a liminal place, a threshold where the living meet the dead, and where national history is intertwined with personal loss. Yet Arlington also is a shrine to valor and sacrifice, to service and fidelity. Those interred here tell a story not just of the Republic in war and in peace, but also of a transcendent ideal, conceived in liberty and reconsecrated in every new grave dug, every benediction murmured, every commitment into the hallowed ground. In this city of the dead, it is an ideal that lives on.

THE ARLINGTON SAGA begins with death.

Hazel-eyed Martha Dandridge was 18 years old in 1750 when she married a wealthy Virginia landowner named Daniel Parke Custis, who abruptly died seven years later. In 1759, she remarried a tall, ambitious soldier-planter named George Washington. Martha's son from her first marriage, John Parke Custis, grew up at Mount Vernon and in 1781 joined General Washington as an aide at Yorktown in time to see Lord Cornwallis surrender his trapped British army, effectively ending the American Revolution. Unhappily, the young man also contracted "camp fever," probably typhoid. Washington arrived at his sickbed, as he later wrote, "in time to see poor Custis breathe his last." He was 26.

The Commander in Chief adopted John Custis's infant son, George Washington Parke Custis, known as Wash, who remained at Mount Vernon for more than 20 years, until after the deaths of the former President, in 1799, and Martha, in 1802. Within months of his grandmother's passing, Wash Custis began to build a memorial to his celebrated kinsmen. He chose an 1,100-acre tract he had inherited after his natural father's death at Yorktown, a bucolic blend of wooded slopes and river bottoms with a commanding view of the new federal city rising across the river. He initially planned to call the place Mount Washington, but instead chose Arlington to honor an earlier family estate on Virginia's eastern shore.

The Greek Revival mansion he built with slave labor—with Doric pillars five feet in diameter—took 16 years to complete. Constructed of brick, with stucco finishes of faux marble and sandstone, Arlington housed not only the Custis family but an enormous trove of Washington memorabilia and heirlooms: British and Hessian battle flags; corn drills; china; Martha's money chest; the Commander in Chief's pocket telescope and the red-trimmed tent he used at Yorktown; the bed in which he died at Mount Vernon. Custis found himself perpetually in debt, not least for his extravagant purchases of mementos to enlarge the so-called Washington Treasury.

Though he considered himself a modern planter using the latest scientific methods, Custis was a poor manager whose true passions ran to painting—usually of huge historical canvases depicting Washington in heroic poses—playwriting, oratory, and party-giving. To those who voiced proper esteem for the Father of Our Country, Custis might snip a swatch from Washington's tent or a signature from an original document to give as a souvenir, according to Kendell Thompson, the National Park Service site manager. Some came simply to admire the gorgeous vista: the Marquis de Lafayette described the panorama from Arlington's center hall as "the finest view in the world."

One visitor came with different intentions. Lt. R. E. Lee, a West Point-trained engineer and scion of another prominent if impoverished Virginia family, had known the Custis clan since boyhood. Wash Custis's only surviving child, the diminutive and vivacious Mary Anna Randolph Custis, had attracted numerous suitors, including a young congressman from Tennessee named Sam Houston. But it was the gallant Lieutenant Lee who won her hand. On June 30, 1831, they were married beneath an archway in the Arlington parlor. Although Lee was often away on Army assignments, he later wrote that in Arlington "my affections and attachments are more strongly placed than at any other place in the world."

Mary Lee chose her childhood room on the second floor as the couple's master bedroom. Six of the Lees' seven children were born in an adjacent closet converted to a birthing room; their survival of infancy was ascribed to scrubbing

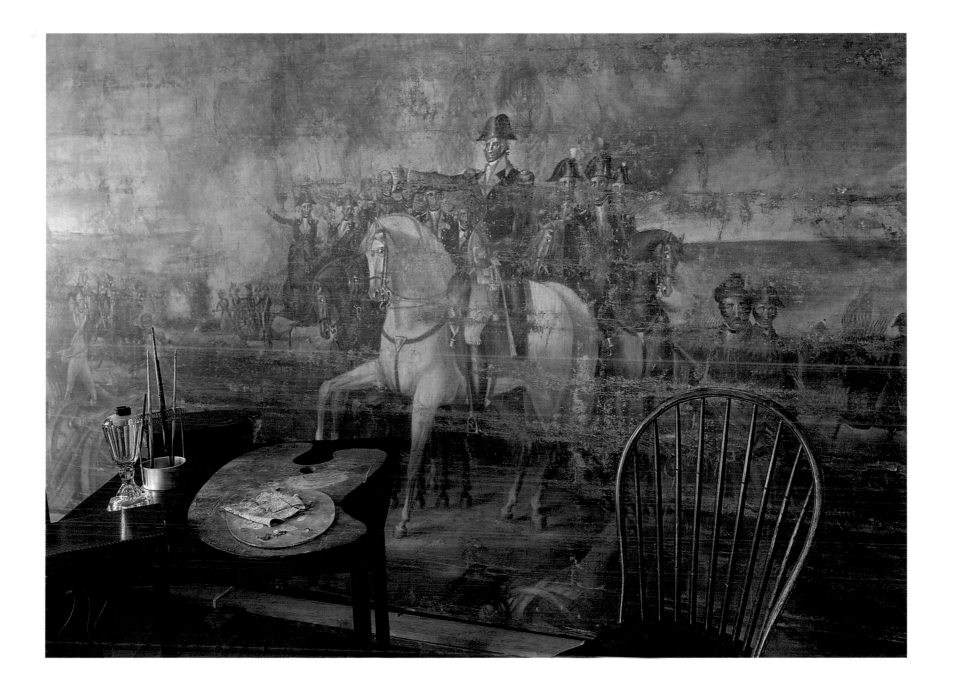

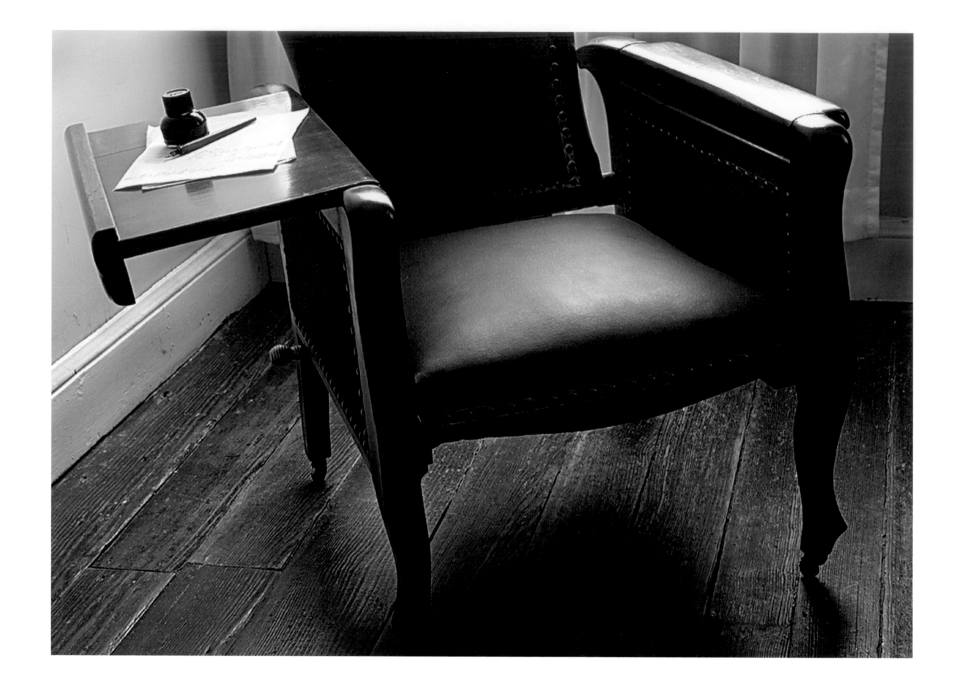

the walls with antiseptic borax. Mary ran the house, which she would inherit upon her father's death in 1857, despite rheumatoid arthritis that eventually confined her to a wheelchair. A landscape painter and an avid gardener who grew 11 variants of rose, she tutored the children and led the family prayers each morning and evening in the parlor.

To Robert fell the task of reviving an estate on the verge of ruin. Custis had owned some 200 slaves to work his three plantations, many of them inherited from Martha Washington. (One light-skinned slave who was said to be Custis's illegitimate daughter, Maria Carter Syphax, had been emancipated in the 1820s and given a 17-acre tract.) More than 60 slaves toiled at Arlington, harvesting corn and wheat for sale in District of Columbia markets. Yet only 300 acres were cultivated, mostly along the river. Taking extended leaves from the Army, Lee adopted severe measures to turn a profit, including renting slaves to neighboring planters and consigning others to field work near Richmond.

It was while on furlough at Arlington that Colonel Lee first stepped to the center of the national stage. On the morning of October 17, 1859, a young cavalry lieutenant named J. E. B. Stuart galloped up to the mansion with a sealed message ordering Lee to report to the War Department immediately. There he was dispatched with a detachment of Marines and militiamen to the river town of Harpers Ferry, where an abolitionist firebrand named John Brown had seized hostages. Lee routed the insurgents, freed the prisoners, and arrested Brown, who was hanged in December.

Sixteen months later the American cataclysm foreshadowed at Harpers Ferry broke in full fury. On April 18, 1861, with the approval of Abraham Lincoln, Lee was offered command of the Federal field army to confront the southern insurrection that had exploded at Fort Sumter several days earlier. For hours Lee paced in his second-floor bedroom, the creaking floorboards audible to Mary and the children in the morning room below. After midnight on Saturday, April 20, he trudged downstairs with his letter of resignation from the Army. "Well, Mary, the question is settled," he told his wife. Soon he was on a train for Richmond and eventual command of the Confederate armies. "War is inevitable," Lee wrote Mary, "and there is no telling when it will burst around you."

She vowed not to "stir from this house, even if the whole northern army were to surround it." But warnings of an impending Union attack across the river caused her to pack up the family silver and George Washington's papers. On May 15, Mary handed the house keys to a trusted slave, Selena Gray, and decamped with 12 wagons of household goods, eventually settling in Richmond, where she and her daughters knitted wool socks for Confederate soldiers.

On May 23, Virginians voted overwhelmingly in a referendum to affirm the state's secession. Within hours, in one of the first major actions of the Civil War, 14,000 Union soldiers crossed the Potomac to capture Alexandria and to occupy the high ground above the river. Within a week three New York regiments were camped on the Arlington estate, felling trees and dismantling rail fences for firewood. The house soon served as a headquarters for Brig. Gen. Irvin McDowell. "The fences are gone and the country around here is all stumped over and trod down," a Union soldier wrote. "Ain't it pleasant?"

Selena Gray, after advising soldiers "not to touch any of Mrs. Lee's things," warned General McDowell that his troops were pillaging the Washington Treasury. Heirlooms that escaped plunder were subsequently crated, labeled "captured at Arlington," and hauled to the Patent Office in downtown Washington for storage. Federal soldiers scribbled graffiti on the attic rafters. "Your old home has been so desecrated that I cannot bear to think of it," Lee wrote his daughters. "I should have preferred it to have been wiped from this earth."

Under a federal "Act for the Collection of Taxes in the Insurrectionary Districts," an assessment of $92.07 was levied against the Arlington plantation. Mary Lee dispatched a cousin to pay the sum only to learn that tax commissioners insisted on property owners appearing personally to settle their debts. On January 11, 1864, the 1,100 acres of the Arlington estate was publicly auctioned and sold to the only bidder, the U.S. government, for precisely the assessed value of $26,810. As General Lee had told his family, "They cannot take away the remembrances."

BRIG. GEN. MONTGOMERY C. MEIGS was a Georgian who not only remained loyal to the Union but also loathed both the Confederacy and those serving it. As quartermaster general of the U.S. Army, Meigs found himself grappling with the urgent issue of dead soldiers in Washington, where mortuaries had sprung up next to houses, markets, and restaurants. The *Washington Chronicle* complained that "it insults the meanest animals to have their dead and food in juxtaposition." With the arrival of early summer 1864, "the weather grew hot. Filled with shipments of corpses, Washington stank like a charnel house," historian Margaret Leech wrote in her Pulitzer Prize-winning *Reveille in Washington*. "The people, who could not accuse the dead, vented their horror on the embalmers."

Meigs petitioned Secretary of War Edwin M. Stanton for permission to convert the Custis-Lee estate into a military cemetery. Without waiting for Stanton's formal authorization, which would be issued on June 15, Meigs ordered the interments to begin. Poor Christman was buried near the northern perimeter of the estate, his name neatly inked in a government ledger with the wrong middle initial: William L. Christman. Soon as many as 40 burials took place each day, perfunctory inhumations that rarely featured even a chaplain in attendance. Still, the conversion of Arlington to a graveyard pleased most Yankees. "The grounds are undulating, handsomely adorned, and in every respect admirably fitted for the sacred purpose to which they have been dedicated," the *National Republican* observed on June 17.

In an August visit to Arlington, Meigs was furious to find that soldiers living in and around the mansion—reluctant to bury the dead too close to their bivouac—had located the cemetery a half mile away, near the old field slave quarters. "It was my intention to have begun the interments nearer the mansion," Meigs later noted. Ordering 26 bodies brought immediately from Washington, he personally supervised their burial along the perimeter of Mary Lee's rose garden "to more firmly secure the grounds known as the National Cemetery to the Government by rendering it undesirable as a future residence or homestead."

Soon the acreage around the house sprouted thousands of wooden grave markers. Lincoln himself occasionally visited ailing soldiers in nearby field hospitals; no doubt the melancholy tranquility of Arlington suited him. Among those interred was Meigs's son, Lt. John Rodgers Meigs, who as chief engineer of the Army of the Shenandoah was gunned down at the age of 23 by Confederate cavalrymen in October 1864. His antipathy to the Confederacy now informed by personal grief, General Meigs made Arlington even less appealing as a homestead by positioning a mass grave in the rose garden with the bones of 2,111 anonymous soldiers, most of them killed at the two Bull Run battles. "A literal Golgotha," the *National Intelligencer* reported. "Skulls in one division, legs in another, arms in another, and ribs in another." An inscription on the sealed vault lauded the "noble army of martyrs."

Defeated and disenfranchised, Robert E. Lee never saw Arlington again and made no effort to reassert his family's ownership of the estate before his death in 1870. But Mary was reluctant to surrender her birthplace without at least a last look. "Life is waning away," she wrote. "I do not think I can die in peace until I have seen it once more." A few months before her death in 1873, she drove to the rear of the house. "They have done everything to debase and desecrate it," she lamented, and refused to step from her carriage.

It fell to her oldest son, George Washington Custis Lee, to challenge the government's confiscation. An 1854 graduate of West Point who had served as an aide-de-camp to Jefferson Davis, the Confederate president, young Lee filed a lawsuit asserting ownership. In December 1882, the U.S. Supreme Court ruled five to four that Arlington had indeed been seized without due process. The U.S. government was therefore trespassing and would be forced to vacate the property and to exhume more than 17,000 graves.

For several months the government and the Lee family haggled. In March 1883, Congress appropriated $150,000 to buy the property outright, and on May 14 the deed was recorded in a local courthouse to forever transfer Arlington to the possession of the people of the United States.

More than 300,000 burials later, Arlington today is a complex, vibrant
organism within the nation's best known necropolis. Gravedigging remains
central to cemetery operations, although the task has been mechanized
since 1955 when the purchase of a Trenchmaster excavator allowed a grave
to be dug in 12 minutes for less than $10; previously, digging by hand with
a long-handed shovel took all day and cost $29.

These days a pair of three-man crews roam the cemetery with John
Deere 310G backhoes, searching for the wooden stakes left by a surveyor
who measures and marks each new plot to be opened. On a late summer
morning in Section 2 on Arlington's upper slopes, a 52-year-old backhoe
operator named Charles Montgomery eases his Deere among headstones
covered with plastic trash cans to prevent accidental chipping. Forty feet
away a stone obelisk marks the grave of Maj. Gen. Joseph "Fightin' Joe"
Wheeler, the Confederate cavalry commander who died in 1906 after also
serving as a U.S. Army general in the Spanish-American War. "Soldier,
Statesman, Gentlest, Tenderest and Most Lovable of Men," his epitaph reads.
A few paces uphill is the grave of Gen. George Crook, which features a
bronze tableau depicting the "Surrender of Apaches Under Geronimo to
General Crook" in 1883.

"My job's just to dig the holes. Dig the holes, then cover 'em back up,"
Montgomery says. "I start my way in the back of the grave and work my way
to the front, trying to keep it straight." Centering the backhoe boom on the
headstone in an adjacent row, Montgomery gnaws at the earth with the steel
teeth of his 32-inch bucket. This particular grave is an "open-up": A recently
deceased 98-year-old rear admiral will be reunited with his wife, who was laid
to rest on this spot, nine feet down, in 1991. The admiral's casket will go atop
hers, at seven feet. In five minutes a yawning hole has been dug, with the
corners square, the sides true, and the spoil in a neat pile. "When I've got the
bucket like this with the boom all the way down, that's seven feet,"
Montgomery says. "I been doin' this a long time, and I just know it."

After each interment a hydraulic tamper beats the earth to crush out air
pockets. Still, subsidence requires refilling up to 10,000 graves each year.

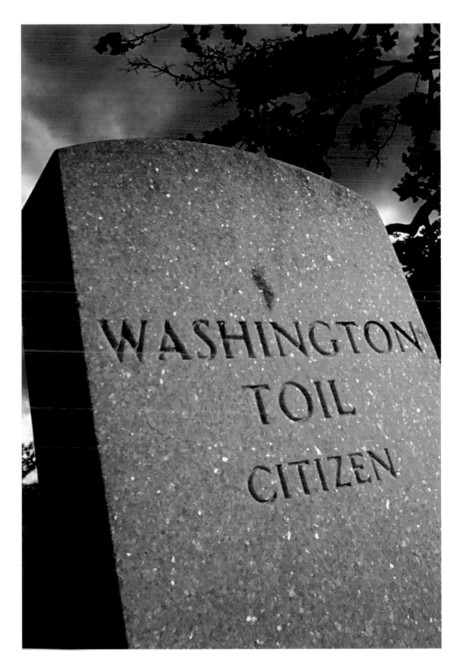

The dead in fact need perpetual care. Each day maintenance crews mow 130 acres, reset several dozen leaning headstones, and power-wash a thousand stones at 68 cents each. (Water pressure must be carefully modulated to avoid chewing into soft marble, particularly the older stones such as those in Sections 1 and 13.) Because the white painted headboards used during the Civil War required replacement every five years—at $1.23 each—Arlington briefly experimented with "Meigs Markers" made of a metal alloy from melted-down munitions. In 1879, the government adopted white marble for all national cemeteries; the familiar slab used today was designed by a board of officers after World War I. Twenty-four inches above ground, thirteen inches wide, and four inches thick, it accommodates only the sparest biographical details and brief "terms of endearment," all within a maximum of 12 lines and 15 characters per line. Each stone can also carry a spiritual symbol of which 38 have been authorized, from Episcopal and Muslim to atheist and Hindu.

Every burial at Arlington since William Christman's is listed on a five-by-eight-inch index card stored on an enormous Kardex revolving file. A large blueprint for each of the cemetery's 70 sections pinpoints every plot, along with trees, old sprinkler heads, gas lines, and other landscape idiosyncrasies. A map key indicates whether a particular plot is "available," "occupied," "obstructed," or "reserved." (Arlington no longer accepts reservations, but more than 7,000 remain valid from before the practice was halted in February 1962.) Cemetery officials someday hope to validate grave locations with global positioning system precision in order to digitize all site information and to confirm precisely how many people are buried here.

More than 6,000 funerals a year end in Arlington. A daily spread sheet lists them hour by hour, giving not only the location and depth of new graves but also a few hints of each life now ended: rank, next of kin, military service, whether the deceased was a decorated veteran. To prevent the corteges from colliding and to keep maintenance work at a respectful distance from graveside ceremonies, a sheaf of maps shows hourly funeral routes on the cemetery's 45 roads and walkways.

"The challenge is to ensure that we beautify the grounds without in any way compromising the grave sites," says chief of grounds and burial operations Erik Dihle, a tall, blond Californian who has worked here for a quarter century. Dihle oversees not only burial operations, but also Arlington's 25,000 square feet of shrubs, 15,000 square feet of flower beds, and 9,000 trees—black cherry, red oak, eastern red cedar—including 600 or so he believes were growing when the Lees lived here. Every morning brings new issues to finesse without roiling Arlington's dignity: A possible pesticide drift has killed a hemlock in Section 33; a water leak in Section 7A threatens to drown a boxwood; a small grass fire in Section 31 has left a charred patch 60 feet in diameter; workers told to "rock hound" a new swatch in Section 56 have not cleared away enough stones and debris.

In Dihle's office, next to the Norfolk Island pine and an angel wing begonia, a quotation from philosopher William James adorns a large wall map of Arlington: "The art of being wise is the art of knowing what to overlook." Regulations prohibit mourners from embellishing graves with artifacts or love tokens other than flowers. (Each week workers collect 90 cubic yards of decaying "floral matter.") Yet in Section 64 a grieving mother has placed several stuffed bears in a weeping willow near the grave of her young son. "She has a whole little colony of teddy bears there," Dihle says with a shake of his head.

In Section 60 the raw graves of the dead from Iraq and Afghanistan are appointed with little amulets for the next world: a ceramic fortune cookie; a bottle of beer; a spent 9-mm brass cartridge; a sliver of agate from the fallen soldier's native Kentucky; laminated photos of wives, sweethearts, children. On a smooth stone, a message neatly printed in indelible ink could crack the hardest heart: "I love you, Daddy. Happy birthday."

A SINGLE SHEET of paper listed the 24 funerals scheduled for November 25, 1963, beginning with an Air Force Reserve colonel named Edward C. Forsythe at 9 a.m. in Section 35. Yet it was the last of those two dozen ceremonies on the list, scheduled for 3 p.m. in Section 45, that would forever

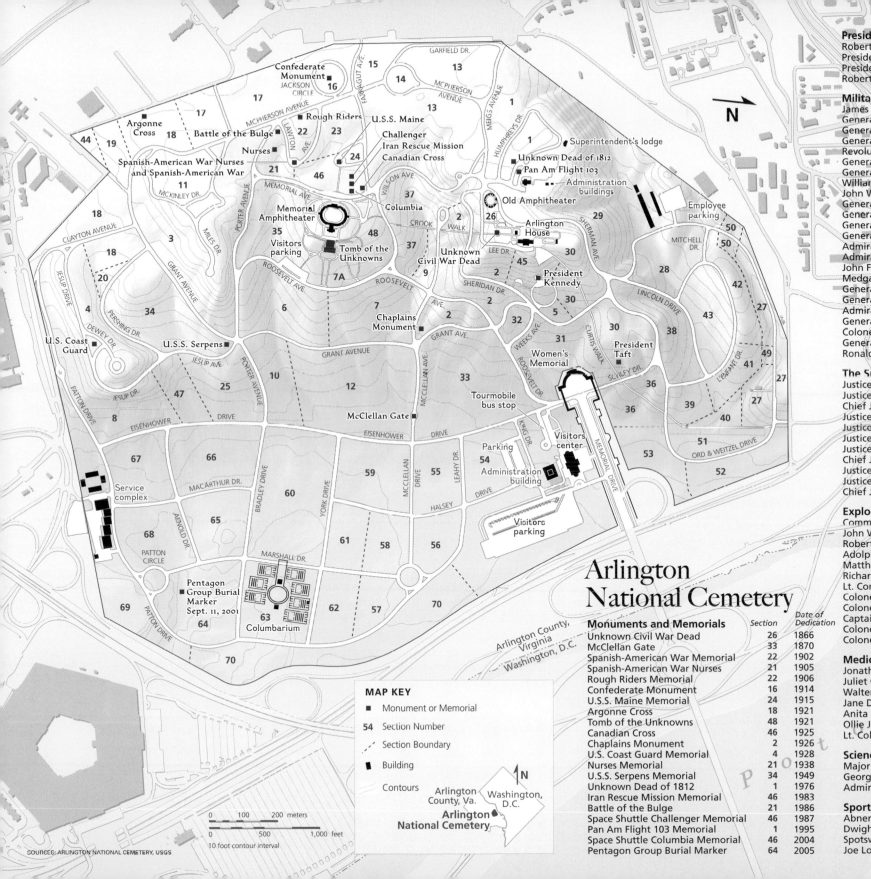

Arlington National Cemetery

Presidents and Family	Section	Date of Interment
Robert Todd Lincoln	31	1926
President William H. Taft	30	1930
President John F. Kennedy	45	1963
Robert F. Kennedy	45	1968

Military and Politics	Section	
James McCubbin Lingan	1	1812
General Philip Kearny	2	1812
General Philip Henry Sheridan	2	1862
General George Crook	2	1888
Revolutionary War Veterans	1	1890
General Arthur MacArthur	2	1892
General Nelson Miles	3	1912
William Jennings Bryan	4	1925
John Wingate Weeks	5	1925
General John J. Pershing	34	1926
General Henry Arnold	34	1948
General Claire Lee Chennault	2	1955
General George Marshall	7	1958
Admiral William F. Halsey	2	1959
Admiral William D. Leahy	2	1959
John Foster Dulles	21	1959
Medgar Evers	36	1959
General Daniel James	2	1963
General Omar Nelson Bradley	31	1978
Admiral Hyman Rickover	5	1981
General Maxwell Taylor	7A	1986
Colonel Gregory Boyington	7A	1987
General James Dolittle	7A	1988
Ronald Brown	6	1993

The Supreme Court	Section	
Justice Oliver Wendell Holmes	5	1935
Justice Hugo Black	30	1971
Chief Justice Earl Warren	21	1974
Justice William O. Douglas	5	1980
Justice Potter Stewart	5	1985
Justice Arthur Joseph Goldberg	21	1990
Justice Thurgood Marshall	5	1993
Chief Justice Warren E. Burger	5	1995
Justice William J. Brennan, Jr.	5	1997
Justice Harry A. Blackmun	5	1999
Chief Justice William H. Rehnquist	5	2005

Exploration and Space	Section	
Commodore Charles Wilkes	2	1877
John Wesley Powell	1	1902
Robert E. Peary	8	1920
Adolphus W. Greely	1	1935
Matthew Henson	8	1955
Richard Byrd	3	1957
Lt. Commander Roger Chaffee	3	1967
Colonel Virgil I. Grissom	3	1967
Colonel Francis R. Scobee	46	1986
Captain Michael J. Smith	7A	1986
Colonel Donn F. Eisele	3	1987
Colonel James B. Irwin	3	1991

Medicine	Section	
Jonathan Letterman	3	1872
Juliet Opie Hopkins	1	1890
Walter Reed	3	1902
Jane Delano	21	1919
Anita Newcomb McGee	1	1940
Ollie Josephine B. Bennett	10	1957
Lt. Col. Albert Bruce Sabin	3	1993

Science and Engineering	Section	
Major Pierre Charles L'Enfant	2	1825
George Westinghouse	2	1914
Admiral Grace Hopper	59	1992

Sports	Section	
Abner Doubleday	1	1893
Dwight Davis	2	1945
Spotswood Poles	42	1962
Joe Louis	7A	1981

Monuments and Memorials	Section	Date of Dedication
Unknown Civil War Dead	26	1866
McClellan Gate	33	1870
Spanish-American War Memorial	22	1902
Spanish-American War Nurses	21	1905
Rough Riders Memorial	22	1906
Confederate Monument	16	1914
U.S.S. Maine Memorial	24	1915
Argonne Cross	18	1921
Tomb of the Unknowns	48	1921
Canadian Cross	46	1925
Chaplains Monument	2	1926
U.S. Coast Guard Memorial	4	1928
Nurses Memorial	21	1938
U.S.S. Serpens Memorial	34	1949
Unknown Dead of 1812	1	1976
Iran Rescue Mission Memorial	46	1983
Battle of the Bulge	21	1986
Space Shuttle Challenger Memorial	46	1987
Pan Am Flight 103 Memorial	1	1995
Space Shuttle Columbia Memorial	46	2004
Pentagon Group Burial Marker	64	2005

MAP KEY

- ■ Monument or Memorial
- 54 Section Number
- --- Section Boundary
- ■ Building
- Contours

Arlington County, Va. | Washington, D.C.

Arlington National Cemetery

0 100 200 meters
0 500 1,000 feet
10 foot contour interval

SOURCES: ARLINGTON NATIONAL CEMETERY, USGS

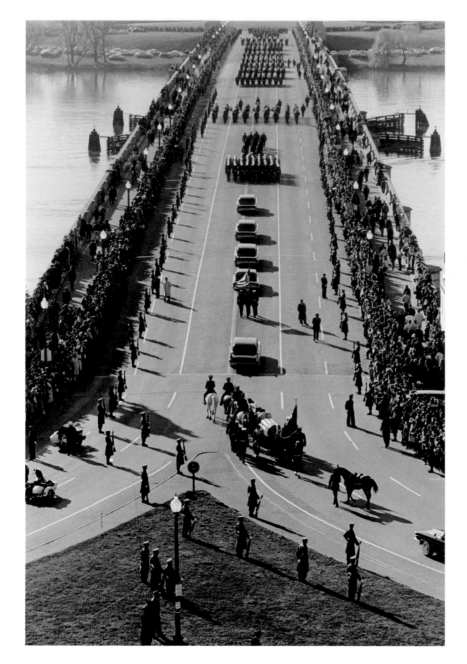

change Arlington. With the name of the deceased's next of kin misspelled— perhaps reflecting the bewildered anxiety that afflicted cemetery officials as it did all Americans—the entry read: "*John Fitzgerald Kennedy, Cdr. in Chief. NOK: Jqcqueline Kennedy, widow.*"

In the decades after the Civil War, Arlington had grown at a modest rate. Among the most poignant events in the cemetery was the first Decoration Day—now called Memorial Day—on May 30, 1868. President Andrew Johnson gave all federal workers the day off "for the purpose of strewing with flowers or otherwise decorating the graves of comrades." Wearing black satin sashes and singing "Father Come Home," children from the Soldiers' and Sailors' Orphan Asylum tossed blossoms on graves near the Custis-Lee mansion; Gen. James A. Garfield, who as President 13 years later would be sent to his own grave by an assassin's bullet, lauded those "for whom death was a poem the music of which can never be sung."

By the end of the 19th century, Arlington harbored almost 19,000 graves, with an average of one interment a day. Visitors often picnicked among the headstones, while vendors peddled ice cream, peanuts, and cigars. On holidays politicians spouted florid oratory of the "sleep on, great host" variety. War dead from the Revolution and the War of 1812 were reinterred here to extend Arlington's historical arc. The mass burial of sailors from the U.S.S. *Maine,* which blew up in Havana harbor in February 1898, raised national awareness of Arlington; in the first repatriation of American servicemen killed abroad, scores of flag-draped coffins were lowered into their graves simultaneously. Eventually the battleship's salvaged mast rose above 229 crewmen in Section 24. The burial of prominent, long-lived Civil War heroes, including Philip H. Sheridan in 1888, also elevated Arlington's status. Yet a facile routine obtained for a century: An Army quartermaster pamphlet in 1933 advised those sending a deceased loved one for interment, "The shipping case should be marked 'Officer in Charge, Arlington National Cemetery, Fort Myer, Va.' "

That all changed with Kennedy's death. The president, during a visit to Arlington earlier that year, had unwittingly selected his own grave site.

Surveying the serene vista below the mansion he reportedly murmured, "I could stay here forever." Mrs. Kennedy approved the location, and a grave was opened through the hard clay and oak roots. Since the solid mahogany casket weighed 1,200 pounds, military pallbearers in the small hours of November 25 practiced carrying a duplicate coffin filled with sandbags and further deadweighted with two soldiers sitting on top.

The President's burial, a somber pageant of grace and dignity, was watched by a worldwide television audience. Within three years, 16 million visitors paid homage to the site in Section 45, which was soon expanded to a three-acre sanctuary paved with Cape Cod granite and softened with sedum plants. The Institute of Gas Technology in Chicago installed an Eternal Flame as a beacon of remembrance. "It's as eternal as anything man-made can be," a cemetery official later observed.

Requests for burial in Arlington dramatically increased, a demand soon aggravated by more than 58,000 American deaths during the Vietnam War, when as many as 47 funerals in one day crisscrossed the cemetery. From the late 1950s until 2000, the number of graves would nearly triple, from 93,000 to 250,000. As cemetery officials searched for more contiguous land to augment Arlington's acreage, new eligibility rules sharply restricted burials to a small percentage of veterans, including those who die on active duty, those honorably retired after a career in the military, those highly decorated for valor, and their spouses.

EVEN A SHORT STROLL through Arlington is a perambulation through the American narrative. The graves of prominent military figures abound, of course, including World War II commanders like Gen. George C. Marshall, Gen. Omar N. Bradley, and Adm. William F. "Bull" Halsey, Jr. Gen. John J. Pershing, who led the American Expeditionary Forces in World War I, lies beneath a simple government-issue stone in Section 34, near his grandson, who was killed in Vietnam. Other veterans achieved fame in arenas beyond the battlefield, including boxer Joe Louis, author Dashiell Hammett, civil rights leader Medgar Evers, Supreme Court Justice Oliver Wendell Holmes,

Jr., and physician Walter Reed, whose headstone in Section 3 notes that "He Gave to Men Control Over That Dreadful Scourge Yellow Fever."

Section 27 is particularly poignant, with stones devoid of dates, terms of endearment, or the leanest biographical detail, such as "Mrs. Bannister, Citizen," or "Jackson, Citizen," or simply, "Power Boy." Here nearly 4,000 African Americans are buried, many of them denizens of Freedman's Village, established in 1863 on the confiscated Arlington plantation as a so-called model community for emancipated slaves, runaways, and those liberated by Union troops. The village was gone by 1900, but the dead remain. Other stones, inscribed "U.S.C.T.," commemorate U.S. Colored Troops who served the federal cause during and after the Civil War. If "in the democracy of the dead all men at last are equal," as poet and politician John James Ingalls wrote, some were more equal than others: Segregation by race and by rank held sway for decades before the ascent of contemporary egalitarianism.

Time has dulled the serrated edges of many tragedies and misadventures memorialized here, such as the Confederate dead who were interred at Jackson Circle beneath headstones that came to a slight point, ostensibly "to keep the Yankees from sitting on them"; or the cenotaph of an Army major who went down with the *Titanic* in 1912; or even the mass graves for the 250 dead from the Coast Guard ammunition ship U.S.S *Serpens*, which exploded and sank off Guadalcanal in January 1945.

Yet other, fresher calamities still sear, like the graves of 21 servicemen killed in the Beirut barracks bombing of 1983, or the memorial cairn to 270 people murdered by a terrorist bomb on Pan Am Flight 103 over Lockerbie, Scotland, in 1988. Of the 184 victims killed when American Airlines Flight 77 smashed into the Pentagon at 9:37 A.M. on September 11, 2001, 64 are buried at Arlington. In the final moments of its flight, the hijacked Boeing 757 screamed over the southern edge of the cemetery at 530 miles per hour. The horrific impact flung debris several hundred yards into Sections 69 and 70, which for more than a week remained an FBI crime scene.

Perhaps nowhere do tragedies past and present mingle more vividly than in a former chapel in Section 13, once known as the Field of the Dead.

The inconspicuous whitewashed building is now routinely used as a receiving vault. Stout wooden trestles on wheels cradle the caskets of soldiers killed overseas and whose interments are scheduled for the following morning. Occasionally a grieving widow keeps a moment's vigil here.

On a storage shelf above the vault's concrete floor, beneath a gray canvas cover, is a wooden platform, seven feet long and upholstered with a black velvet pall and black cotton tassels. It is a catafalque, an exact duplicate of the platform upon which the body of Abraham Lincoln lay in state in the Capitol Rotunda in 1865. The original bier remains in the Capitol crypt, but this second catafalque was built in 1958 when it was decided to inter unknown soldiers from both World War II and the Korean War simultaneously. Five years later, John Kennedy's mahogany casket would lie on this bier in the East Room of the White House. Now it awaits another national cataclysm.

A FOUL AUTUMN RAIN lashes Arlington at dawn. Inside the memorial amphitheater facing the Tomb of the Unknowns, a soldier in dress blues stands at attention while reciting the Sentinel's Creed for his assembled family and comrades from the Old Guard, the Third Infantry Regiment, which provides many of Arlington's ceremonial troops. "My dedication to this sacred duty is total and wholehearted," vows Specialist Jason R. Magnuson. Then his commander, Col. Robert P. Pricone, pins a Tomb Sentinel's badge on Magnuson's right breast pocket. "To date since 1957 we've given out only 548 badges. You are number 549," Pricone tells him. "We expect soldiers in our honor guard to embody warrior values. Your challenge now is to live up to that every day."

The Tomb Sentinel insignia is among the most difficult service badges to earn in the U.S. Army; of 15 soldiers in a recent trainee class, none was deemed worthy. It is also easy to forfeit. Seventeen badges have been revoked over the past half century for actions deemed dishonorable, from drug use to dozing on duty. If a nation's character can be gauged by how its war dead are treated, then the Tomb of the Unknowns and those who guard it are intended as a perpetual American affirmation of duty and honor. "My standard," the Sentinel's Creed asserts, "will remain perfection."

In the "Catacombs," a subterranean warren beneath the tomb, perfection requires compulsive attention to detail. Sentinels spend hours each day preparing their uniforms, with an Ajax press machine, fabric steamers, elbow grease, and endless "mirror time." A ruler calibrated to one sixty-fourth of an inch is used to be certain that buttons and decorations are properly aligned. White cotton gloves are molded to the hand with Velcro straps and soaked in water to allow a better grip on the slick M-14 rifle stock. A rubber "fat man belt" helps even those with husky torsos achieve the hourglass ideal, preferably with a 29-inch waist. Heavy wool tunics fit so snugly that each sentinel requires help wriggling into it. Masking tape rollers lift lint from the fabric, while stray threads are singed off with a cigarette lighter; when the tunic grows nappy, soldiers carefully "burn the blouse" with hair spray and flame.

"The shoes get weathered—humidity, sun, rain," says Sgt. Christopher J. Moore, a Las Vegas native and badge holder number 544. "We sand the pores from the leather, starting with 800 grit and working to 2000 grit, then add Kiwi polish and water to build it back up to a mirror finish. It might take six hours to get a good finish where there are no smudges. The soles are rubber and leather, and they're built up to force us to lean back so that the yellow stripe down the side of the pant leg is vertical. Humans naturally lean forward on the balls of their feet, but that would make the stripe less than perpendicular to the ground."

Precision and ritual also hold sway before the Tomb, where sentinels in American Optics mirrored sunglasses walk half-hour shifts "on the mat" in summer, hour-long shifts in winter. With an idiosyncratic stride intended to keep the upper body from bobbing, the soldier glides for 21 steps across the memorial plaza, then turns to face the Tomb for 21 seconds before retracing his steps. (In finding a personal rhythm, Sgt. Moore has learned that 15 respirations equal 21 seconds.) During the changing of the guard, sentinels signal each other with discreet scrapes of their steel shoe taps on the granite plaza. In the evening, when Arlington is closed to the public, the vigil shifts to a less formal "roving guard" in everyday uniforms, while sentinels work to correct

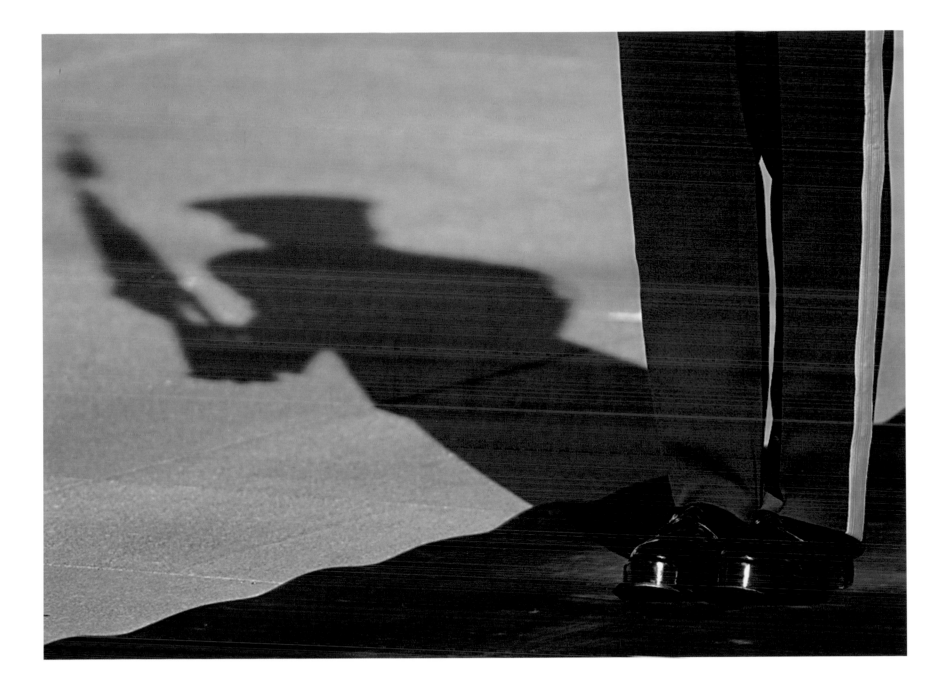

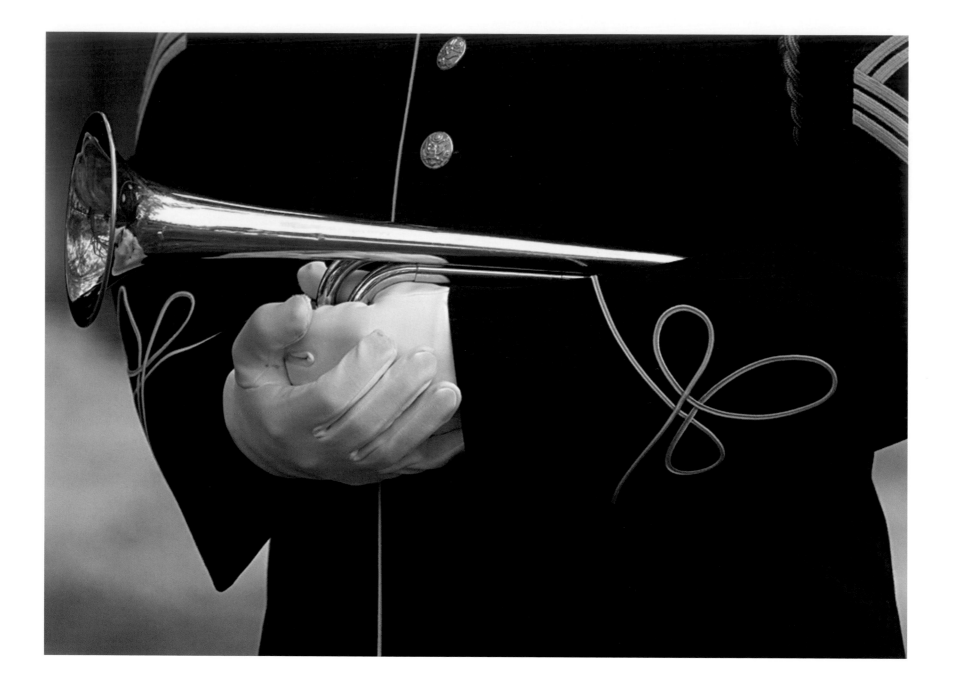

their defects, from imprecise heel clicks to "monster walking"—striding, for example, with the left leg and left arm in unison rather than in counterpoint.

"After being here for a while people start to have orthopedic problems from their feet up," says Staff Sgt. Anthony Oliva, badge holder number 526. "Heel clicks are tough on the knees, and the rigid posture can hurt the lower back." He shrugs and smiles, then returns to his relentless pursuit of perfection.

"It's not just a duty, not just a job. It's an honor," Sergeant Moore adds. "The more you know about the Tomb, the more reverence you have for it. It's a way of keeping tradition."

That tradition began with the random selection of a single soldier in France among more than 1,200 unidentifiable remains from the Great War. Brought home aboard the U.S.S. *Olympia*, the casket was interred on November 11, 1921, and eventually surmounted by a roughly 80-ton sarcophagus of Yule marble quarried in Colorado, similar to that used for the Lincoln Memorial. Cabinet secretaries and Supreme Court justices, veterans and foreign dignitaries poured into Arlington for the ceremony, many of them forced to walk across the Potomac bridges by what was described as "the greatest traffic jam in Washington's history." Mourners sang "Nearer My God to Thee," and in his eulogy President Warren G. Harding voiced hope that the day would mark "the beginning of a new and lasting era of peace on earth, good will among men."

It was not to be. World War II and Korea produced more unknowns, who were interred on Memorial Day 1958 in a ceremony meticulously planned with a 73-page script but marred by torrid weather that prostrated some 400 spectators with heat exhaustion. They may have been the last unknowns, not because President Harding's "lasting era of peace" arrived, but because modern DNA analysis and identification procedures now give a name to even the most insulted remains. A Vietnam unknown, entombed in 1984, was exhumed in 1998 and reinterred in St. Louis after tests proved that the serviceman was 1st Lt. Michael J. Blassie, an Air Force pilot shot down in May 1972. Today the empty vault carries the inscription "Honoring and Keeping Faith With America's Missing Servicemen, 1958-1975."

Among other challenges, cemetery officials today face replacing the massive Tomb because two hairline cracks, now with a combined length exceeding 44 feet, nearly encircle the monument. First discovered in 1963, the fissures have grown worse despite grouting repairs in 1975 and 1989.

HOUR BY HOUR, year by year, ritual and ceremony at Arlington link yesterday to today, while providing a rhythm that dignifies death and consoles the living. The morning begins at 4 A.M. in the stables of the Third Infantry Regiment caisson platoon on adjacent Fort Myer. Soldiers assigned to the Old Guard shine their brass, clean the equestrian tack, and wash the horses to be used in the day's funerals—deep dents in the sheet metal lining the shower room walls show that some steeds resent the pre-dawn ablutions more than others. The platoon has its own coal-fired forge and master farrier, who shoes the horses every six weeks and adds borium studs for extra traction on Arlington's hilly roads. A platoon leatherworker, using the 1916 "Field Artillery Harness Quartermaster Drawings" as a blueprint, also fashions the reins, girths, and other tack from thick rolls of cured rawhide.

"Horse teams are in matched colors, all blacks or all grays," says Sgt. Jared M. Bolton. Six horses pull a 1918 artillery caisson that bears either a coffin or an urn with cremated remains placed on a tray that slides out of a Batesville mock casket. (Any officer buried in Arlington is entitled to ride to his or her grave on a caisson.) Soldiers in dress blues ride postillion style on the left mounts. Deceased Army or Marine Corps colonels and generals may also be honored with a caparisoned horse—a riderless mount tacked with a saber and cavalry boots fitted backward in the stirrups to signify a fallen warrior looking back at his troops a final time. An ancient ritual, the "cap horse" was used in Lincoln's funeral but most famously in Kennedy's cortege, where the handsome, spirited Black Jack, a gelding morgan and quarter horse cross, seemed representative of the slain President's vigor.

By midmorning, honors are under way across the cemetery. "Many traditions in today's military funerals can be traced to the Civil War," says

Thomas L. Sherlock, Arlington's historian. For example, caissons were used because of a shortage of ambulances; shortages of caskets meant that flags were used to cover bodies.

Now each ritual has its own intricacies. The flag used in a military officer's funeral is boxed—folded 13 times into a trim triangle, stars out—in one minute and fifty-four seconds, which is precisely the duration of the hymn played by the band. The seven soldiers in a firing party pull their triggers three times successively so that each volley of blanks sounds like a single shot, a particular challenge given that acoustics vary from section to section. "Every movement that these guys do with their weapons has to have a cadence that's burned into their brains," says Staff Sgt. Robert F. McLauchlin, who waited with the honor guard in Section 54 to bury a retired colonel, a World War II veteran. "The goal is to make the movements look mirrored, like you cloned one guy."

No ritual is repeated more often, or carries more enduring emotional power, than the playing of "Taps" at the end of a ceremony. It too has Civil War origins, having been composed in July 1862 during the Peninsular campaign on Virginia's James River by Brig. Gen. Daniel Butterfield, who supposedly whistled a new tune for his brigade bugler to replace the bland "lights out" call previously used in Union bivouacs. Again, the most memorable rendition came during Kennedy's funeral when an Army bugler, numb from standing outdoors for nearly three hours, cracked the sixth note. "It was like a catch in your voice, or a swiftly stifled sob," wrote author William Manchester.

Today more than 50 military buglers play at Arlington, including Army Master Sgt. Allyn Van Patten, who estimates he has blown "Taps" at least 8,000 times in a quarter century of service at the cemetery. "It's a nice piece of music. It's like a song," Van Patten says. "Unlike a lot of bugle calls, you can inflect it, you can play music with it." Adds Master Sgt. John Abbracciamento, a Marine Corps trumpeter, "I don't want to be detached when I play during a funeral. I want to do something for that family. They'll never know who I am, but they'll never forget."

At 24 notes, "Taps" has the virtue of brevity. At Arlington, where every day more than 25 services must be coordinated with military precision, time can become the enemy.

SPACE IS ALSO an enemy, or rather the lack of it. For more than a half century, Arlington's guardians have cautioned that the cemetery is running out of room. As author Philip Bigler noted in his comprehensive history, *In Honored Glory,* a surge in interments during World War II led to a warning in 1944 that grave space "will be exhausted in five to seven years. . . . Only 14,000 more persons can be buried in Arlington." Grave dimensions were reduced, from 6 by 12 feet to 5 by 10; tiered burials—with caskets stacked like bunk beds in the same hole—were adopted in the early 1960s, followed by the controversial new regulations that sharply curtailed eligibility. Parcels of land were appended over the years, notably 190 acres from Fort Myer South Post. Still, at the current rate of interment, Arlington will be at capacity around 2060.

Few issues have greater urgency for John C. Metzler, Jr., Arlington's superintendent since 1991. A former Army helicopter crew chief in Vietnam, Metzler lives in the same gabled house behind the Custis-Lee mansion where he grew up: His father, who is buried in Section 7A, was superintendent here from 1951 to 1972. Asked to pick his favorite section of the cemetery, Metzler replies, "I always walk around Section 1 because that's where I live. I know virtually everybody in Section 1. But Section 2 has a wonderful view of Washington, D.C. I'll walk over there sometimes at night and just ponder for 20 minutes or half an hour."

Metzler's master plan, drafted in 1998, identified 14 parcels of land abutting the existing cemetery. Collectively those tracts, mostly owned by other federal agencies, would provide another 125 acres; Metzler so far has acquired 3 of the 14. Topography is always an issue because steep slopes are the gravedigger's bane. "Eight hundred graves per acre is the optimum," Metzler says, "and if there are less than six hundred, then you're probably talking about too much slope to stabilize the grave-digging equipment."

The surface roots of an old oak encase a grave marker. Space
is the challenge to Arlington's future. At the current rate of
interment, the cemetery will reach capacity around 2060.

Arlington has benefited from the increasing American preference for cremation, which requires much less space for both in-ground burial or inurnment in the cemetery's columbarium. "When I joined the national cemetery system in 1974, cremation was an odd thing," Metzler says. "Now it's 60 percent of our business." If additional land is procured, Arlington's census by the end of this century could reach a half million, comparable to the living population of the District of Columbia. Eligibility—"a very political and very sensitive area," Metzler adds with a cocked eyebrow—may be tightened again in the distant future.

Each opened grave yields roughly one and a half cubic yards of excess dirt, and that spoil is now used to build up the final few acres in a new swatch formerly owned by South Fort Myer. Some 20,000 graves will occupy the sector, with a sweeping view of the Potomac, and 5,000 niches for cremated remains will be built into the cemetery's perimeter wall. A long, grassy stretch also remains unturned in Section 60, sacred ground awaiting those whose fates will lead them here. Roughly one in every ten soldiers killed in Iraq is buried at Arlington, a higher percentage than from any previous American war.

THE SEASONS RISE, the seasons fall away. Arlington bustles year round, but with a stately, measured grace. Wash Custis's mansion will soon close for a three-million-dollar overhaul that includes installing fire suppression and climate-control systems. The National Park Service hopes to discover more secrets during the rehabilitation: Archaeologists recently found an antebellum well beneath the south wing, which later was used to store milk from the plantation's dairy cows.

A squall line blows through, tossing the great trees. Rain pelts the graves and laves the headstones, each emblematic of who we were, where we've been, and what we have become. Then the afternoon skies fair and the final funeral processions of the day snake through the great yard, bearing another old soldier to his rest, or perhaps a soldier no older than William Christman was.

Across the river, the federal city gleams in the dying sun. A tranquil silence descends, broken only by the distant rap of a drum.

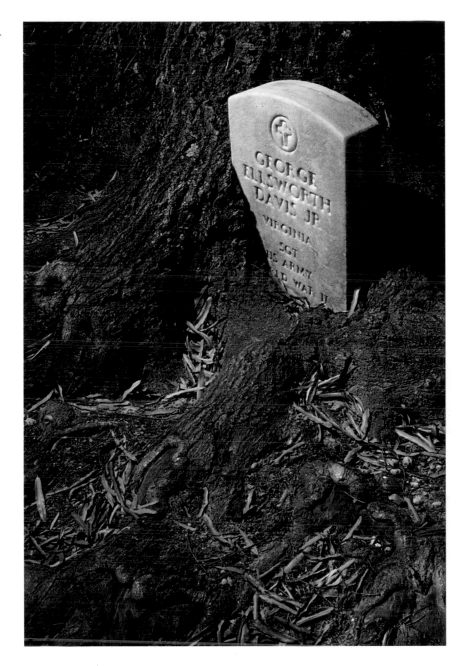

No landmark more solemnly embodies the historical arc of the United States than this shrine to the fallen, where every hallowed acre narrates the growth of our republic and the affirmation of its ideals through sacrifice. Arlington is the HISTORY

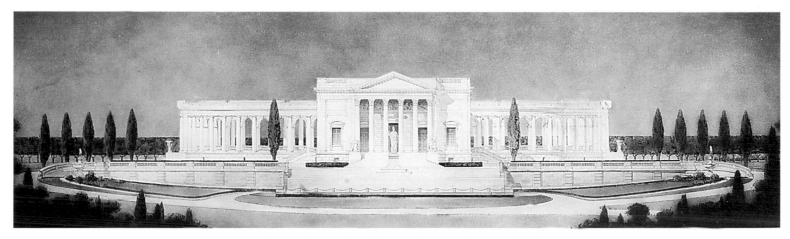

Arlington Memorial Amphitheater dedication rendering, circa 1920

ESTABLISHED IN 1864 on the acreage once owned by the families of two of this country's greatest generals—George Washington and Robert E. Lee—Arlington inters the remains of soldiers from battles dating from the Revolutionary War to the present. The land, which for a time functioned as farmland for freed slaves, currently serves as the final resting place for more than 300,000 valiant men and women, including 2 Presidents, 11 Supreme Court justices, 16 astronauts, and a myriad of prominent Americans and foreign nationals. In addition to the endless rows of white grave markers and the expanding columbarium, more than two dozen structures punctuate the landscape, including the Confederate Monument, John F. Kennedy Memorial, Pentagon Group Burial Marker, and the Tomb of the Unknown Soldier, dedicated to American soldiers "known but to God." The most prominent edifice, the Memorial Amphitheater, annually hosts services on Easter, Memorial Day, and Veterans Day. In addition, some 150 of Arlington's lovingly maintained trees pay homage to the fallen. Planted in memoriam by numerous organizations, they provide living cenotaphs in this sacred bivouac of the dead, immortalizing courage and enshrining sacrifice in the same way every marble grave marker does. The result is a tableau that chronicles the forging of a nation.

Photographs from the ARLINGTON ARCHIVE

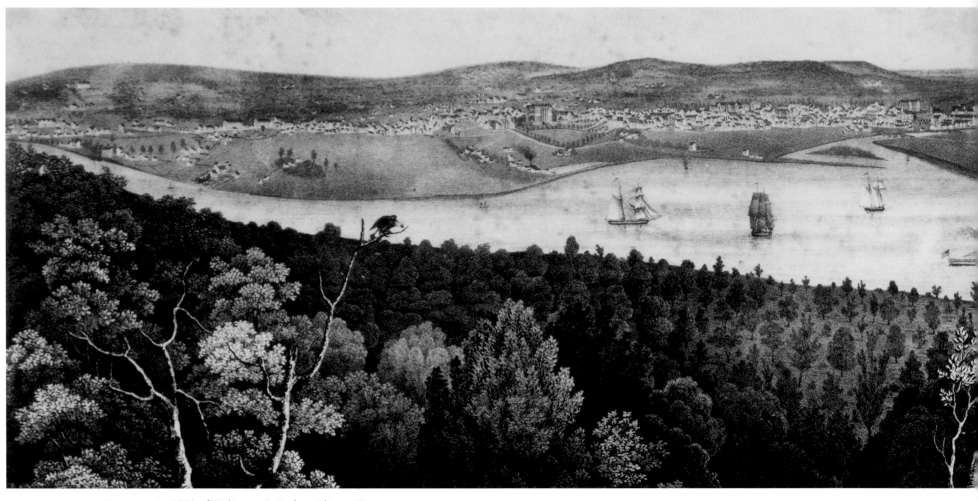

A rare view, circa 1838, of Washington, D.C., from Arlington House

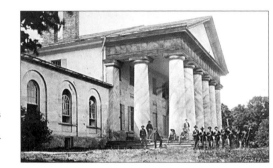

1861
Civil War begins. Gen. Robert E. Lee resigns from the Union Army, joins the Confederacy, and abandons his 1,100-acre Arlington estate. Union troops occupy the house. ▶

1864
Federal government confiscates Arlington when Mrs. Lee fails to pay property taxes in person. More than 1,100 freed slaves are given Arlington land.

1864
U.S. government purchases Arlington and establishes a national cemetery. Pvt. William H. Christman is Arlington National Cemetery's first interment.

1865
Civil War ends. More than 15,000 are now buried at Arlington.

1868
First Decoration Day (renamed Memorial Day) is held.

1883
After a Supreme Court decision returns title of Arlington to Lee's son, he sells it to the U.S. government for $150,000.

1892
The first of the Revolutionary War casualties are reinterred.

1898
U.S.S. *Maine* explodes in Havana, killing 260. The Spanish-American War galvanizes the nation.

1900
Congress approves construction of Confederate Memorial.

1911
Pierre L'Enfant, planner of Washington, D.C., is reinterred with a monument overlooking the city.

1913
President Woodrow Wilson dedicates *Maine* Memorial.

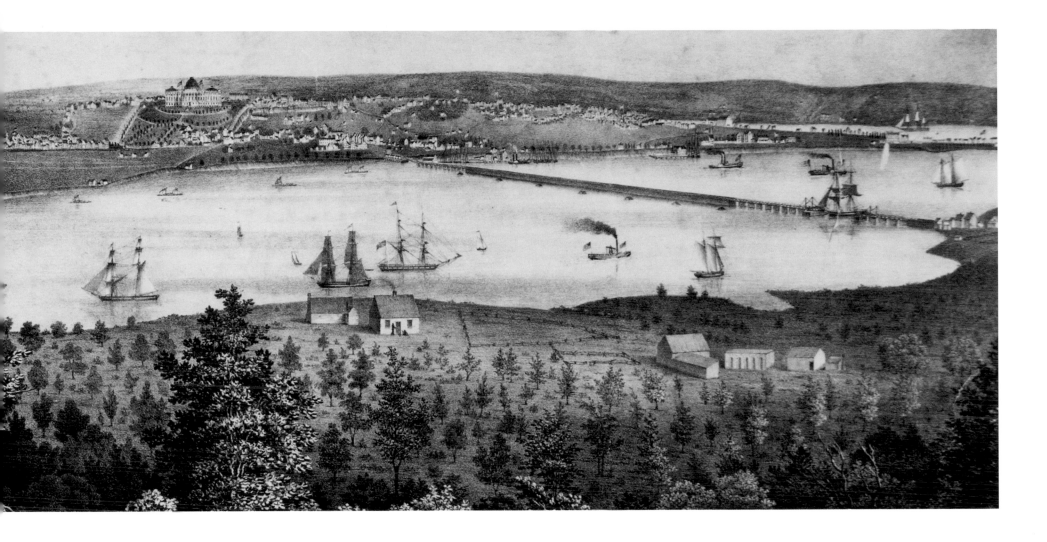

1915
Construction on the Memorial Amphitheater begins. ▶

1917
United States enters World War I.

1920
The Memorial Amphitheater opens. A beaux arts structure designed by Frederick D. Owens of Carrere & Hastings and dedicated to the Army, Navy, and Marine Corps, it serves as a place of assembly.

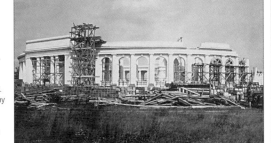

1921
In the plaza of the amphiteater, President Warren G. Harding presides at the opening of the Tomb of the Unknown Soldier, a white marble sarcophagus commemorating the unidentified remains of soldiers of World War I.

1925
Arlington House becomes Memorial to George Washington Parke Custis and Robert E. Lee.

1930
William H. Taft becomes first President buried at Arlington National Cemetery.

1937
The Tomb of the Unknown Soldier is put on 24-hour guard. Elite Third Infantry Division sentinels take over 11 years later.

1941
The U.S. enters World War II.

1949
Mass memorial service for 250 casualties of the U.S.S. Serpens explosion.

1950
Korean conflict begins.

1958
Burial of World War II and Korean conflict unknowns.

Shortly after interring its first soldier, Arlington erects its first monuments in June 1864. A sequence of images (opposite) chronicle the construction of the Memorial Amphitheater, 1915-1920.

1963
◄ President John F. Kennedy is interred at Arlington National Cemetery. His grave site overlooks the nation's capital and is marked by the eternal flame.

1967
Eligibility criteria changes limit burials to members of the active armed forces, retired members, Medal of Honor recipients, elected officials, and persons holding high-level government positions.

1968
Senator Robert F. Kennedy is interred in a grave adjacent to his brother, John F. Kennedy.

1971
Audie Murphy, the most decorated World War II soldier, is buried in Arlington. ►

1980
The first of Arlington's nine Columbarium Courts, for cremated remains, opens.

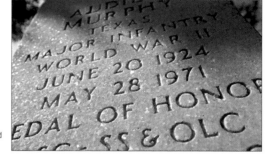

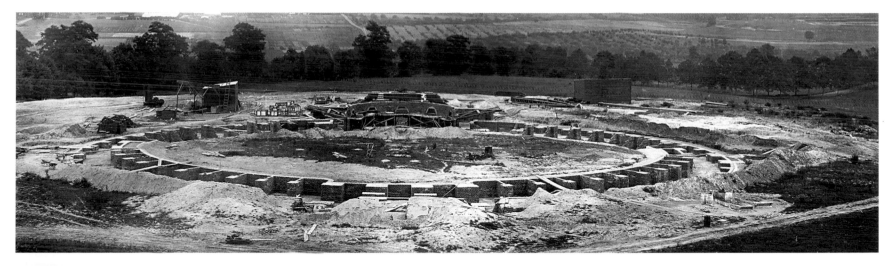

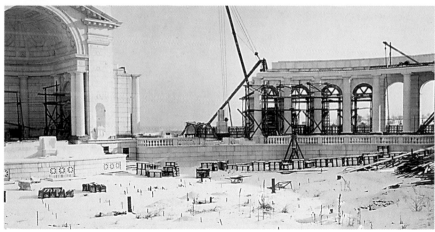

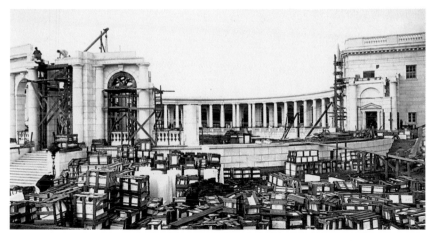

1984
President Ronald Reagan presides over the interment of the Vietnam Unknown soldier. ▶

1987
Space Shuttle *Challenger* Memorial is dedicated.

1991
Persian Gulf War begins.

1996
Sgt. Heather Lynn Johnsen becomes first female Tomb Guard.

1998
Vietnam Unknown is exhumed and identified as Air Force 1st Lt. Michael Joseph Blassie.

1998
The secretary of the Army identifies land around Arlington for the next 100 years of burials.

2001
Global war on terrorism begins after World Trade Center and Pentagon attacks.

2002
Group burial for the unidentifiable remains of Pentagon attack victims. The Pentagon Group Burial Marker is dedicated.

2004
Memorial to the space shuttle *Columbia* victims is dedicated.

2005
Interments/inurnments at Arlington pass 300,000.

2006
Land Development 90 completed, the last 40 acres of the old South Fort Myer lands. Further acquisitions give Arlington National Cemetery enough land to accommodate burials through 2060.

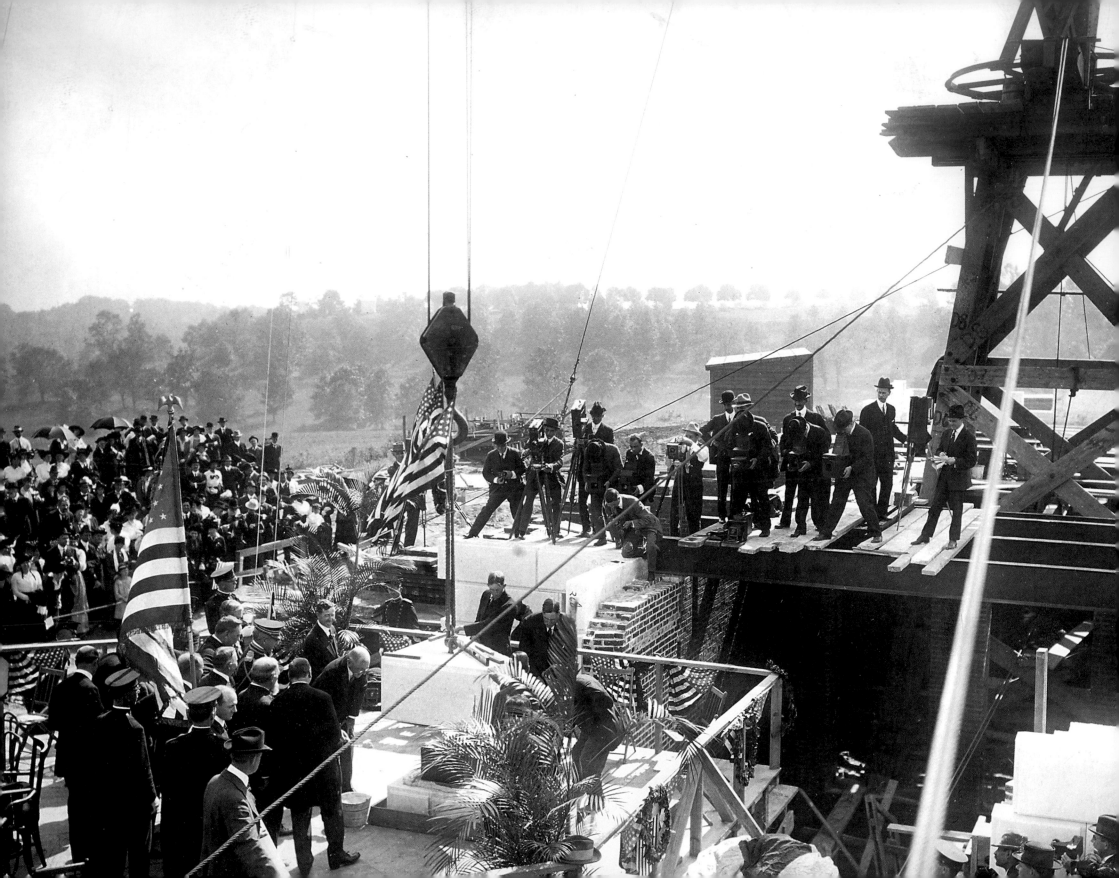

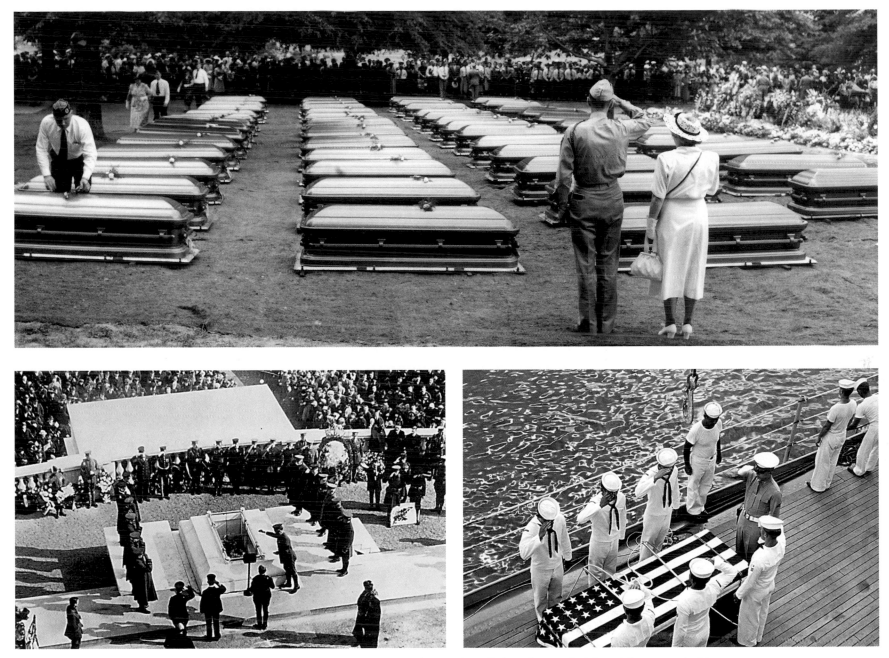

President Woodrow Wilson (opposite) lays the cornerstone at the Memorial Amphitheater on October 13, 1915. Clockwise from top: In Arlington's largest group burial ever, 52 caskets honor the 250 victims in the U.S.S. Serpens explosion; naval pallbearers in Guantánamo Bay render appropriate honors before moving the casket of the Unknown Soldier in 1958; President Warren G. Harding presides over the emplacement the Tomb of the Unknown Soldier in 1921.

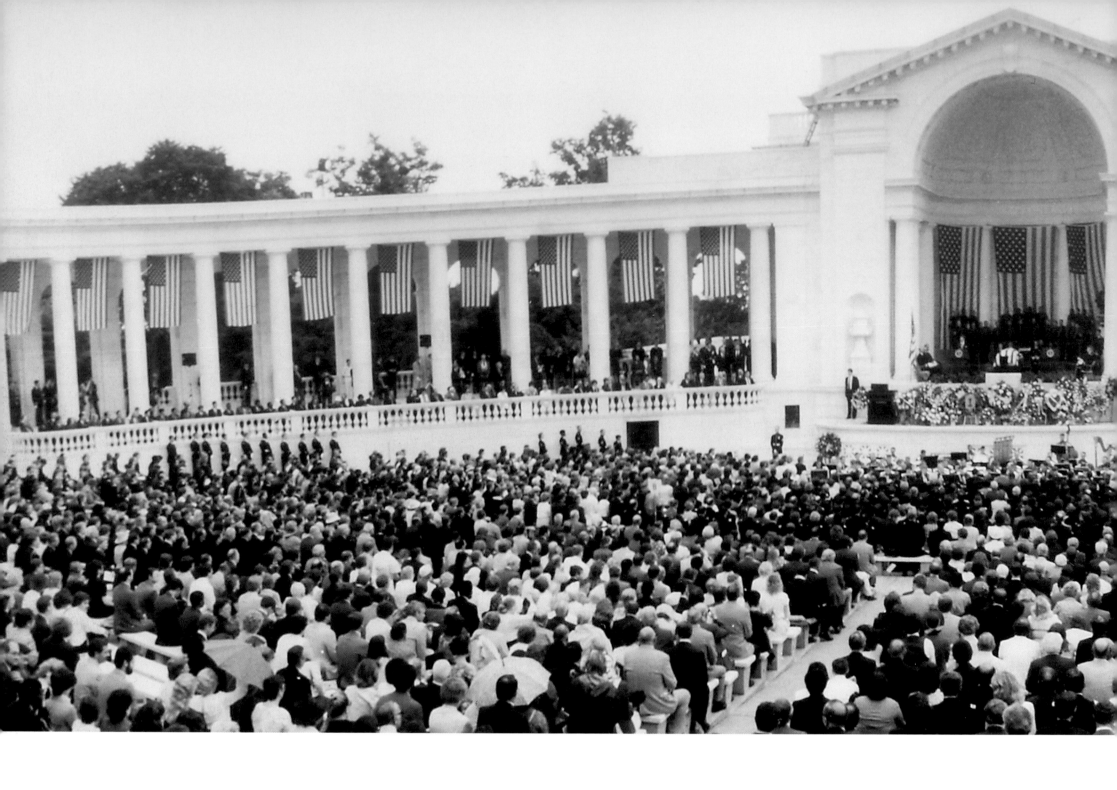

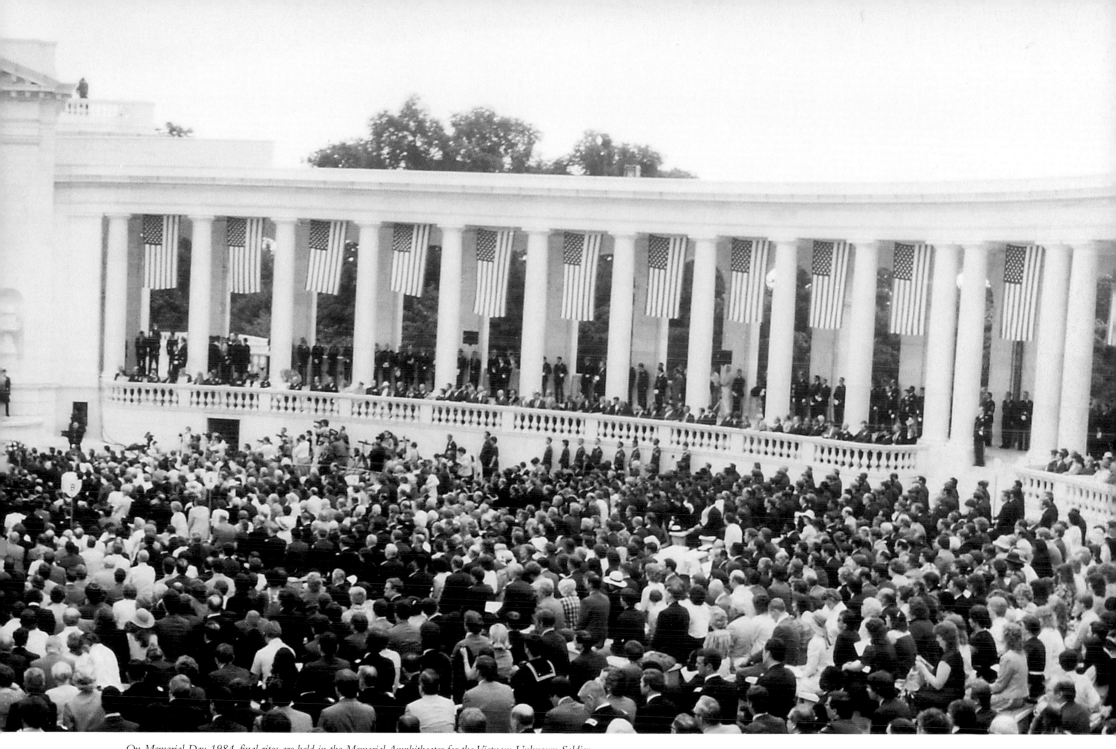

On Memorial Day 1984, final rites are held in the Memorial Amphitheater for the Vietnam Unknown Soldier.

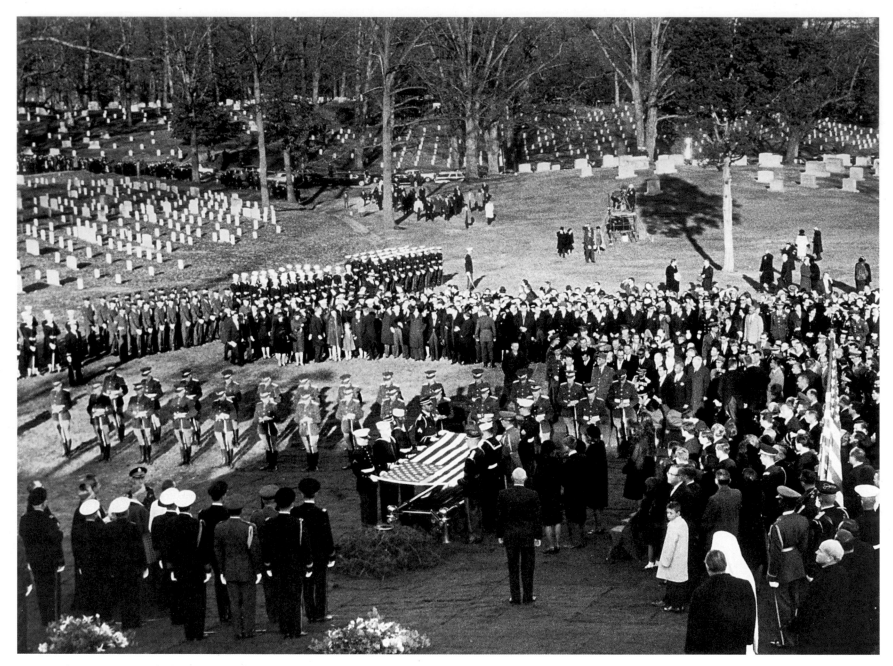

Joint Armed Forces Honor Guard (above) remove the flag from the casket of John F. Kennedy, 1963. A lone visitor (opposite) lost in Arlington's serenity, 1965.

Burial at Arlington eternally and ceremonially unites the soldier with hundreds of thousands of his or her compatriots. As it rolls along the tree-lined hills studded with endless rows of headstones, the funeral cortege represents the **FINAL MARCH**

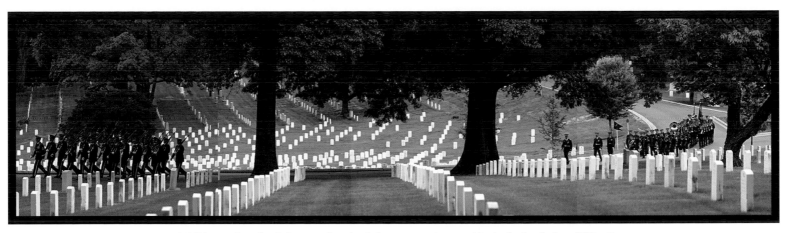

A full honors funeral includes a marching band, firing party, caisson, and bugler for the playing of "Taps."

IN ADDITION TO "standard" military honors, which include a chaplain, a three-round volley by a firing party, and the playing of "Taps," Arlington offers officers, warrant officers and any active-duty soldier a "full" military honors funeral consisting of a procession to the grave site with a horse-drawn caisson carrying the flag-covered casket, marching band, escort of troops, and a four-man color guard. The funeral cortege presents a ritualized pageant that dates to the Civil War and resonates with the hypnotic rhythm of Arlington's undulant terrain. The procession repeats itself two dozen times a day, every hour on the hour, employing the services of some 300 soldiers and numerous volunteers from the different service branches—all of whom ensure that no soldier ever goes to his grave alone. Every funereal step in these elaborately choreographed marches inspires reflection on mortality and the continuum of history. Captured in evolving panoramas, the images on these pages express that continuum. Their composition and construction suggest both the passage of time and the timelessness of ritual, both the finality of death and the nobility of life lived in service to the nation. Each frame seamlessly flows into the next, like so many monuments to time spaced evenly across the landscape, echoing the solemn cadence of the soldier's ultimate retreat.

Photographic Essay by JAMES BALOG

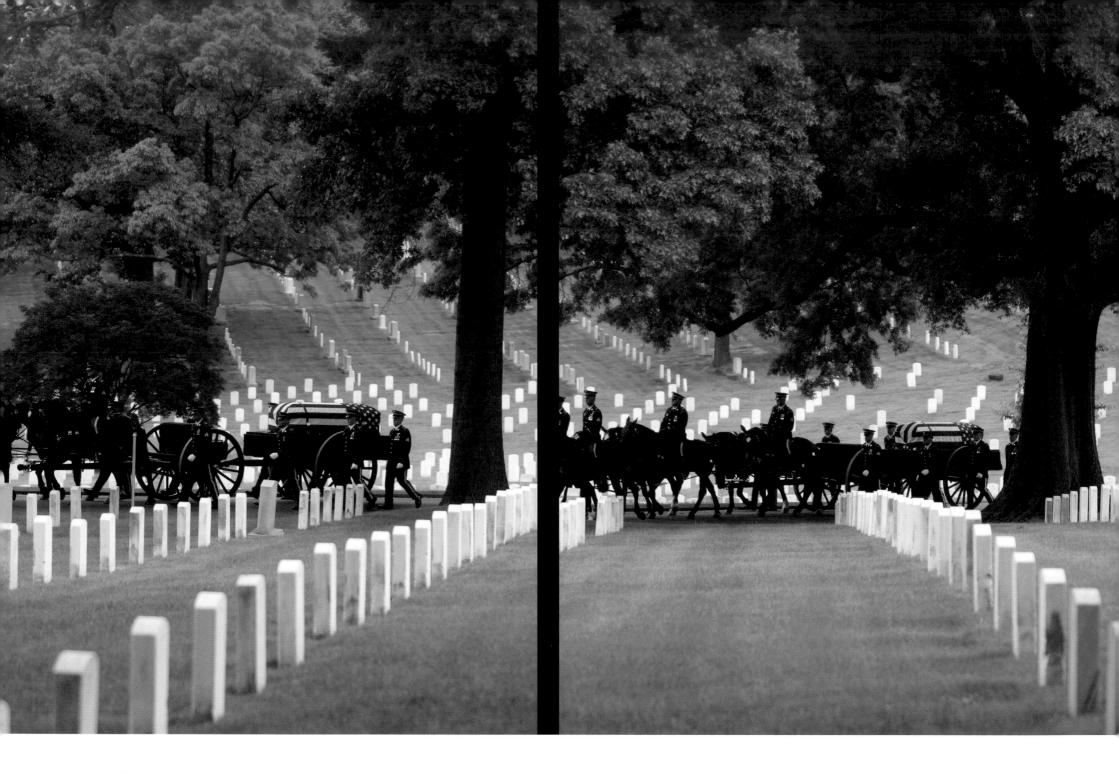

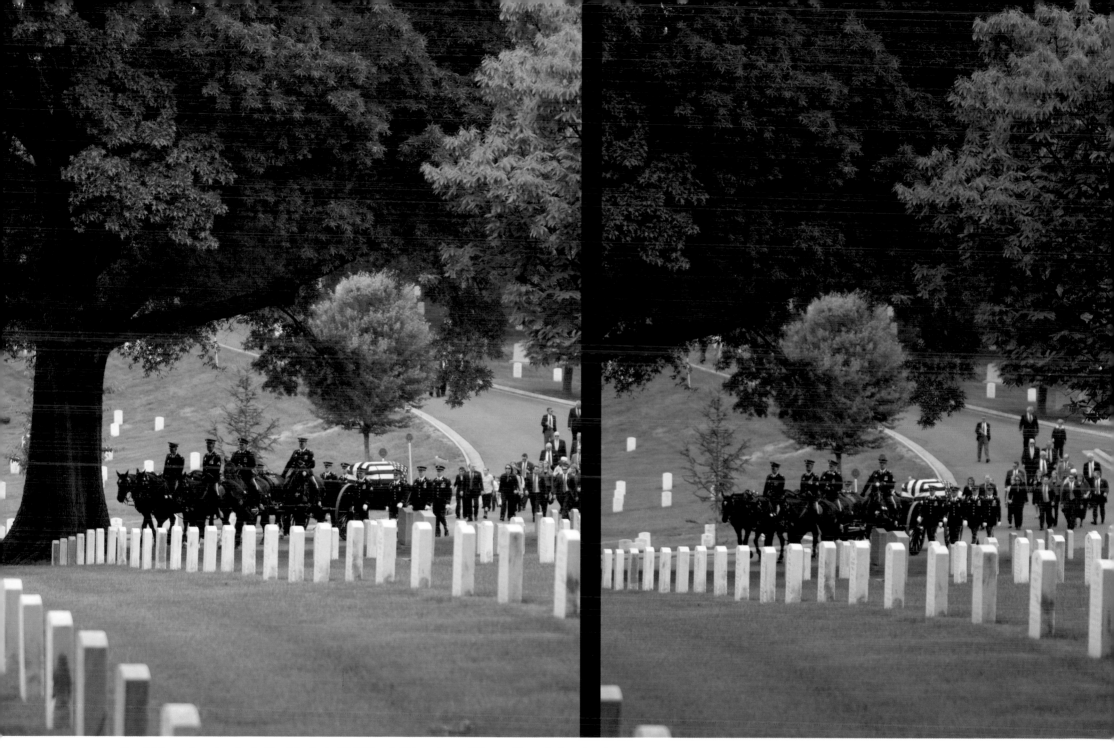

In a full honors funeral, a ritual with origins in the Civil War, a half dozen horses ridden postillion style draw the caisson bearing the flag-draped casket of an Army officer. Here, Capt. Walter Hynes makes his last retreat.

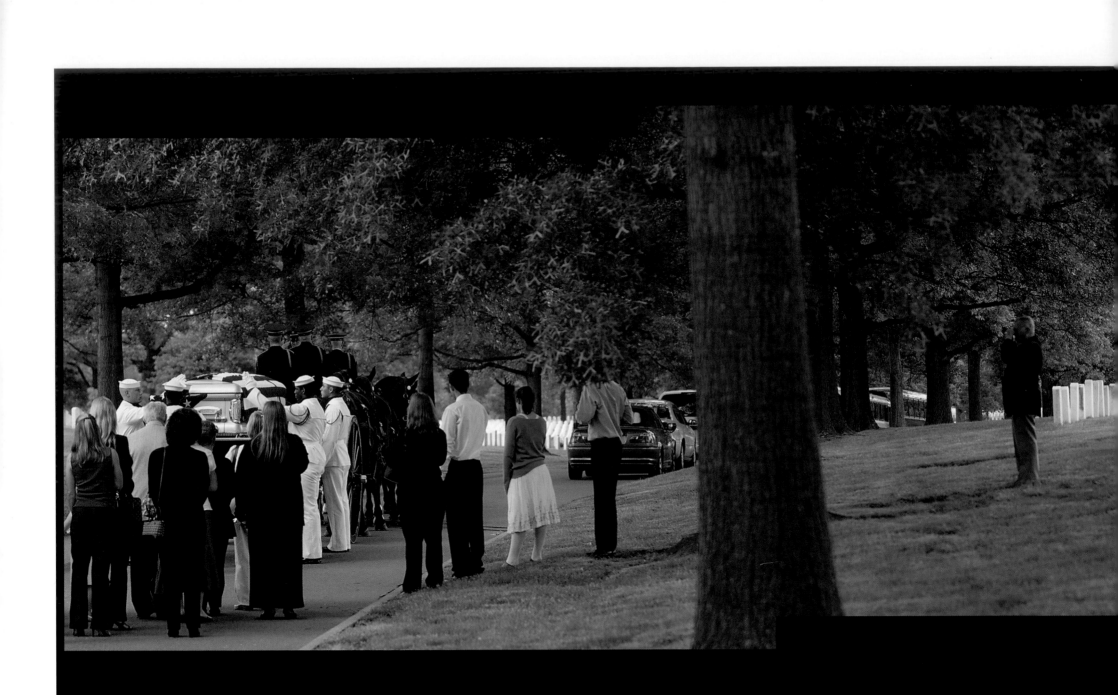

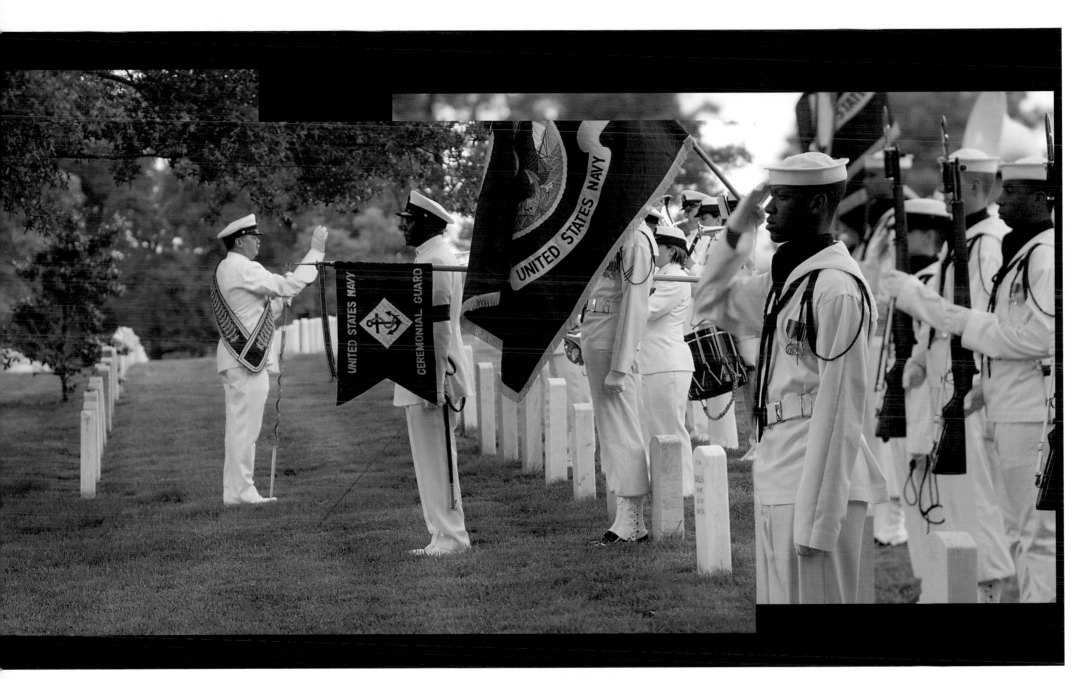

Mourners witness the unveiling of the casket during the full honors ceremony of Navy Lt. Cdr. E. Joseph Kalakowski. Since 1931 the U.S. Navy Ceremonial Guard has rendered final honors at every Navy funeral at Arlington.

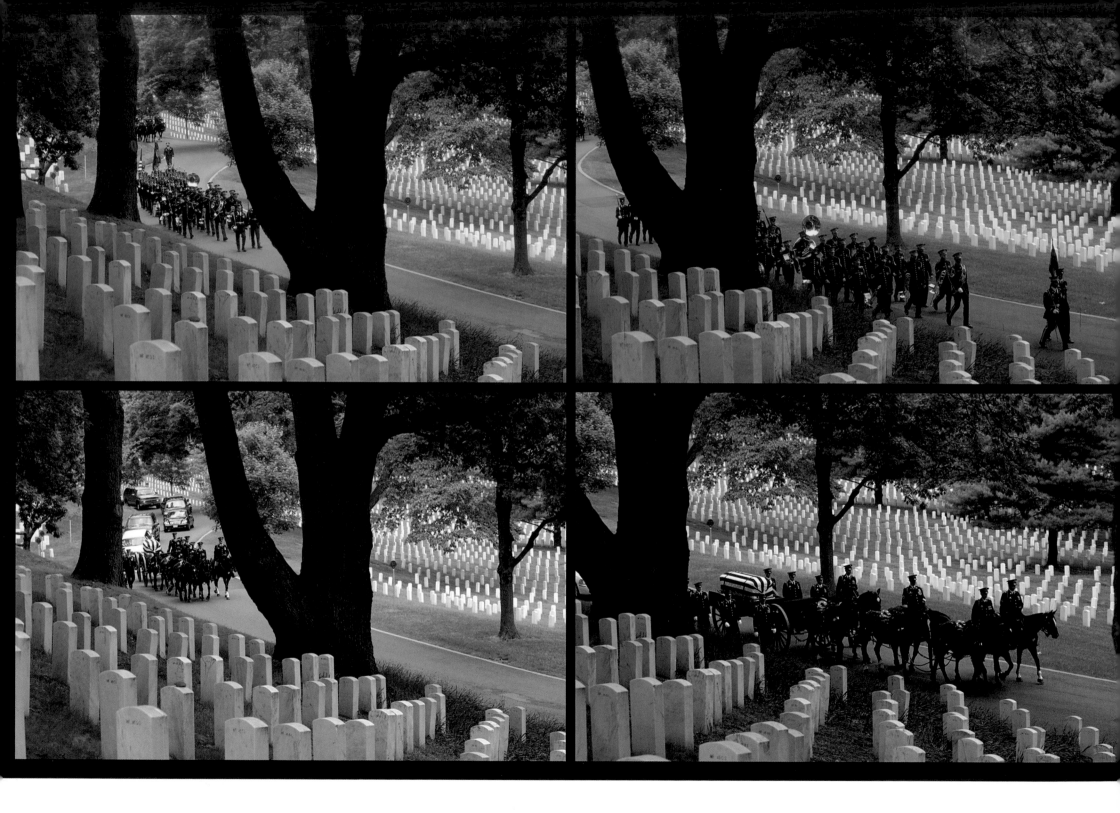

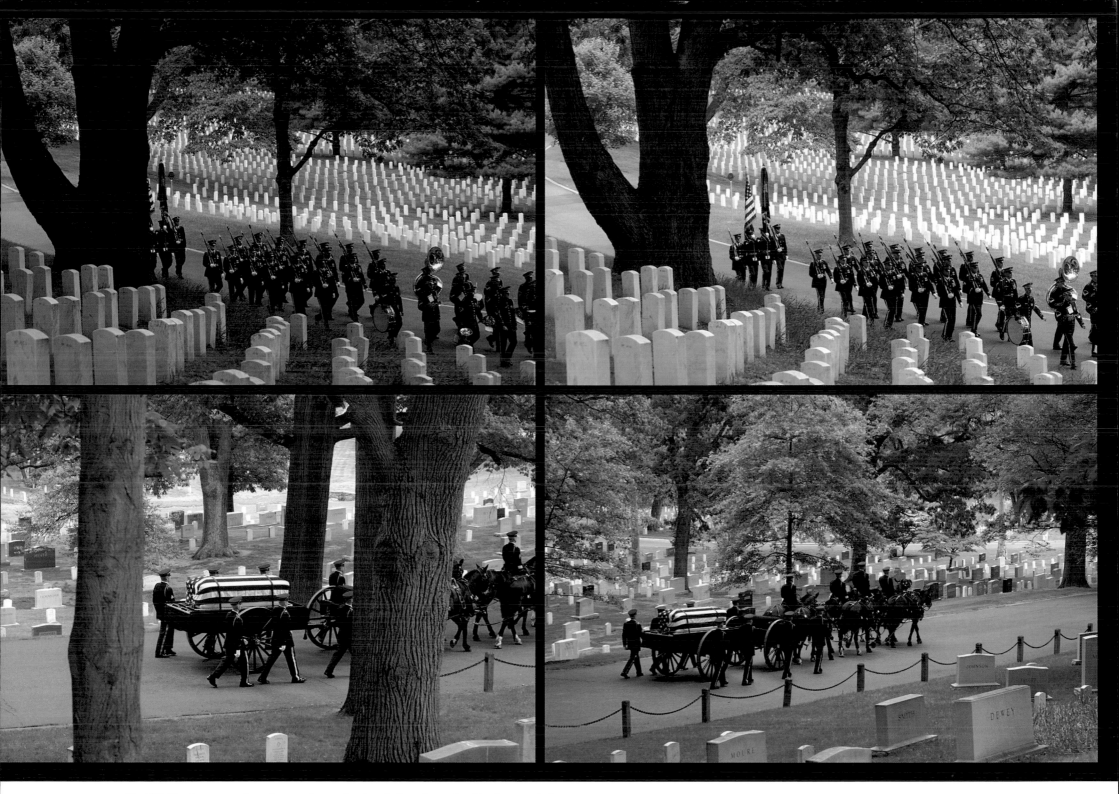

The Old Guard escorts one funeral cortege after another through the endless ranks of headstones each day.
The sounds of another soldier going to his grave provide a rhythm that dignifies death and consoles the living.

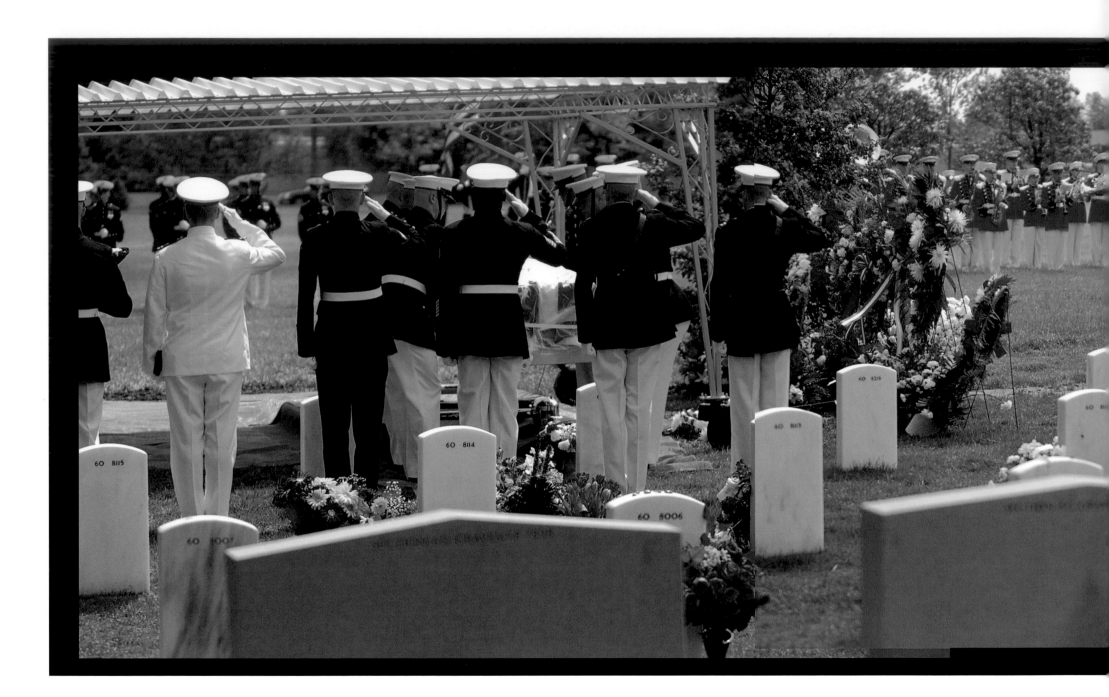

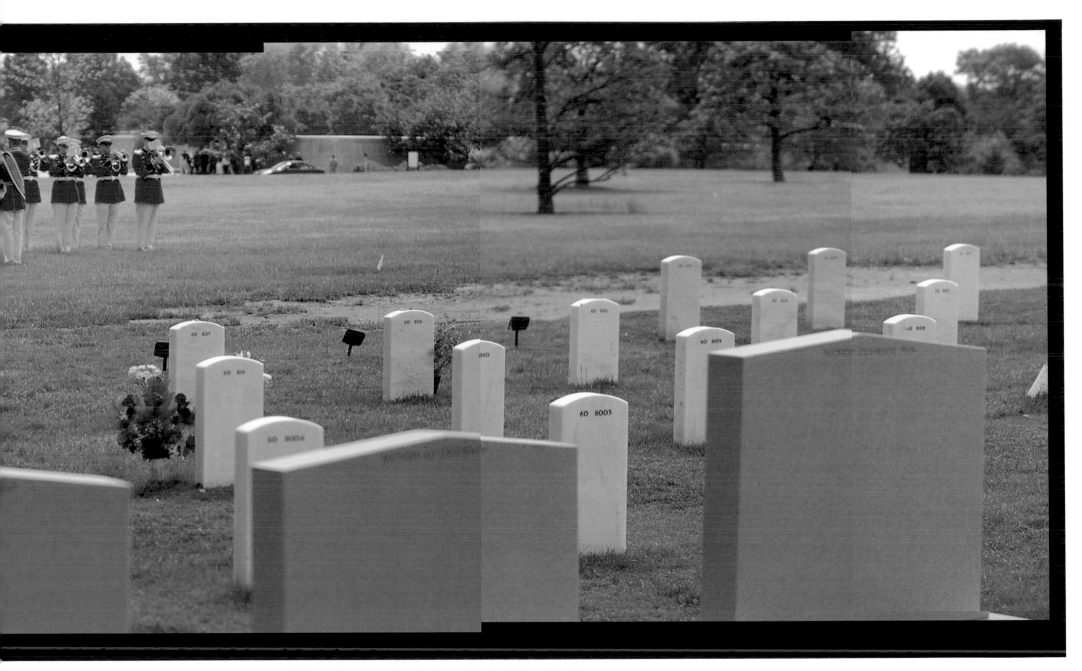

All soldiers killed in active duty receive full honors funeral, regardless of rank. On May 15, 2006, U.S. Marine Corps Capt. Brian S. Letendre, a 27-year-old killed in Iraq, was buried in Section 60 at Arlington. As the body bearers perform the final transfer of the casket to the resting site, the Marine Band plays the "Marines' Hymn."

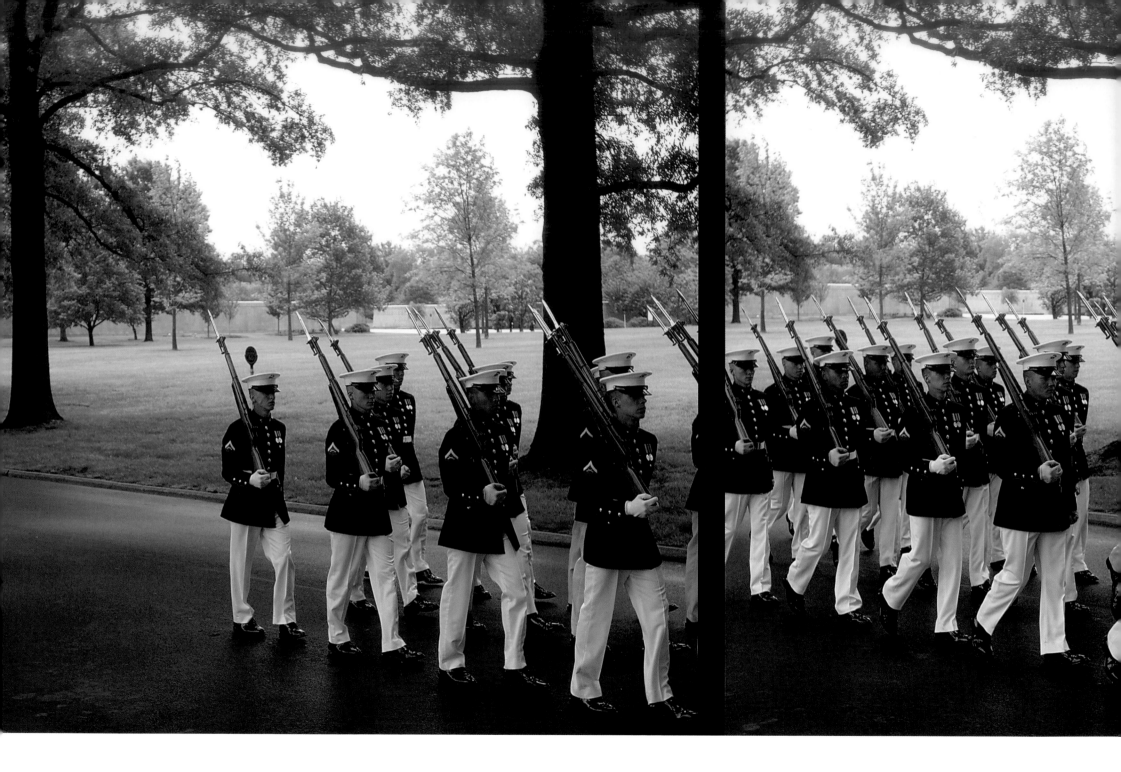

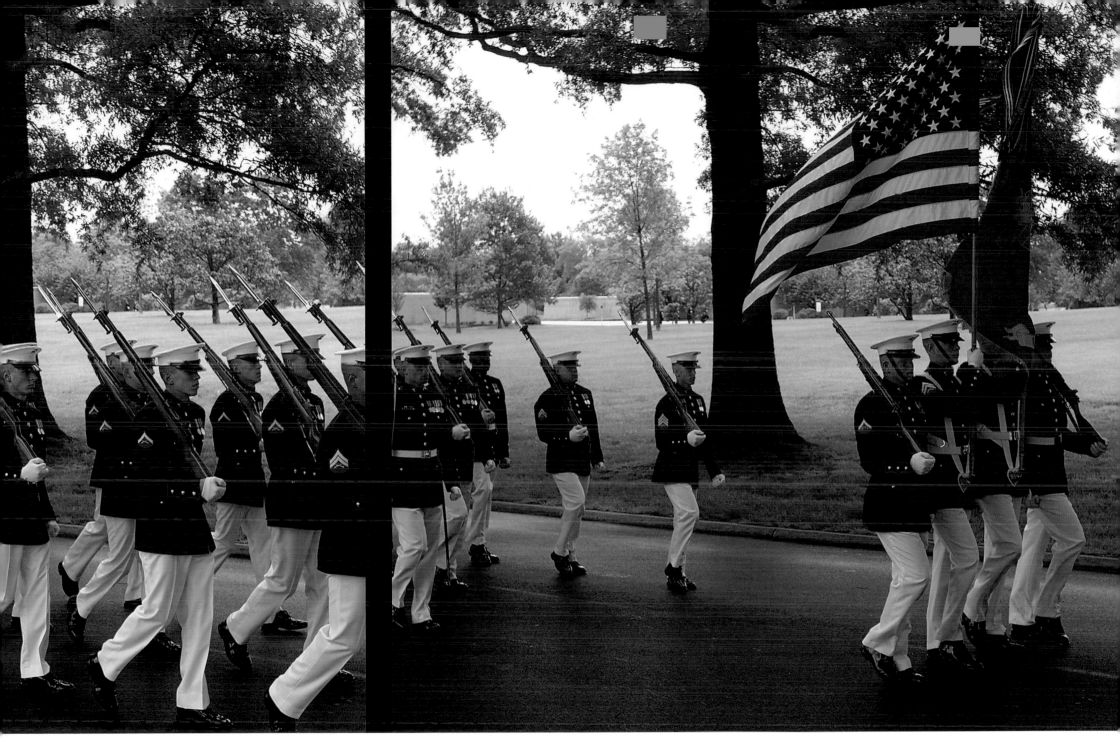

From the angle of their bayonets to the shine on their boots, members of the U.S. Marine Corps Honor Guard mirror each other with clonelike precision as they march from the grave site of fellow corps member Capt. Brian S. Letendre.

If fall is, as Albert Camus wrote, "a second spring, when every leaf is a flower," then it is also the season when Arlington National Cemetery blossoms, proudly displaying its colors in an annual celebration of AUTUMN

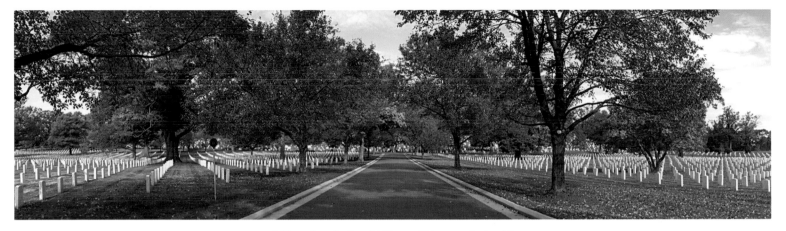

A blaze of maples lines McPherson Drive, near Section 18.

ARLINGTON CARRIES THE season in vibrant bouquets. Maples, birches, oaks, and other tree species from around the world take root in this fertile earth, their flourishes of red, gold, purple, and orange foliage soughing and waving, like so many flags, above the serried rows of still, white stones. As the days grow shorter, the air crisper and more invigorating, the land aches with the expectation of erewhile harvests. All the world seems alive with color, a spinning, kaleidoscopic canvas of life. Yet the leaves are brightly dying. They will drop to the ground, as many a soldier did, in blazing glory. Some will be raked, some will rot, and some will become almost ethereal as their pigment drains. They will then drift, featherlike, among the headstones, dancing and mingling with the spirits that inhabit these hallowed grounds. Their communion is organic, an inexorable, natural element of the season's spectral cycle. Its dramatic arc, is recorded on the following pages with traditional and infrared photography techniques, celebrates both the fiery beauty of autumn and the pallor of its inherent melancholy, the splendor of fall amid the splendid ranks of the fallen. To every thing, Ecclesiastes instructs us, there is a season—and autumn irrefutably and beautifully belongs to Arlington National Cemetery.

Photographic Essay by BRUCE DALE

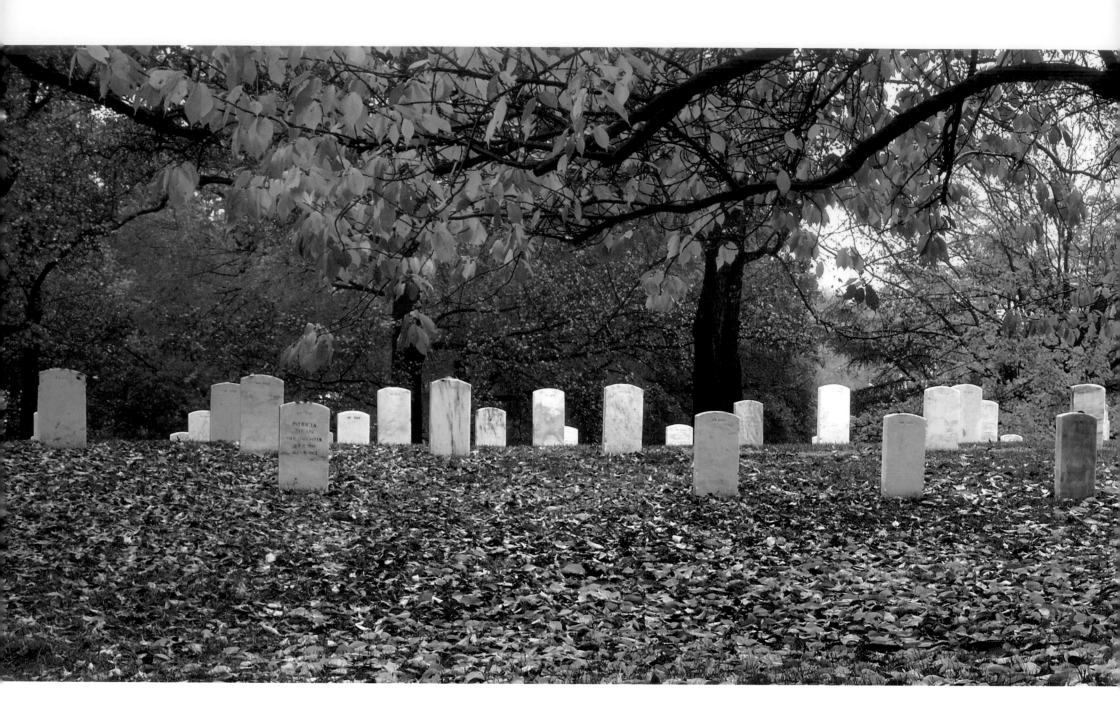

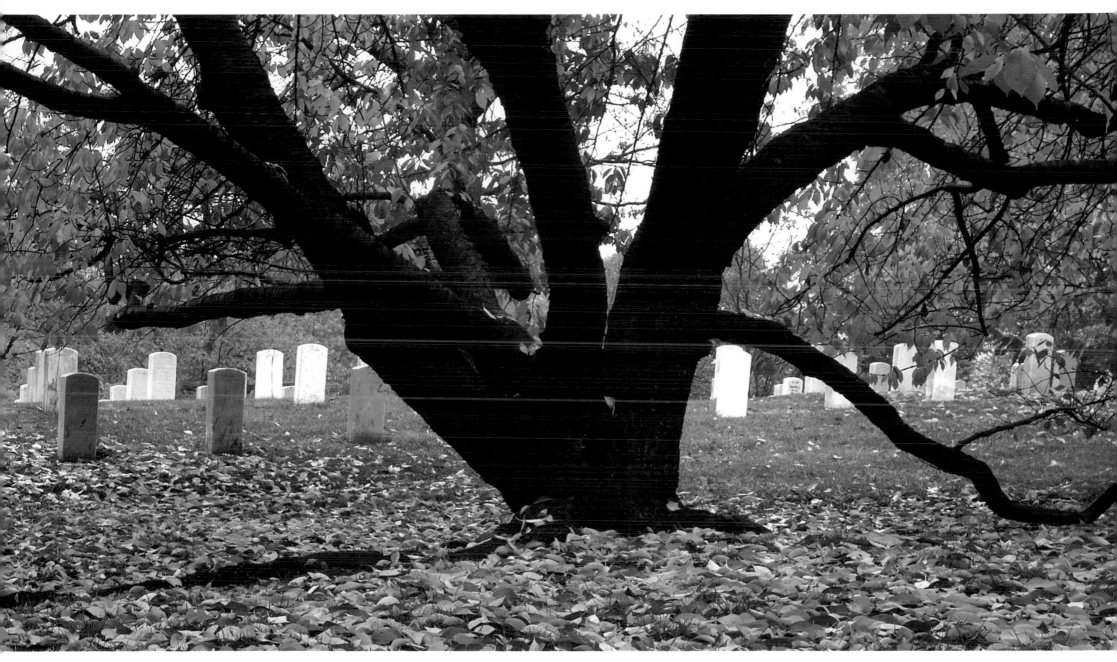

Autumn leaves blanket the ground under a Japanese cherry tree.

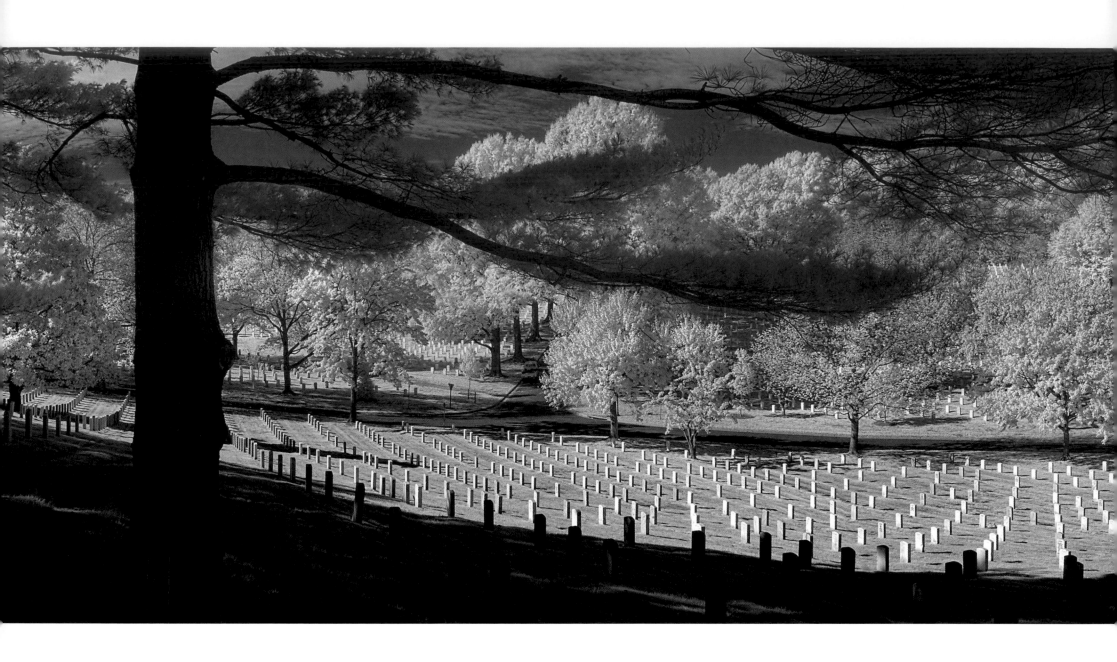

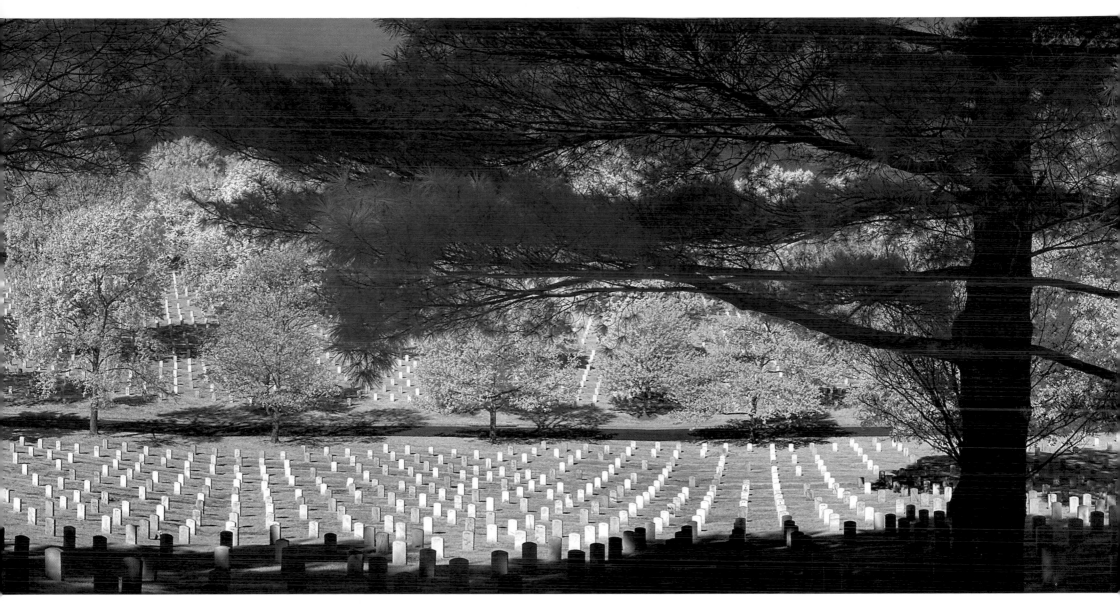

Although autumn leaves fill the cemetery with color, their lack of life-sustaining chlorophyll casts them in a ghostly light through the use of an infrared camera.

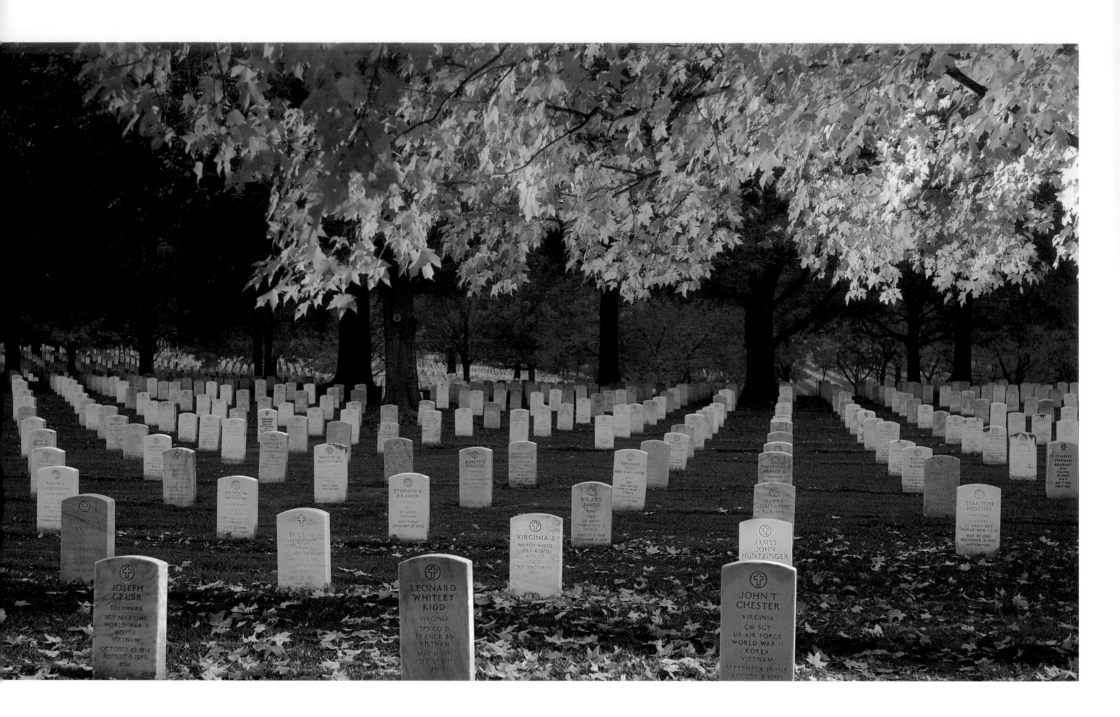

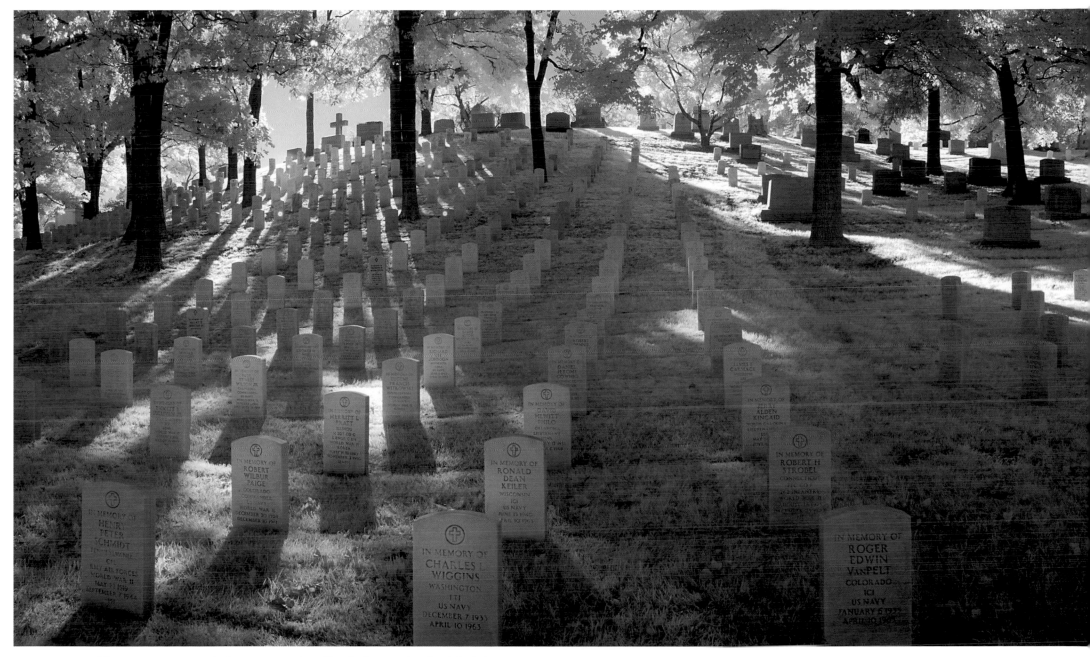

The same autumn sun can bathe a cemetery section with a glowing warmth or frost it in shadows.

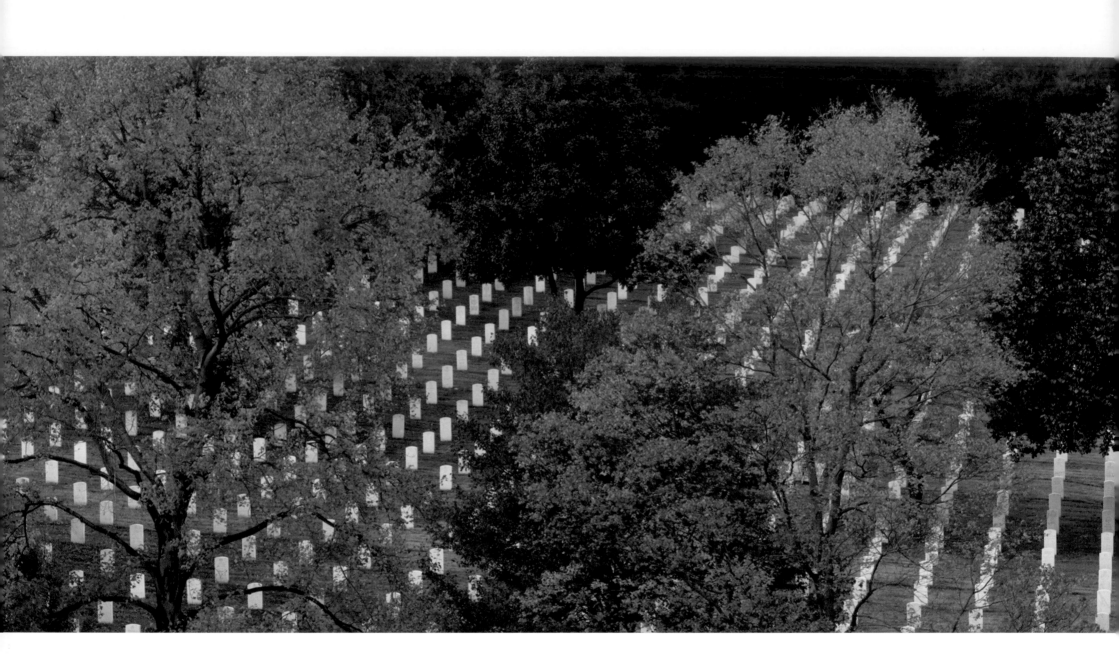

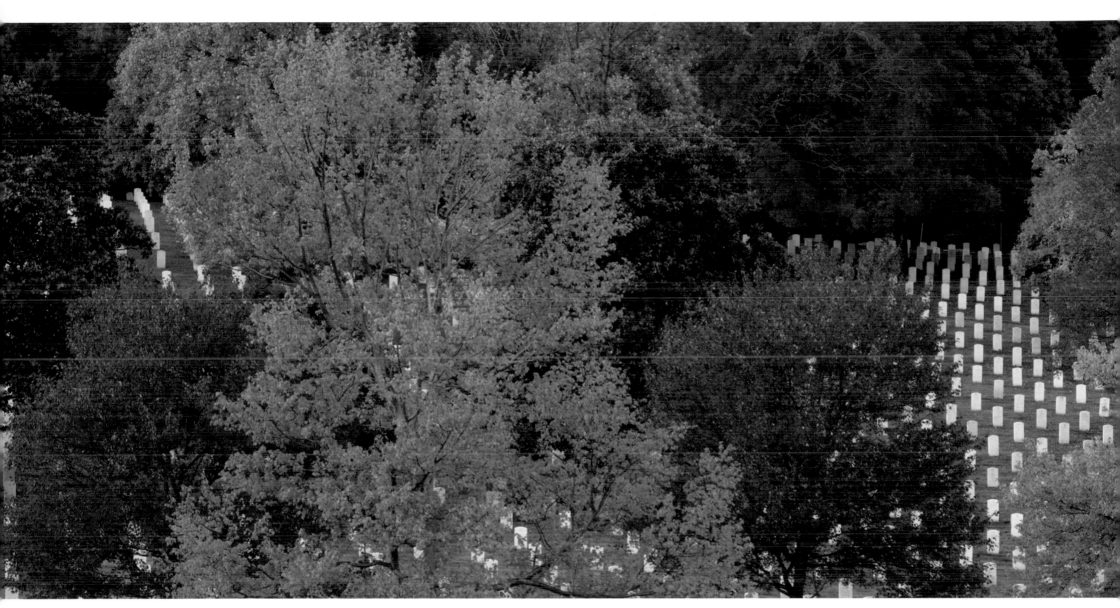

Seen from above, the grid of marble headstones provides a clean canvas for the annual splatter of colors.

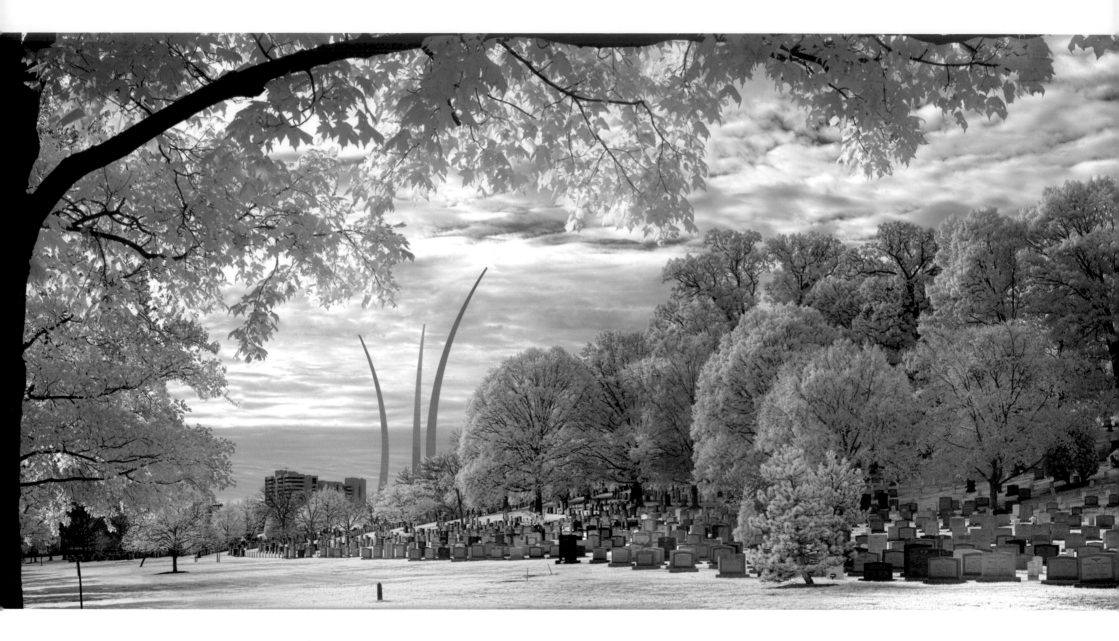

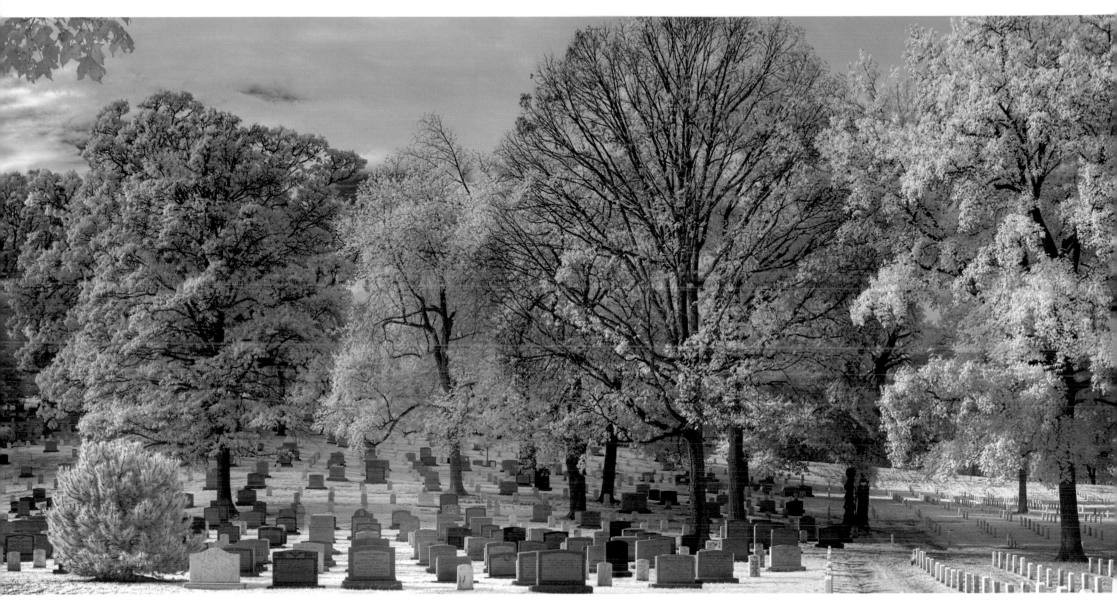

The Air Force Memorial looms as one of the many architectural forms of our nation's capital that echo the natural shapes of Arlington's wooded necropolis.

Like the valiant men and women laid to rest at Arlington National Cemetery, the individuals whose paths cross on these hallowed grounds represent the diversity from which our nation springs and draws its strength. These are the PEOPLE

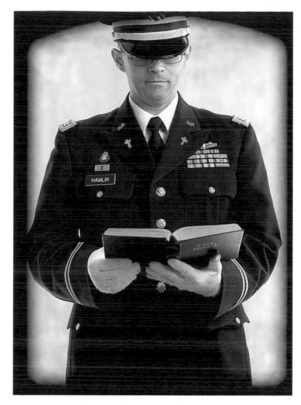

CAPT. CHARLES HAMLIN
Army Chaplain

THEY ARE THE visitors, soldiers, workers, and volunteers from all walks of life who make Arlington National Cemetery the sacred place it has become. They respect and appreciate the beauty of the flowing land and the sacrifice of those who lie beneath it. They are the men and women in whom Arlington inspires a common reverence for our nation, its history, and its ideals. They represent a cross section of America, a people whose very presence amid the tombstones and memorials bears out Lincoln's resolution that the dead shall not have died in vain, that those who served—and died—did so for a purpose greater than themselves. For Arlington is more than a military burial ground; it is an organic chronicle of the nation, fertilized not only by the blood of the fallen and the tears of their loved ones, but also by the sweat of workers, the honor of soldiers, the commitment of volunteers and the heartfelt appreciation of the four million men, women, and children who make the pilgrimage every year. In their own words, the individuals pictured on the following pages express their communion with this living monument. Woven together, their impressions epitomize in very different, personal, and profound ways the necessary ingredients to forge a national identity and to ensure an enduring heritage.

Photographic Essay by BRIAN LANKER

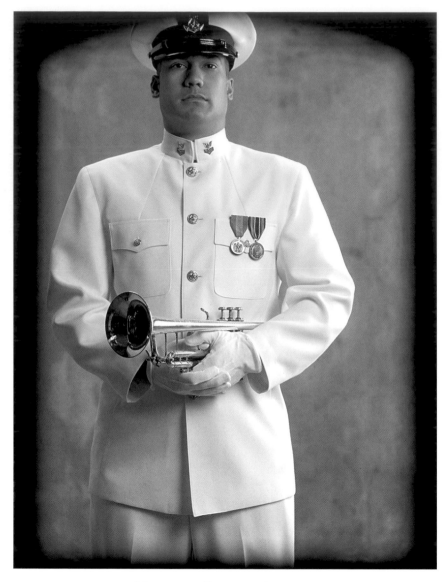

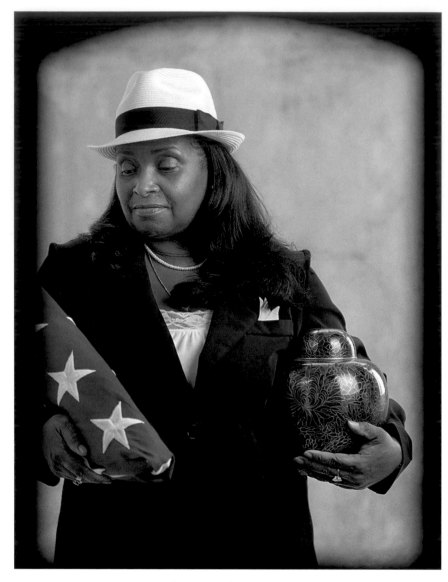

MUSICIAN 1 BRANDON ALMAGRO
Navy Trumpeter

"Whether it's a full honors service or standard honors service, it's always a very heavy feeling playing taps at Arlington, even when no family is present. All I can do is give my most heartfelt honors and respect to the particular person who is being buried, no matter what his or her rank. The only way I can describe it is that whole aura comes about you and you want to make it as perfect as you possibly can."

SHARRON CAMPBELL
Cemetery Representative

"When families come for the committal services or funerals, I meet with them and get them to the service. My mother, a funeral home manager, taught me to respect grieving people. So I treat them gentle, just let them talk. I explain exactly how the service will be. Surprisingly, they like the order of things. When they all leave smiling, I feel like 'mission accomplished.' It's like the final stage of grief."

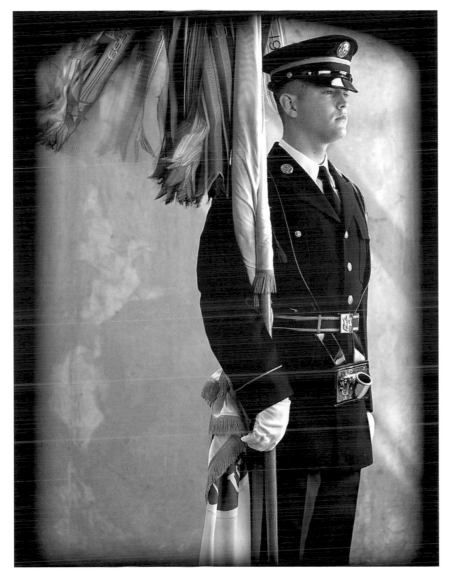

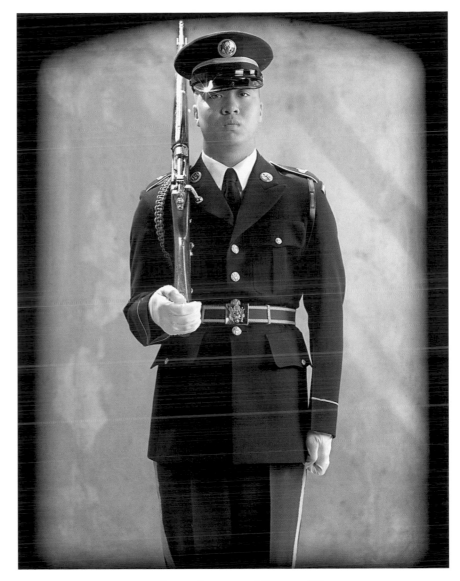

SPECIALIST BYRON SMITH
Army Color Guard, Third U.S. Infantry

"Even with all the training that goes into becoming a color guard, I did find my first full honors funeral pretty depressing. I suppose that's normal, but I always remember it's my duty to be there for the family and the other soldiers. I perform as many as four funerals a day, and I usually prefer the flag-bearer positions. Family members and visitors are in awe of what we do. It's a good feeling."

PVT. 1ST CLASS ANTHONY MONROE-WARREN
Army Color Guard, Third U.S. Infantry

"Our batallion performs colors at services for officers and active-duty personnel. We try to be as precise as possible, giving the best honors we can give. Seeing so many people crying every week can be extremely emotional, but the role we perform is not about us or for us. It's about our fallen brothers and sisters and for their families. Our job is to put service above self."

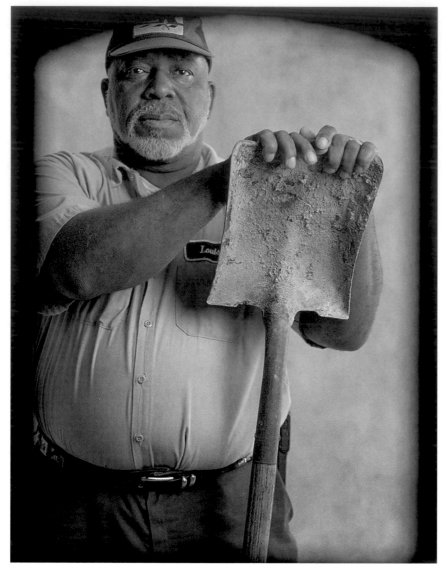

LOUIS D. PACK

Gravedigger / Backhoe Operator

"I never knew a cemetery could be so beautiful and be so sad. When you work here, you take such pride in what you do. We straighten headstones, replace headstones, clean them, and keep the place looking beautiful. I like to think that what I'm digging aren't just holes in the ground. They are the eternal resting places and the final honors for those who honored our country."

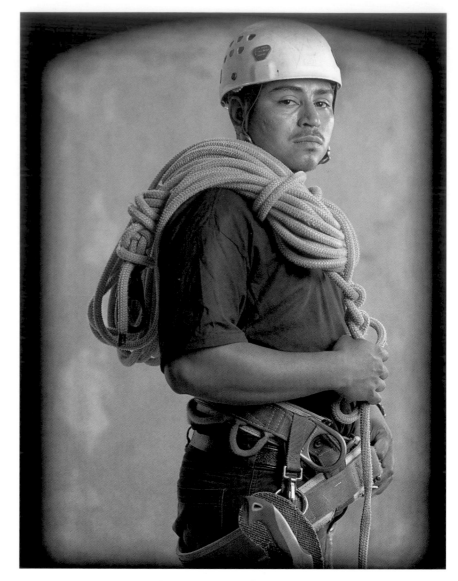

JESUS VASQUEZ GONZALEZ

Arborist

"This was my first job after coming from Mexico, and everything I've learned about this country comes from Arlington National Cemetery. It gives me pleasure to help make things so beautiful. The trick is to be as unobtrusive as possible when trimming the hedges and trees because there are funerals and ceremonies happening all the time. We have to cut, clean, and clear out quickly and quietly."

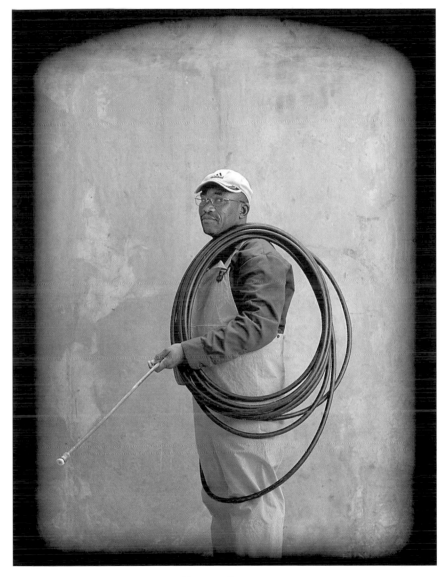

FIRMIN BENOIT
Pressure Washer

"I personally clean about 700 to 800 headstones a day, plus monuments, and every Thursday I wash John F. Kennedy's grave. When I first read his quote, 'Ask not what your country can do for you; ask what you can do for your country,' I swore I would wash this place special. I also make sure to help visitors when they ask for directions. I help so many people. I never take their money, only their gratitude."

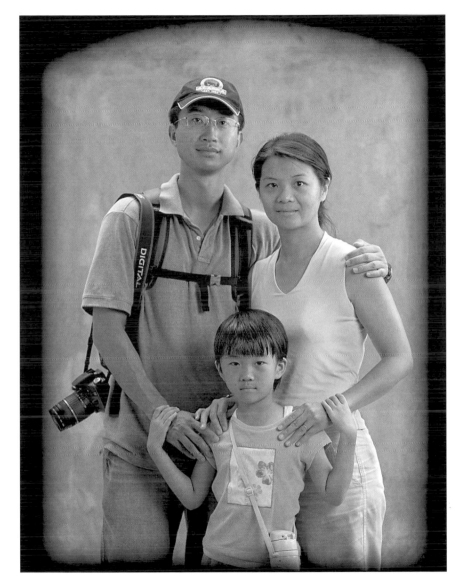

PEIYONG ZHOU, LILY QIN, AND REBECCA ZHOU
Chinese Tourists

"We lived in Chicago briefly, and before we returned to Beijing we visited Washington to see the famous monuments and buildings. But a cemetery? We had heard a great deal about Arlington National Cemetery, about how beautiful and moving it was, but nothing prepared us for the emotions we felt. You don't have to be an American to appreciate the strong sense of history and sacrifice."

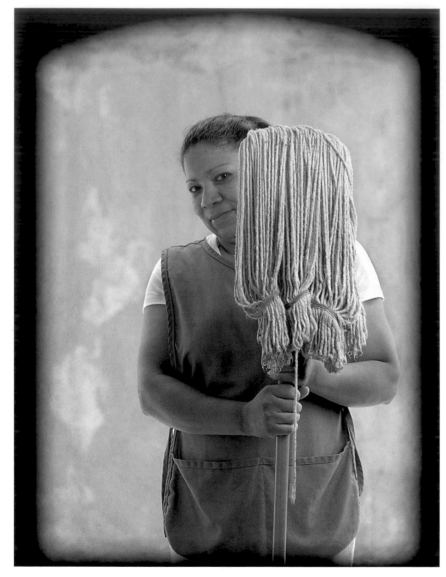

MIRIAN VENTURA
Janitor

"Coming from El Salvador, I do not know that much about the history of this country. But in the two years I've worked in the Visitor Center at Arlington, I've looked at the displays while I clean and I get a sense of how important this place is to so many people. I can see the emotion and I can sense their interest. Seeing how much this place means to them makes me work hard to keep it clean."

BERNICE DUNHAM
Navy Arlington Lady

"I feel truly honored to serve as a naval representative at Arlington. The thing that attracted me from the beginning was that I was giving of myself, with the purpose of comforting the family. We always have a military escort. They're fine young men, but sometimes they have problems, too, and just need a person to talk to. It means a lot in life to have compassion; and not everyone is able to give in this way."

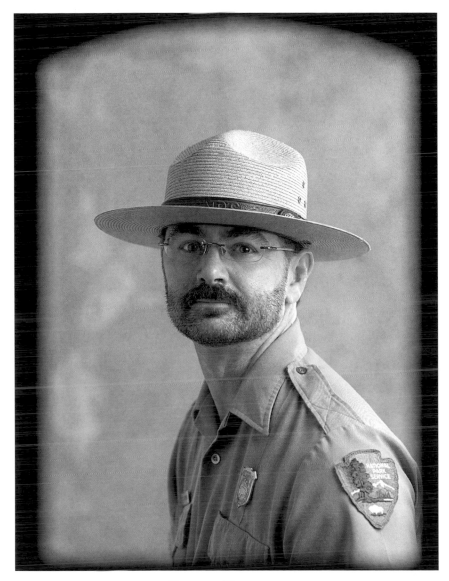

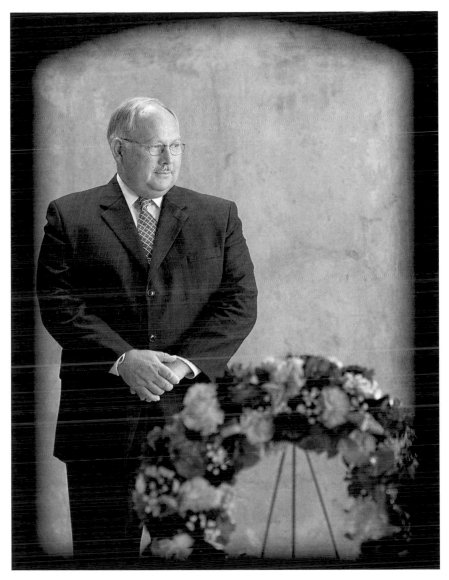

KENDELL THOMPSON
Arlington House Site Manager

JOHN C. METZLER, JR.
Superintendent

"What amazes me about Arlington House is the human element, that one moment in Robert E. Lee's bedroom when he decided to resign from the Union. It's a pivotal point in U.S. history and a visceral human moment. You put yourself in his position and you just squirm. That decision, in effect, created the cemetery—a place that reminds us every day about decisions, such as Lee's, regarding war."

"I literally grew up here. My father was superintendent for 21 years, and in 1991, 18 years after he retired, I got the job. My mission is to preserve and protect this hallowed ground of our nation, to keep it in optimal condition at all times, and to expand it to keep the legacy alive. We bury 25 to 30 a day, and have the land to take us to 2060, with plans to acquire enough property for the next 100 years."

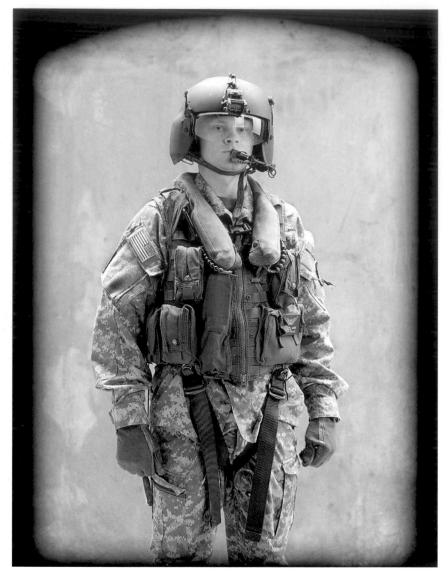

CHIEF WARRANT OFFICER 2 DANIEL HANSEN
Army Helicopter Pilot

"Any time you're part of a flyover at Arlington it chokes you up, knowing what these people gave and actually looking down on the cemetery and the families. It's one of the proudest missions we do. It takes timing and coordination, so we'll practice days in advance. Creating one of the last memories in honor of someone who gave everything for their country is about as far from routine as it gets."

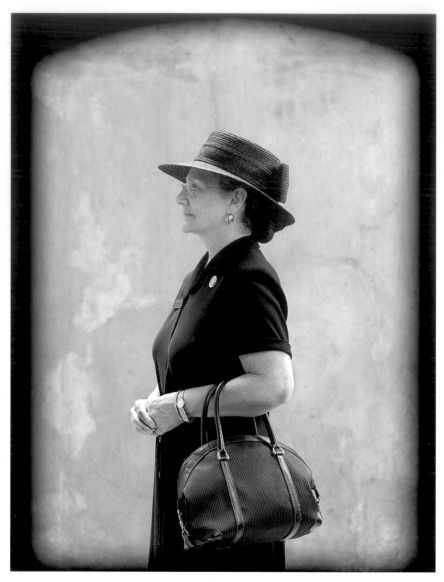

ALBA THOMPSON
Army Arlington Lady

"As one of the representatives of the Chiefs of Staff, I bring condolences to the next of kin, present them with a handwritten note, and console them. It's a great honor. I tell them to remember that long after we're gone, thousands will know their loved one was an honorable man. And I always tell families they can contact me or ask me to visit, which they've done. I do this one day a month, at five funerals."

JUDITH AND PAUL W. SCOWDEN
Ohio Tourists

"We've been to Washington, D.C., eight times since 1958, and every time we visit Arlington. It's just a beautiful experience to see all those tombstones and the names of those who gave their lives for our country's freedom. It's a patriotic thing, but it's also living history, something that, if it weren't around, our kids wouldn't know about it. History is disappearing from our textbooks; this provides a lesson in itself."

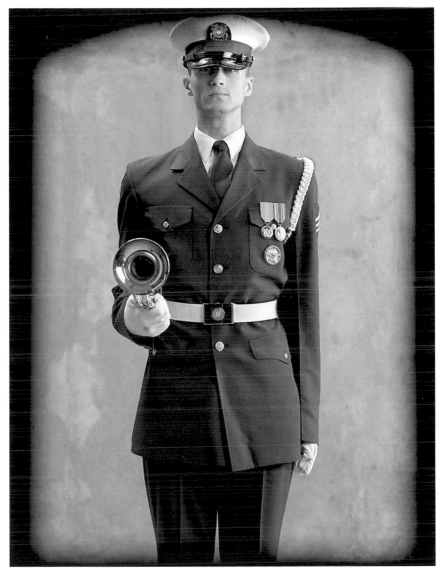

SEAMAN KENNETH MCABEE
U.S. Coast Guard Bugler

"We're a small service, small honor guard. But when it comes to the passing of our fellow soldiers, it's important to have someone play the bugle instead of turning on some electronic device. I always play 'Taps' no matter the rank of the soldier. I'll also play 'America the Beautiful' during the flag folding. One time a family asked me to play 'Amazing Grace' and I naturally honored the request."

MASTER SGT. JOHN L. ABBRACCIAMENTO
Marine Trumpeter

"I've played for the President at the Kennedy Center, but I can't think of anything more significant than anonymously playing 'Taps' at Arlington. I've done it for 14 years and it never gets old. You don't want to say a funeral is beautiful, but that's what a military funeral is. When people hear the haunting notes of 'Taps,' they *know*. They cry. And I feel their grief. It's not about me; it's about the families."

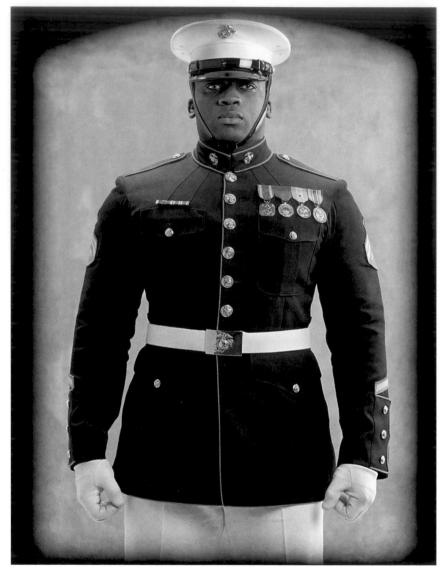

CORPORAL THOMAS SCATES
Marine Body Bearer

"It takes seven months to complete Body Bearer Ceremonial Drill School. The whole time you're lifting weights and learning drills. Six of us carry the casket, which can weigh 700 pounds. I'm a 'tugger,' one of the two gentlemen in the middle who are the weight carriers. There are 16 body bearers, and we take great pride in seeing our fellow Marines to their final resting place. There are no do-overs."

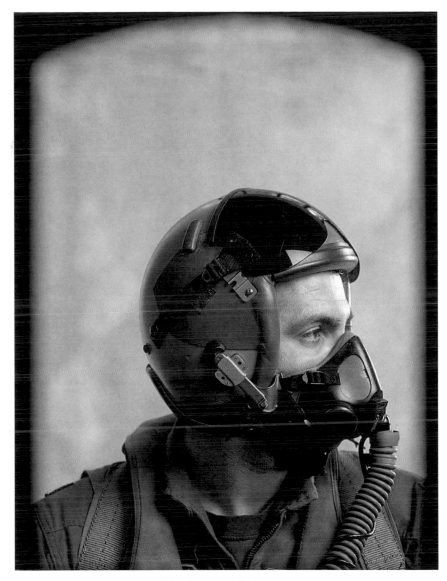

MAJ. ROBERT BALZANO
Pilot, D.C. National Guard

"My squadron, the Capital Guardians, defends the National Capital Region and supports memorial services at Arlington. When we fly over in the missing man formation—wherein the number three plane abruptly pulls straight up—we do so not for ourselves, but for our fallen comrades. It is one of the greatest honors for a fighter pilot to be part of such an event. It brings everything into perspective."

MASTER SGT. ALLYN VAN PATTEN
Army Bugler

"I figure I've played 'Taps' about 10,000 times during the two dozen years I've been a bugler. The workload at Arlington has certainly increased with the passing of many World War II veterans. I've had people ask how I can isolate myself from all the sorrow, and I tell them I can't do that. I wouldn't want to do that. I appreciate the role I play in the grieving process and hope that it's the beginning of some closure."

WYONNA, TONY, ALEX, AND CORAL JEANE
Louisiana Tourists

"We had come to D.C. for our son's leadership conference and wanted to experience Arlington. It's so beautiful, so solemn. Those rows and rows of headstones, each one a fallen soldier, are just incomprehensible in number. We saw the changing of the guard and a horse-drawn funeral procession that stopped not far from us. We did not intrude, but felt, as Americans, extremely connected to it."

SEAMAN CARA WARNER
U.S. Coast Guard Firing Party

"Every funeral at Arlington gets a firing party. We're well prepared, although I'm always nervous something could go wrong with the weapon. We march a certain number of yards behind the casket and stand at a distance from the service before firing our salute. We're far enough away not to hear a lot of the service, but the body bearers have to look the widow in the eye. I don't think I could do that."

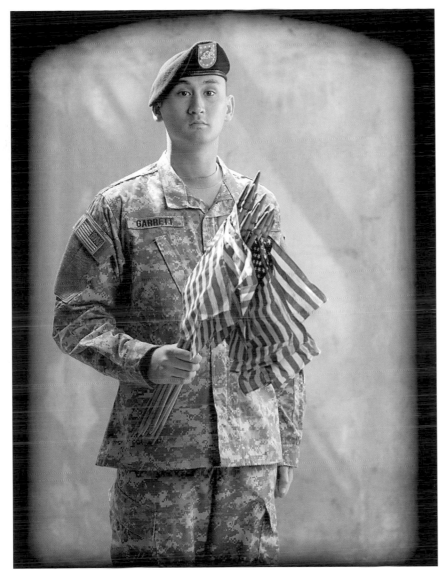

PVT. 1ST CLASS JUSTIN GARRETT
Soldier, 3rd U.S. Infantry

"My regiment, known as 'The Old Guard,' gets to perform the flags-in ceremony every Memorial Day. We center a flag exactly one foot in front of more than 250,000 gravestones. It takes about three hours; then we patrol the cemetery all weekend to ensure no grave loses its flag. Getting to sow the cemetery with symbols memorializing those who died for our country is an honor I can't describe."

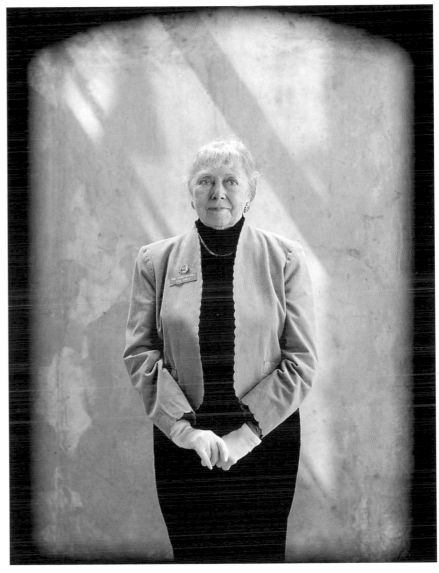

CISSIE CHRISCO
Army Arlington Lady

"I've served as an Arlington Lady for 30 years. I believe no soldier should go to his last retreat alone. The families feel as though they have a human connection. I've made many friends among them. Over the years, I've placed wreaths for them, or accompany them to the grave or columbarium when they visit. They thank us, but it's us who should thank them. Arlington's a place where everyone's a hero."

Every aspect of this sacred square mile reflects the standard of perfection to which platoons of workers and soldiers aspire on a daily basis. In the execution of their duties, they exhibit an extraordinary sense of CARING

Kelvin Dixon, one of seven cemetery representatives, counsels the next of kin.

THE SAME PRIDE, orderliness, and precision that defined the lives of the soldiers buried at Arlington also distinguish them in death. The cemetery's 500 servicemen and workers see to that. From the bugler blowing "Taps" to the groundskeeper blowing leaves, these ministrations ensure that every monument sparkles, every tree majestically branches, every section stays green and groomed, and every burial proceeds with reverence and dignity. For Arlington is a tableau that intrinsically commands the full respect not only of those who visit it, but also of those who nurture and maintain it, as well as of those who duly perform the ceremonies that take place throughout the day. Whether you consider the farrier who shoes the caisson horses or the leatherworker who fashions their reins, the quarrier who grinds the marble headstones or the pressure washer who blasts them clean, the members of the cemetery's supporting cast acquit themselves with profound pride. They never intrude, never waver in their commitment. They imbue the place with nobility, holding as their ideal the fallen men and women who so valorously executed their duties—and who were so regally marched to their graves. There, for eternity, they will rest in honored glory beneath an impeccably and lovingly maintained landscape.

Photographs by SELECT PHOTOGRAPHERS

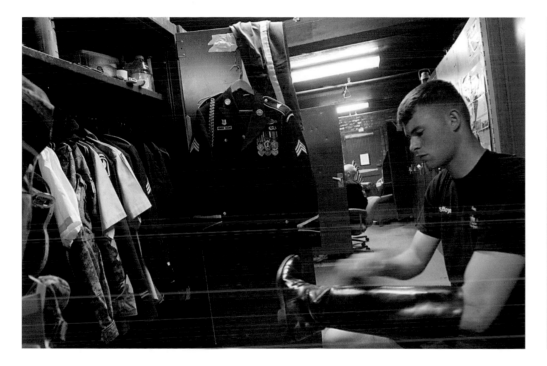

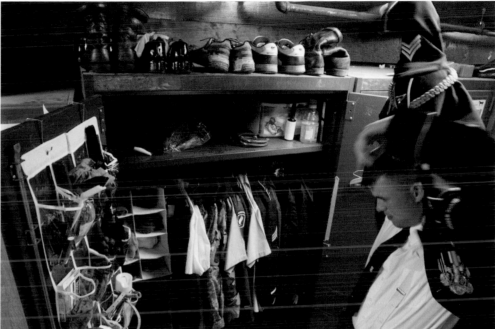

Responsible for all ceremonial displays in the cemetery, soldiers in the Old Guard maintain an impeccably perfect appearance. Brass gets polished, uniforms stay starched and pressed, and boots often take six hours to polish.

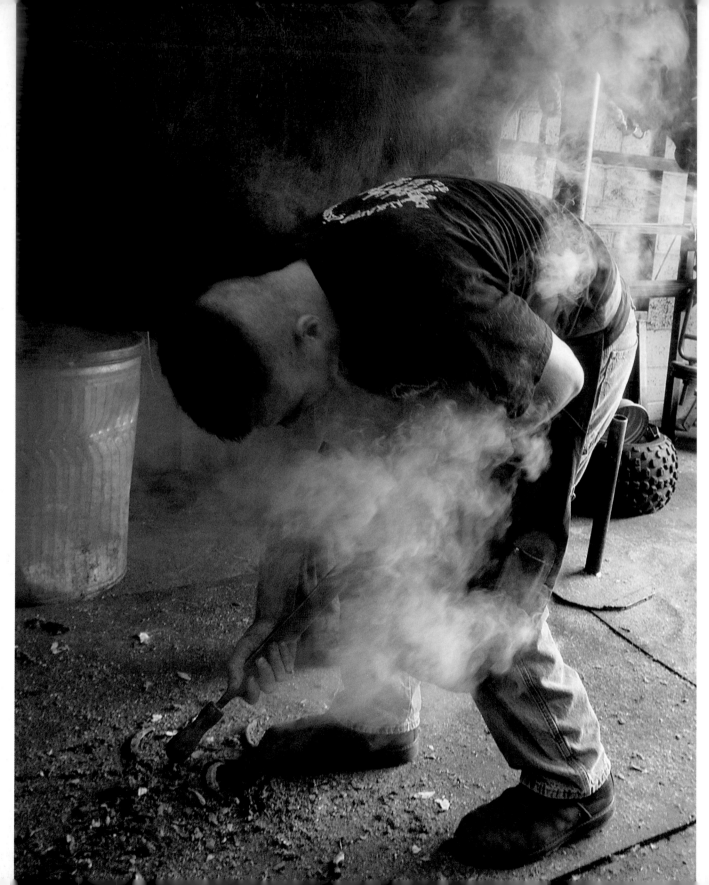

Every six weeks, the Third Infantry's master farrier (left) reshoes the caisson horses, often adding borium studs for traction. Always matching in color, the horses are led to the procession by a handler (opposite).

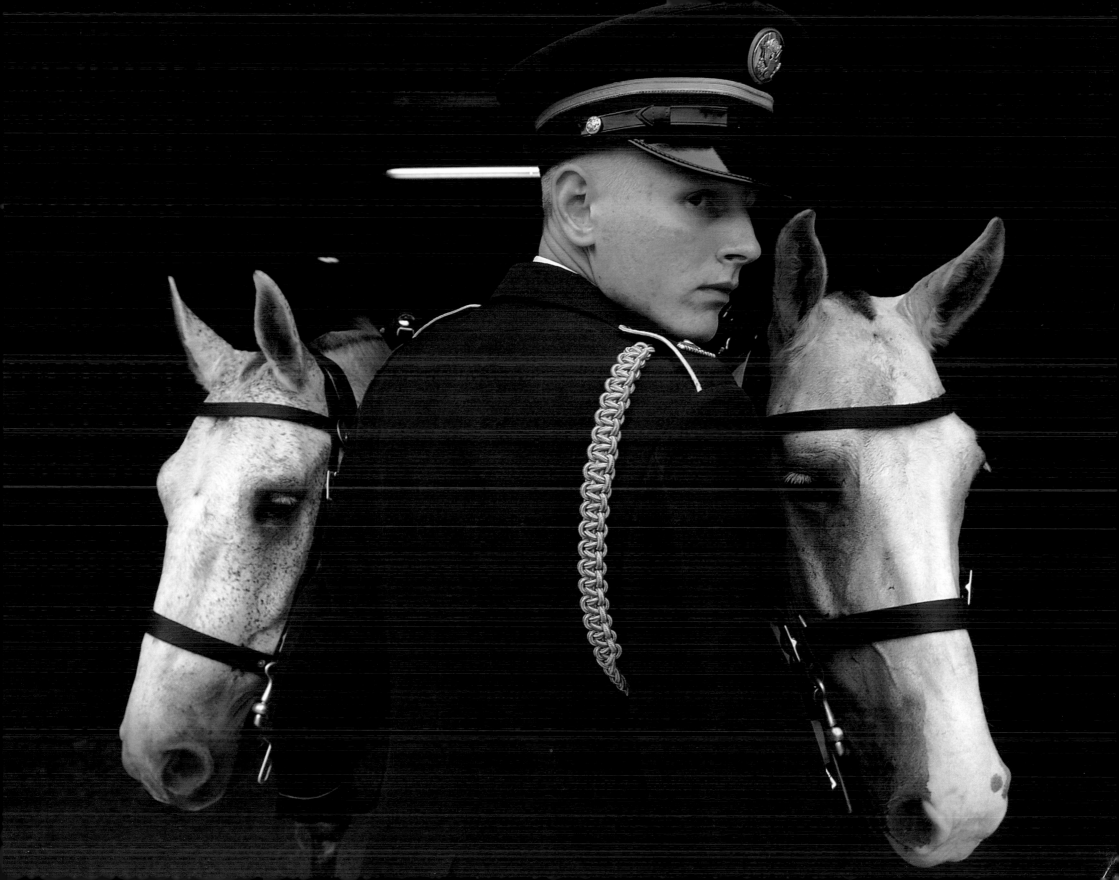

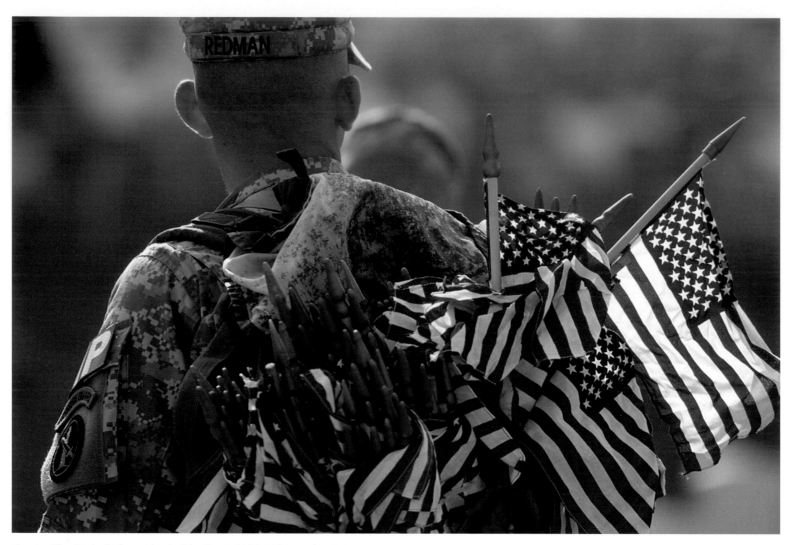

Pvt. 1st Class Kevin Redman (above) of the Army's 289th Military Police Company along with Marines from the Marine Barracks 8th and I (opposite) distribute miniature flags during the annual flags-in ceremony on the Thursday before Memorial Day.

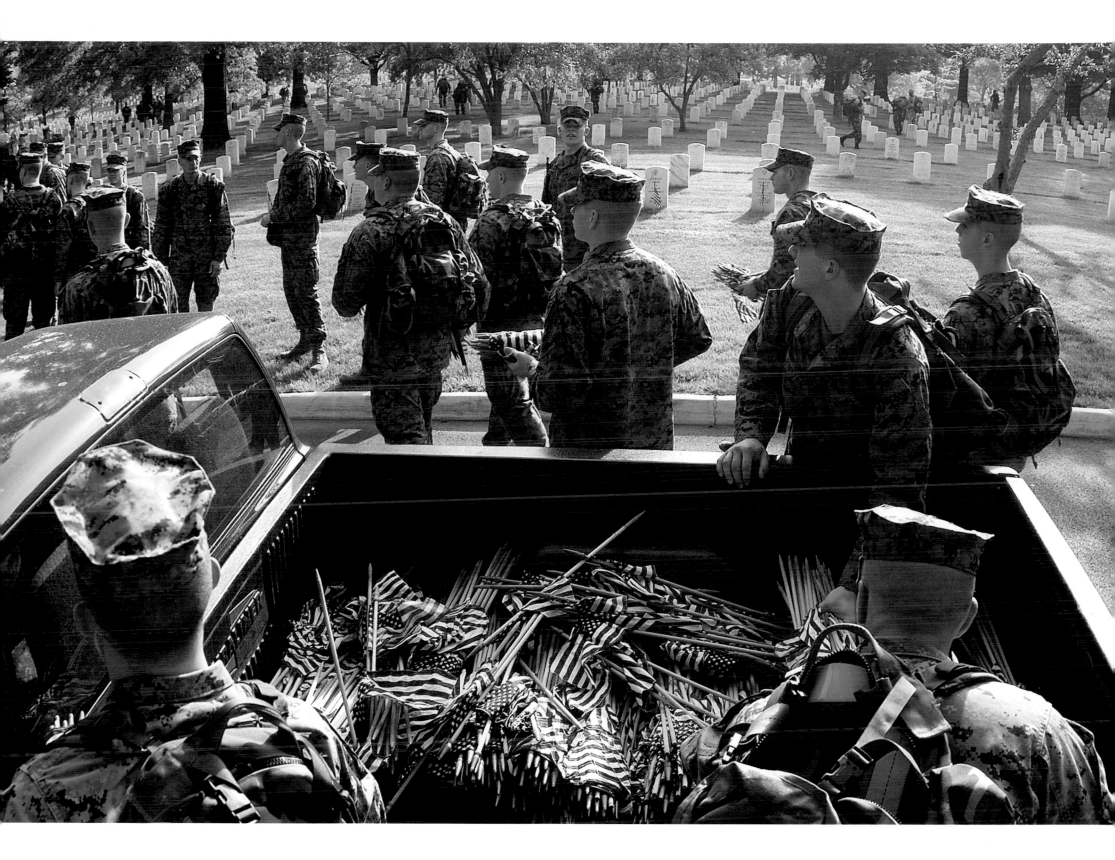

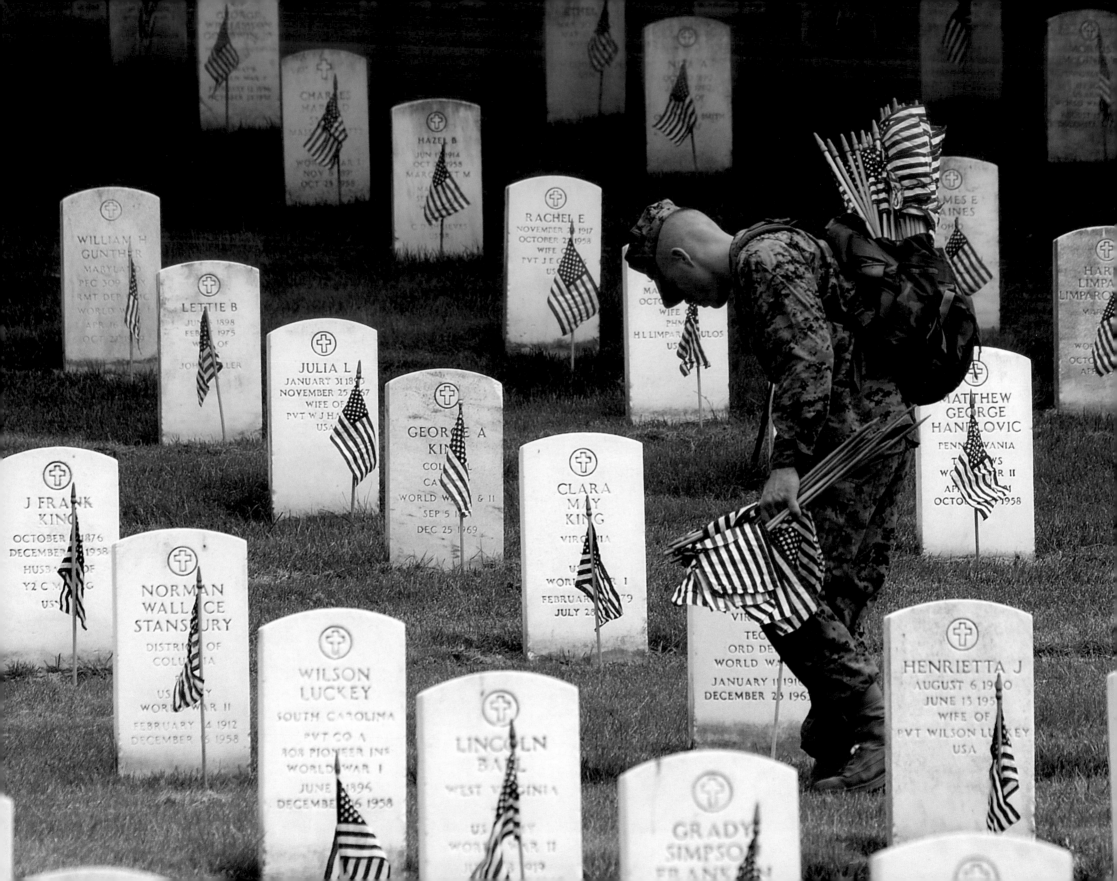

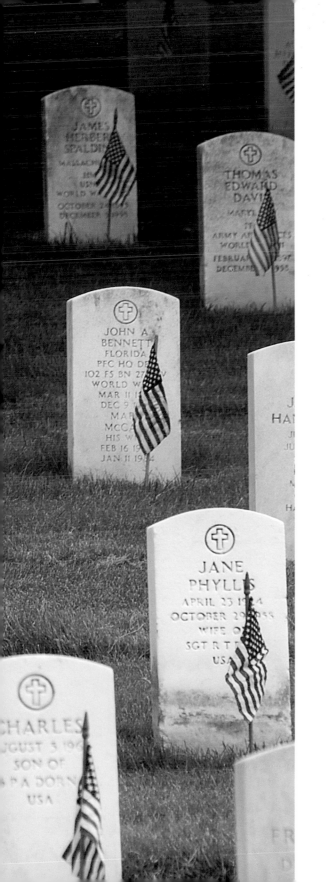

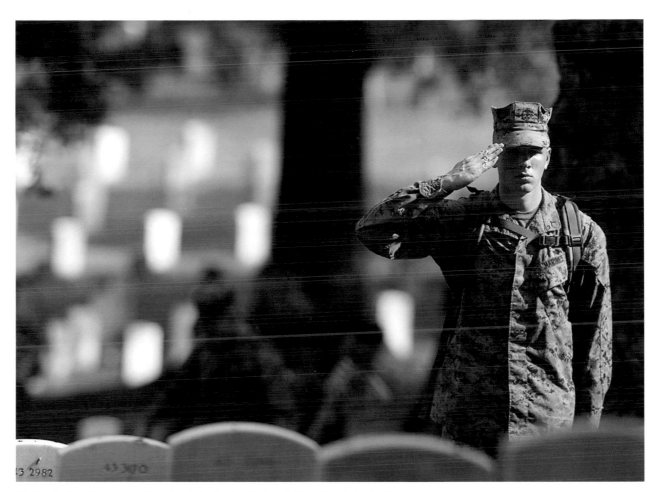

During the flags-in ceremony, all services, including the Marines (left), participate in planting flags exactly one foot from the center of each grave marker. Here a Marine (above) finishes the task with a salute.

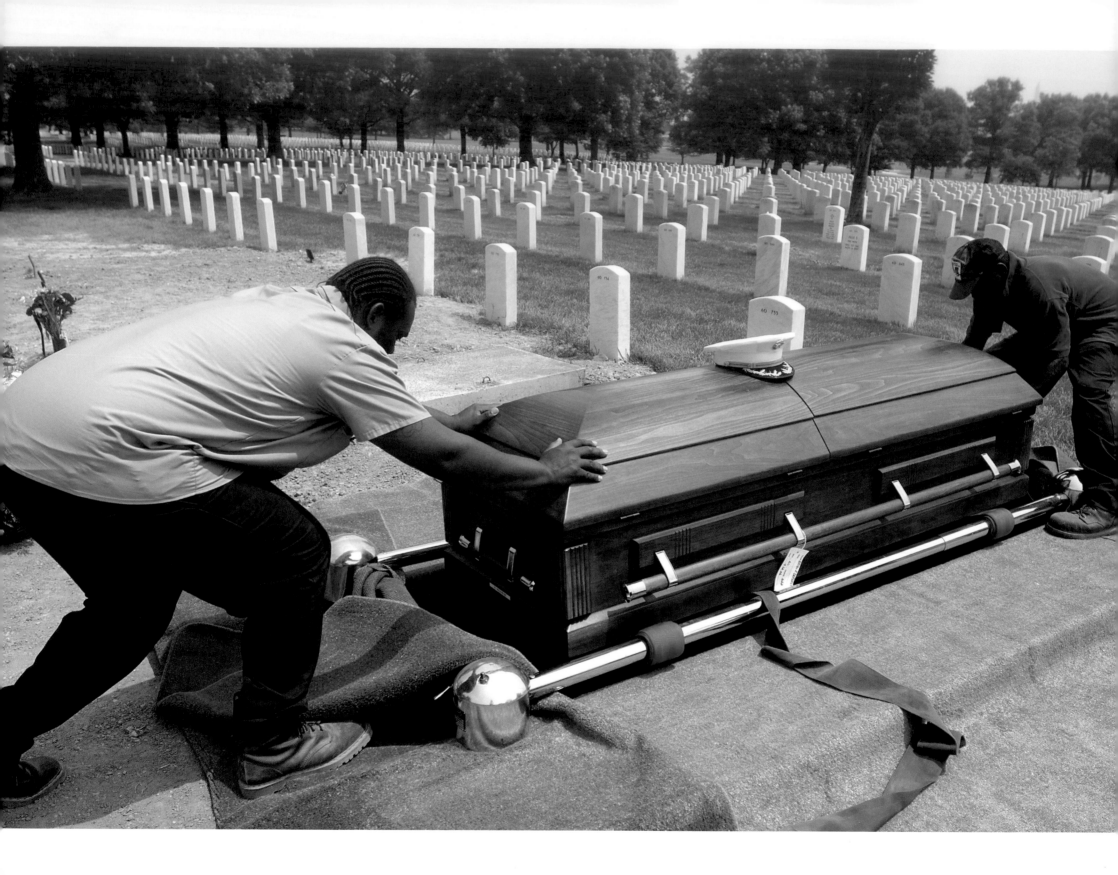

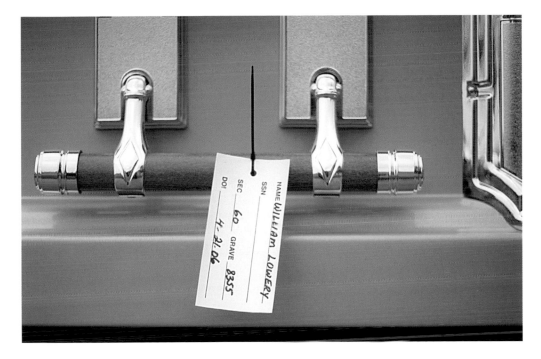

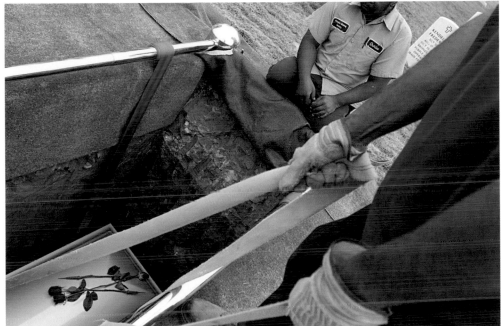

With precision and physical strength, workers position and lower caskets dozens of times every day. The remains of Staff Sgt. William Lowery, middle, identified after being missing in action for almost six decades, await interment.

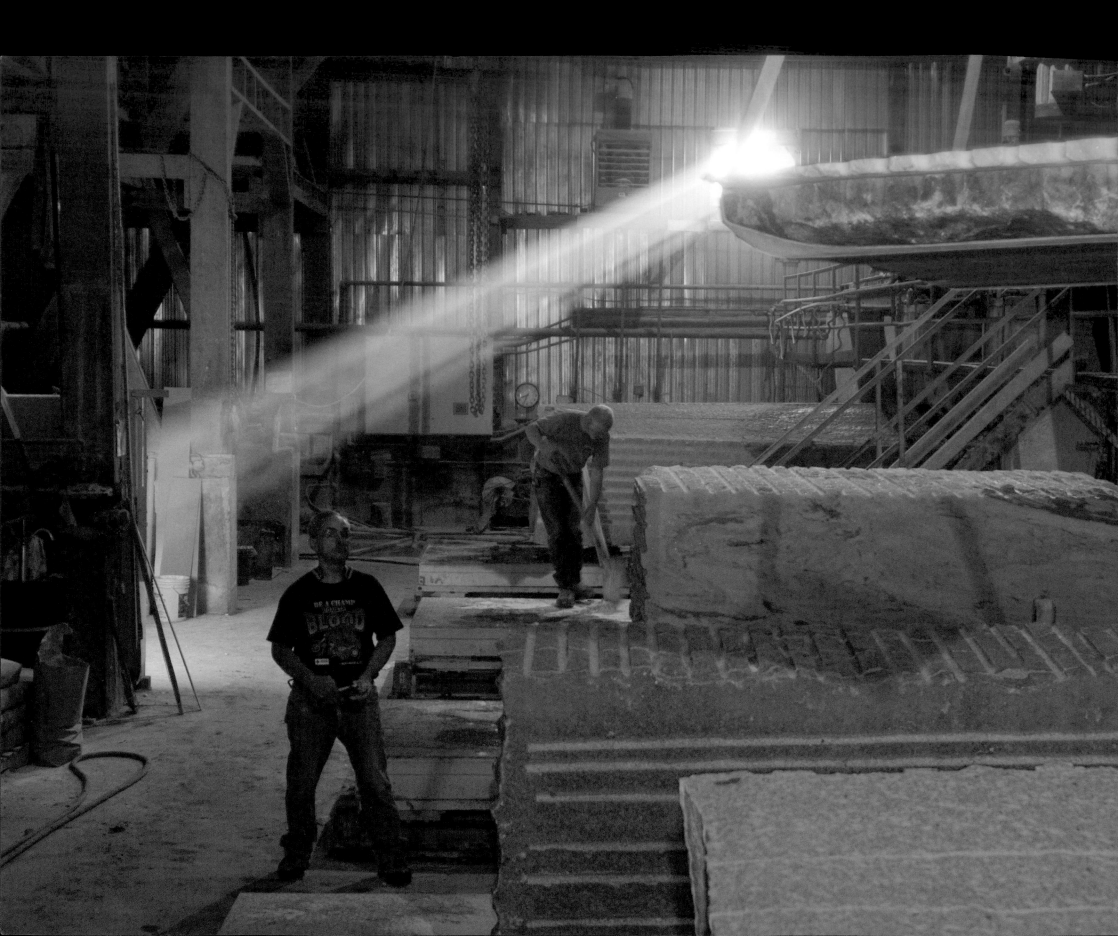

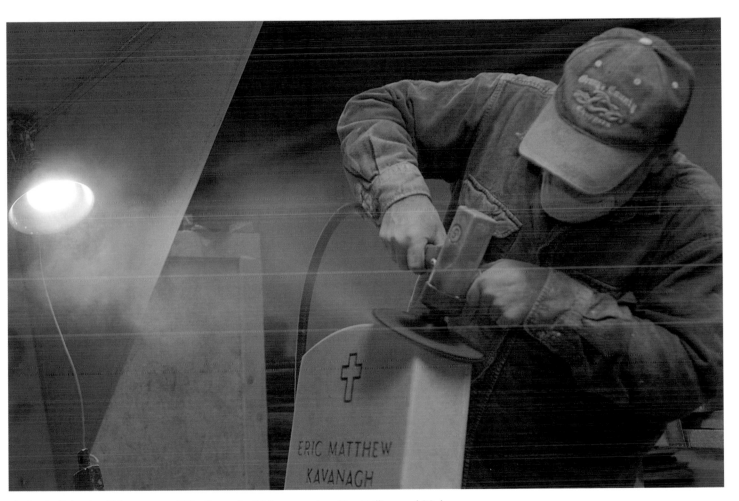

At Granite Industries of Vermont, some 550 miles north of Arlington, workers Gary Williams and Mark Beaudet (left) move a massive slab of Danby marble, from which grave markers will emerge. Robert McCallum, a combat engineer with the Vermont National Guard who just recently returned from a tour in Iraq, grinds down the grave marker of Pvt. 2 Eric Kavanagh, who was killed in action there September 20, 2006.

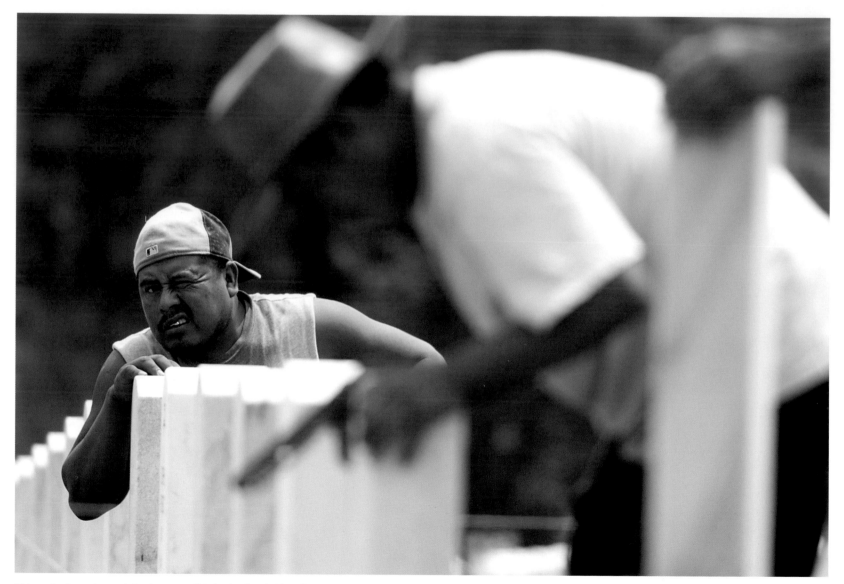

Using a level, a string, and the sharp eye of his brother Israel, Alejandro Simaj DeLaCruz repositions a tilting headstone.

JOSEPH L
KRIEGER
CAPT
US NAVY
WORLD WAR II
FEB 6 1916
SEP 10 1990

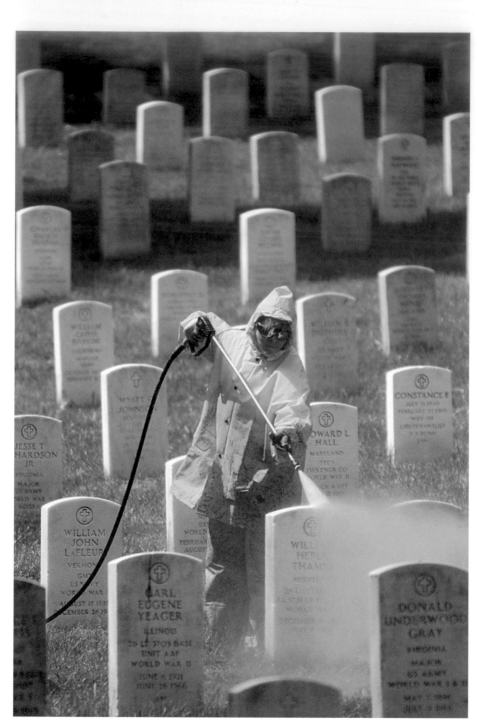

A worker carefully bathes every monument to the fallen. On dawn patrol,
Kevin Thomas (right) cleans the tops of headstones in preparation for a funeral.

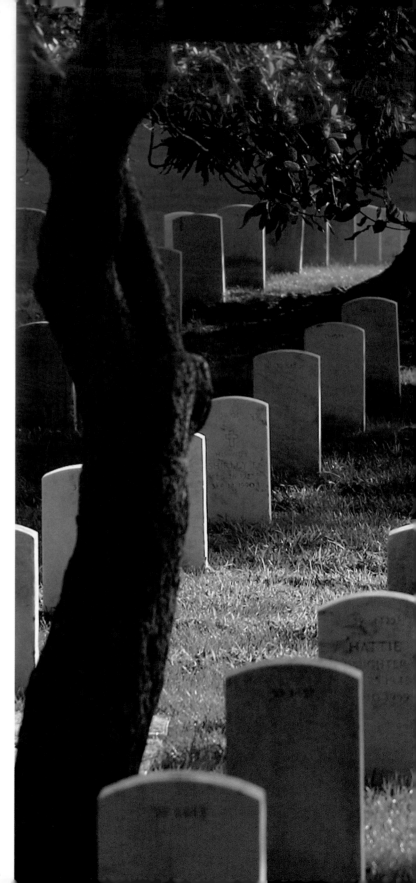

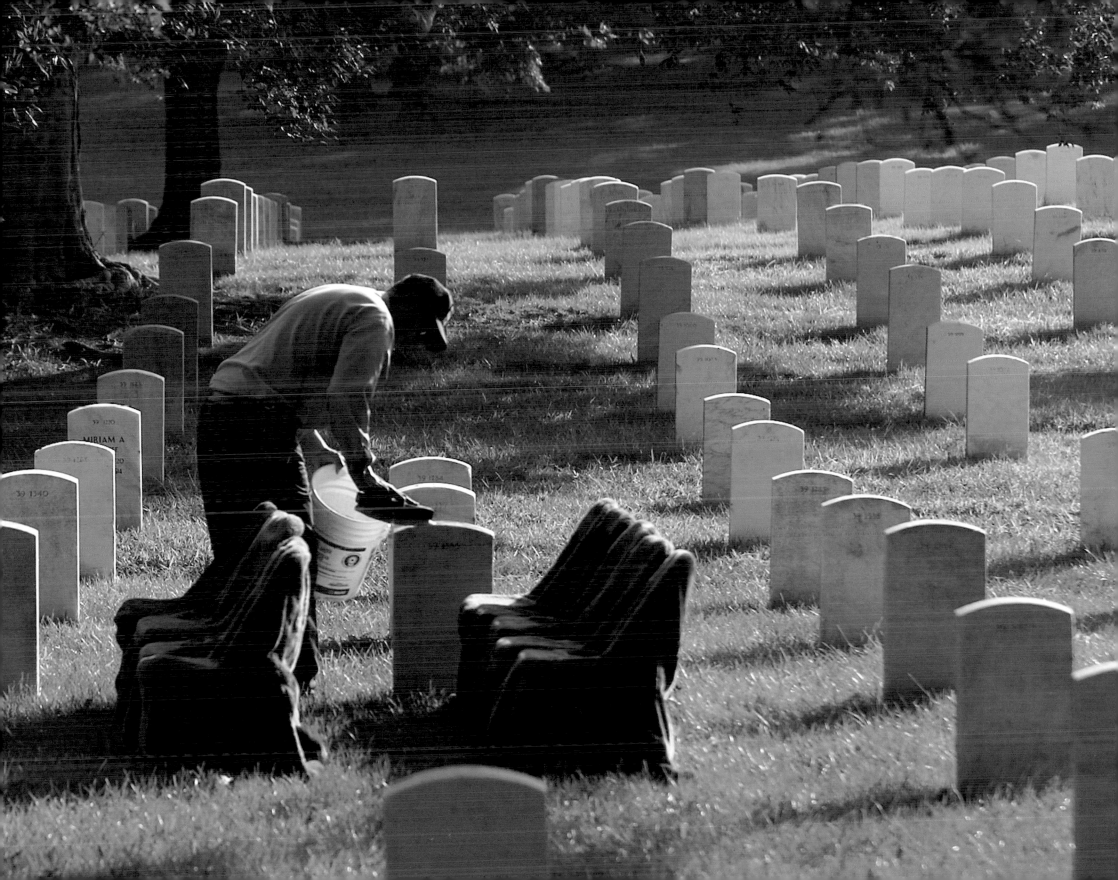

In their martial pomp and lockstep precision, Arlington's memorial observances inspire pride, reverence, and unity; they bond the living and the dead, the soldier and the civilian. Taking place in the air and on the ground, they are **SALUTES**

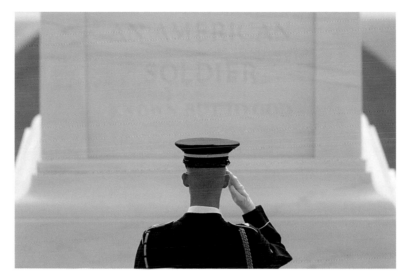

The Sergeant of the Guard salutes the Tomb of the Unknown Soldier.

EVER SINCE MAY 30, 1868, when the dedication of its original amphitheater took place on what would become known as Memorial Day, Arlington National Cemetery has served as the most visible and appropriate setting for the nation to honor those who died in its defense. By the eve of World War I, the popularity of military ceremonies helped occasion the construction of the much larger Memorial Amphitheater—a commanding marble structure, modeled on ancient Greek and Roman edifices, that opened in 1920, five years after President Woodrow Wilson laid the cornerstone and shortly before the establishment of Veterans Day. Today, numerous military societies assemble amid the columns for annual memorial events. More than 5,000 patriots arrive every Easter, Memorial Day, and Veterans Day. They come to pay tribute to heroes, both known and unknown, and to bear witness to the spectacle that accompanies official observance: the presentation of colors, the presidential laying of the wreath, the planting of flags, the firing of guns, the roar of cannons, the ruffle of drums and flourish of trumpets. Jet fighters streak directly above, while soldiers, sailors, airmen, and Marines all stand at attention. As the following photographs suggest, these salutes transcend pomp. They kindle something within us that is bigger than we are—the pride in being part of a nation.

Photographs by SELECT PHOTOGRAPHERS

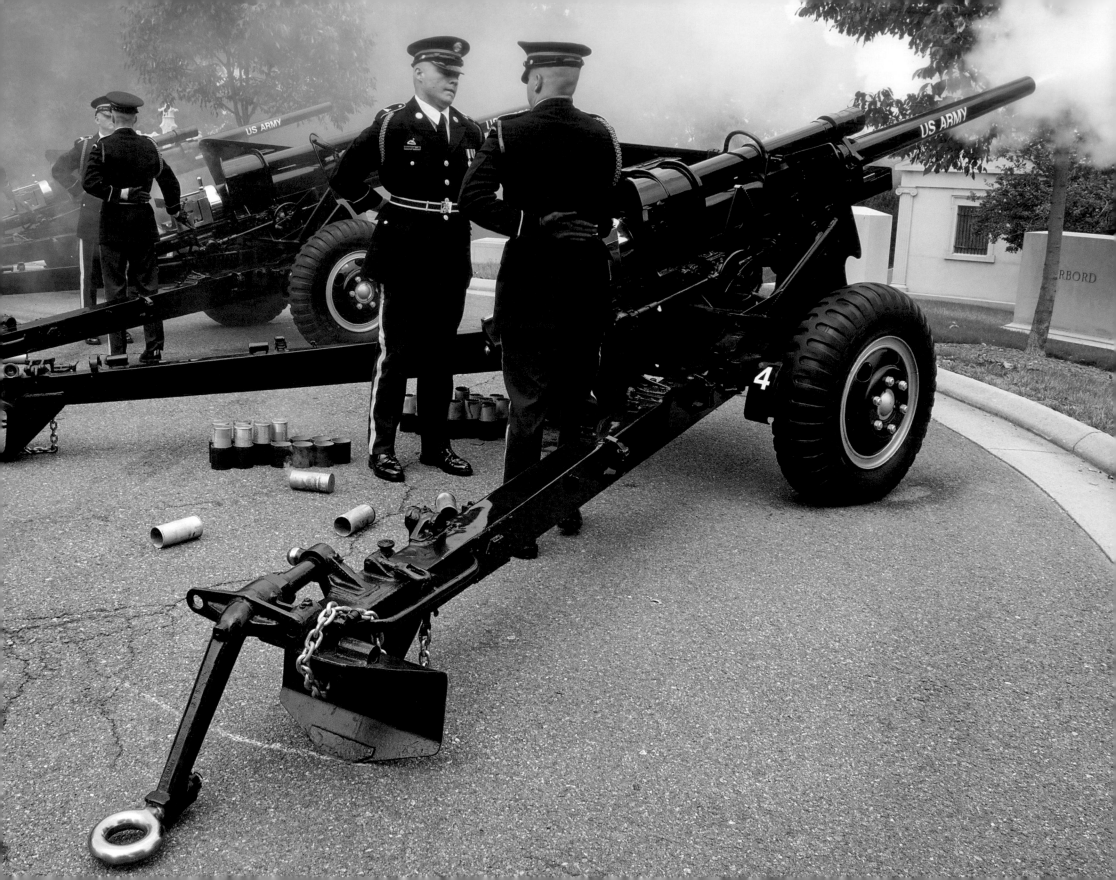

Among the Memorial Day observances, members of the Old Guard, the Army's official ceremonial unit, fire a cannon salute (opposite). Armed forces representatives such as Marine Stephen J. Jones and Navy Seaman Adam Daly (above) render honors during the playing of "Taps" at the Memorial Amphitheater.

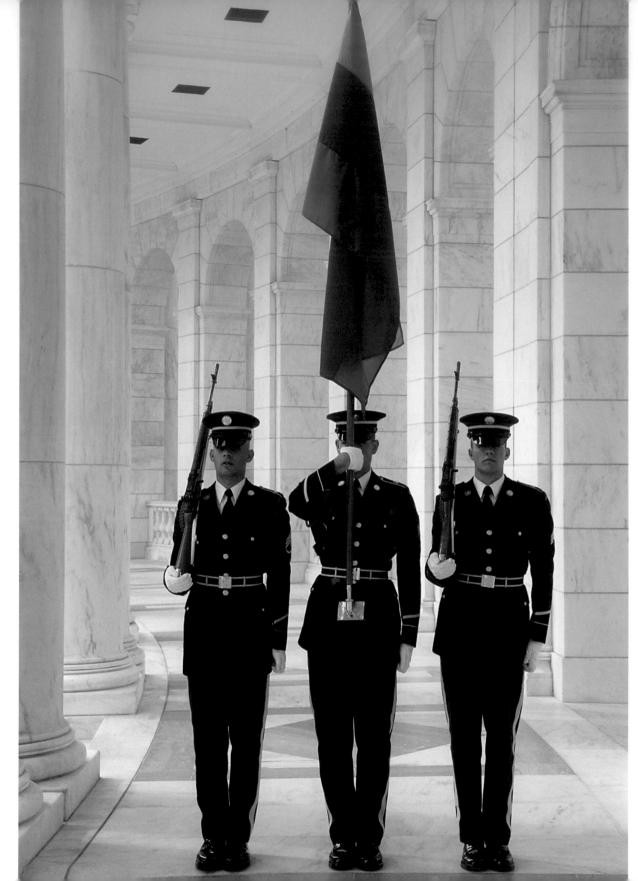

An Army Honor Guard stands at attention in the amphitheater's portico. Tuscarora Chief Johnny Rocca, from nearby Leesburg, Virginia, raises a ceremonial pipe (opposite) in honor of the Creator and his friend, fallen Navy Capt. Russell Harry Mitchell, M.D.

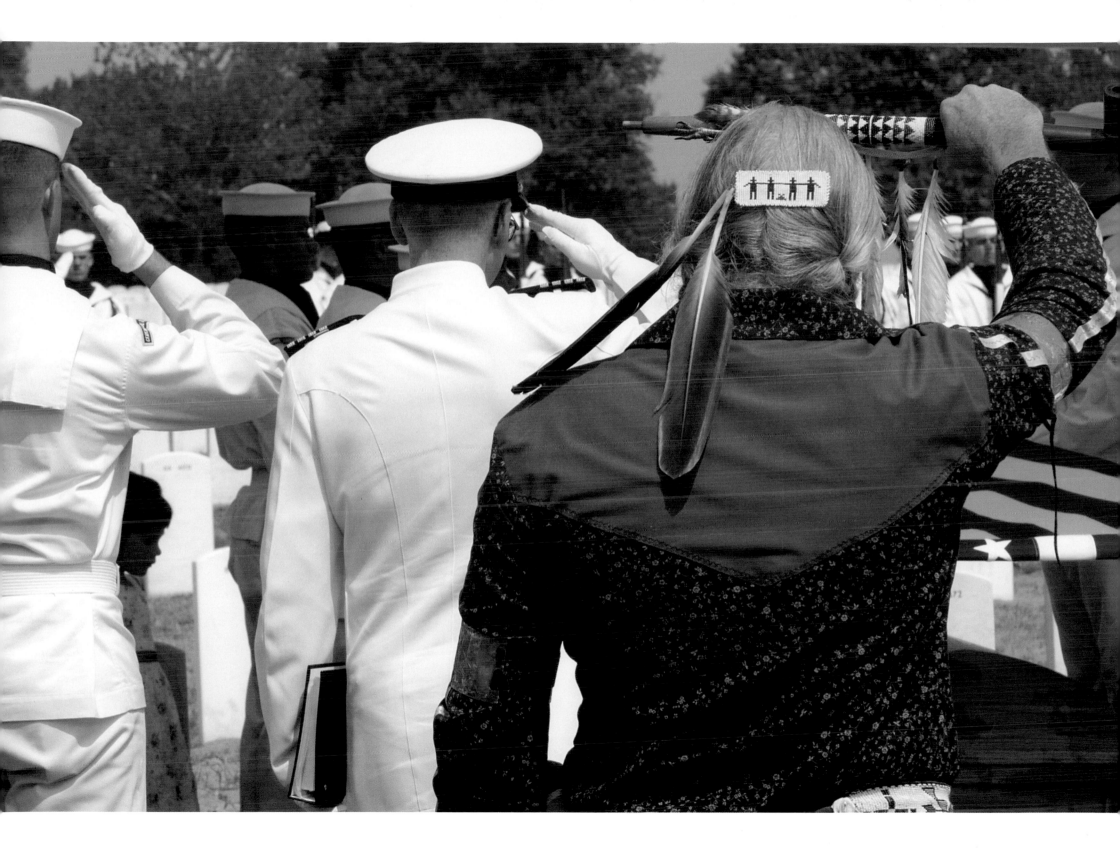

As one plane pulls straight up and away from the others, the "missing man formation"—seen here from below and from above—ranks as the Air Force's most impressive aerial display.

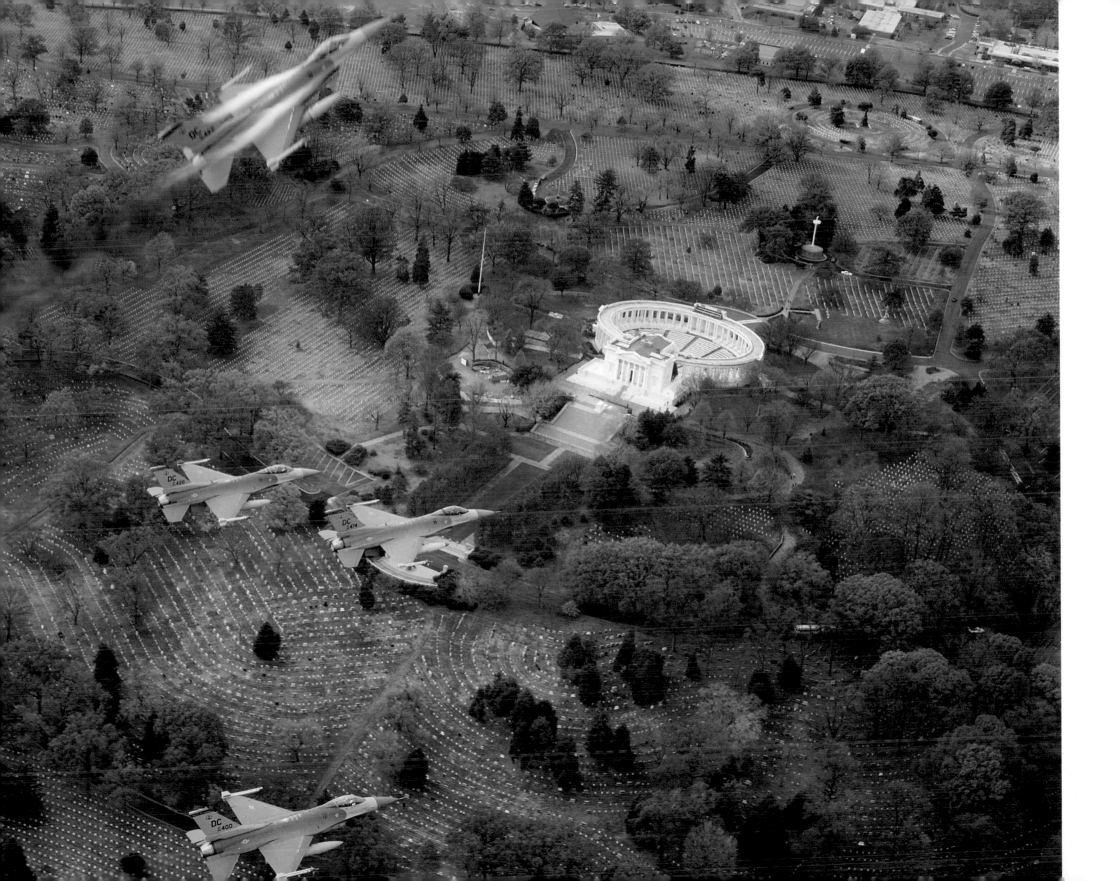

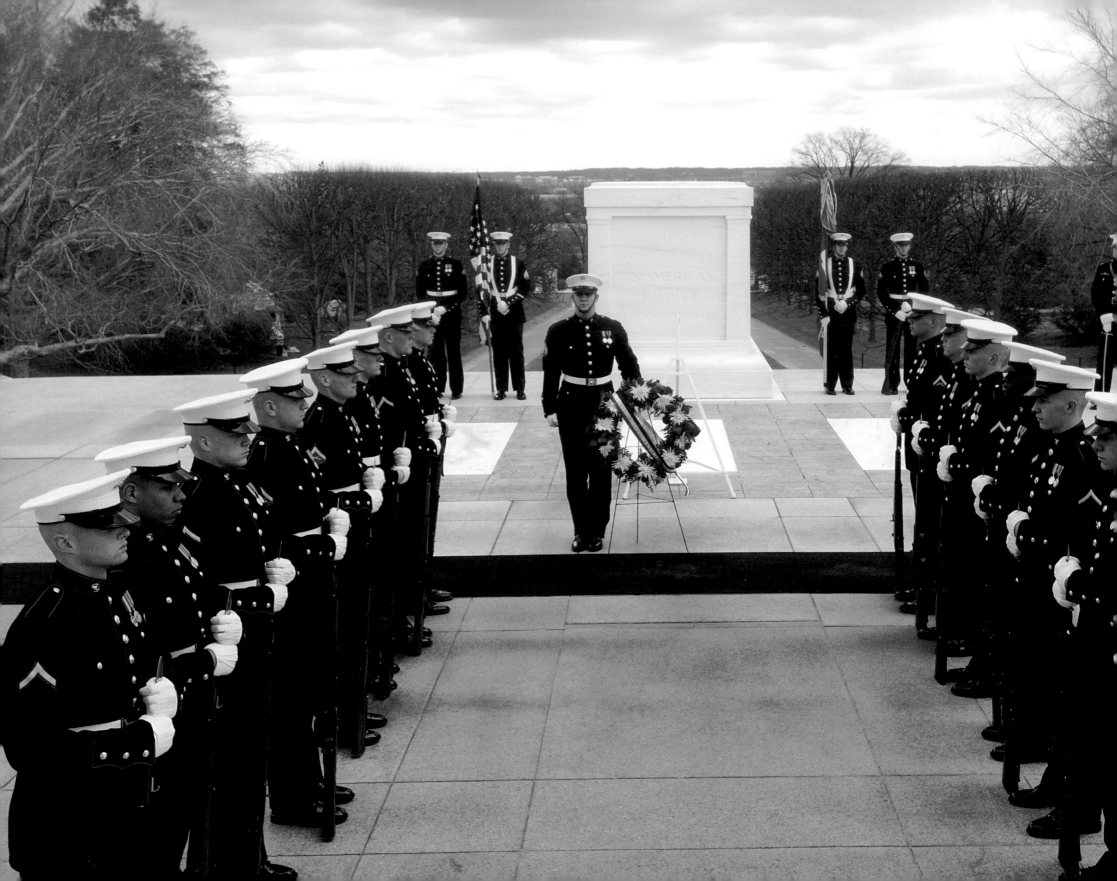

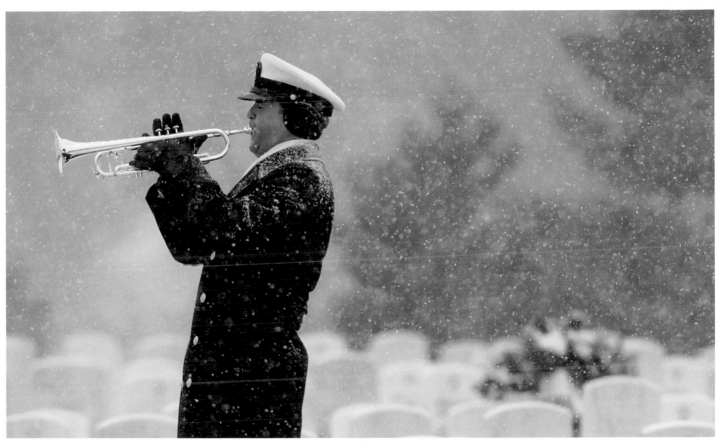

Marines (left) prepare for a wreath-laying ceremony at the Tomb of the Unknown Soldier.
Musician 1 Timothy Stanley (above) plays "Taps" for a Navy funeral.

Memorial Day is Arlington's annual moment in the national spotlight, when mourners and veterans by the thousands convene at the Memorial Amphitheater to pay respects to their fallen comrades and to witness the **CEREMONY**

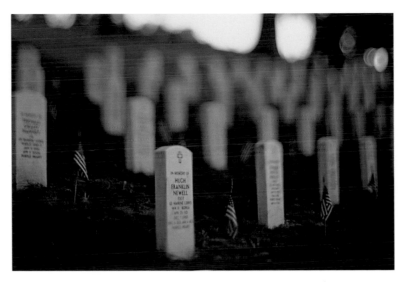

American flags adorn every headstone at Arlington on Memorial Day.

VISITNG ARLINGTON, LIKE visiting the White House, never fails to strike a deep emotional chord. Attendance at the annual Memorial Day observance resonates with particular profundity. The holiday began here in 1868, when Gen. John A. Logan, commander of the Grand Army of the Republic, dedicated the 30th of May "for the purpose of strewing with flowers or otherwise decorating the graves. . . . of our heroic dead, who made their breasts a barricade between our country and its foes." The flowers have since been replaced by small American flags placed in front of each of Arlington's more than 260,000 grave markers by soldiers of the Third U.S. Infantry, who patrol 24 hours a day during the weekend to ensure that each flag remains standing. Members of every military branch participate in the solemn pageantry and colors presentations. The President places a wreath at the Tomb of the Unknown Soldier before addressing the assemblage. The military band plays. Color guards present. And wave upon wave of tourists silently marvel at the precisely orchestrated changing of the Tomb's sentinels. As chronicled during a recent Memorial Day, even on the hottest, brightest spring morning, these rituals of remembrance fill Arlington with a somber, crepuscular air, one of reverence and respect.

Photographic Essay by DAVID BURNETT

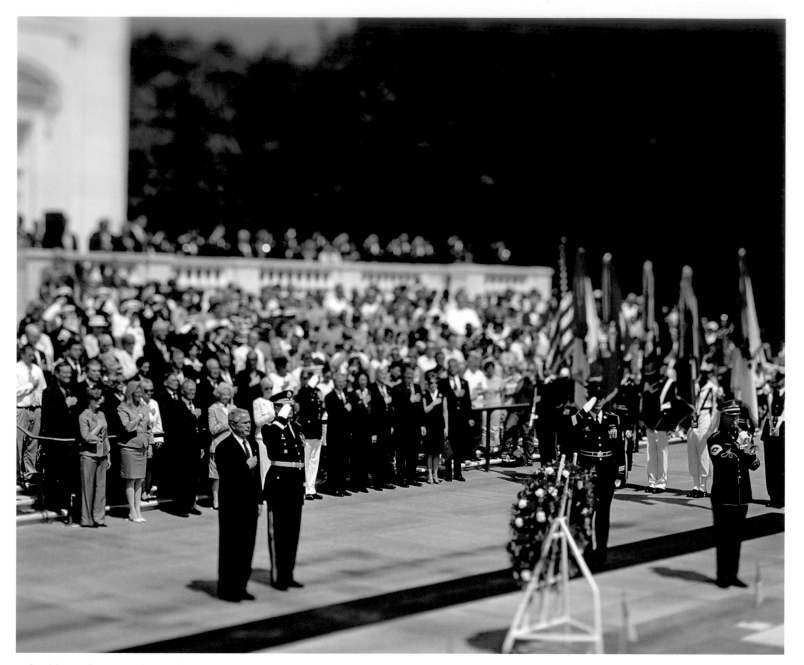

Before delivering his Memorial Day address, President and Commander in Chief George W. Bush (above) joins the Commanding General of Military District of Washington, Gen. Guy C. Swan III, in the wreath-laying at the Tomb of the Unknowns. Ceremonial units from all military branches march past the marble sarcophagus (opposite).

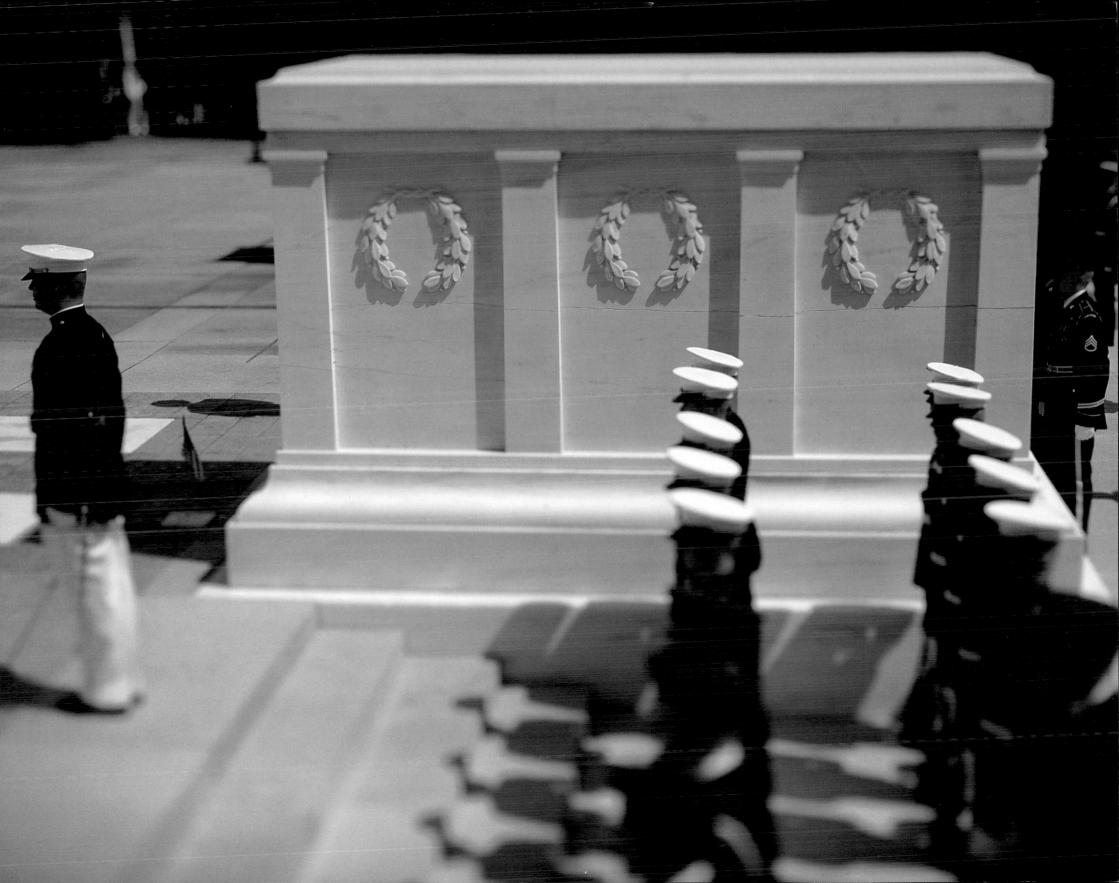

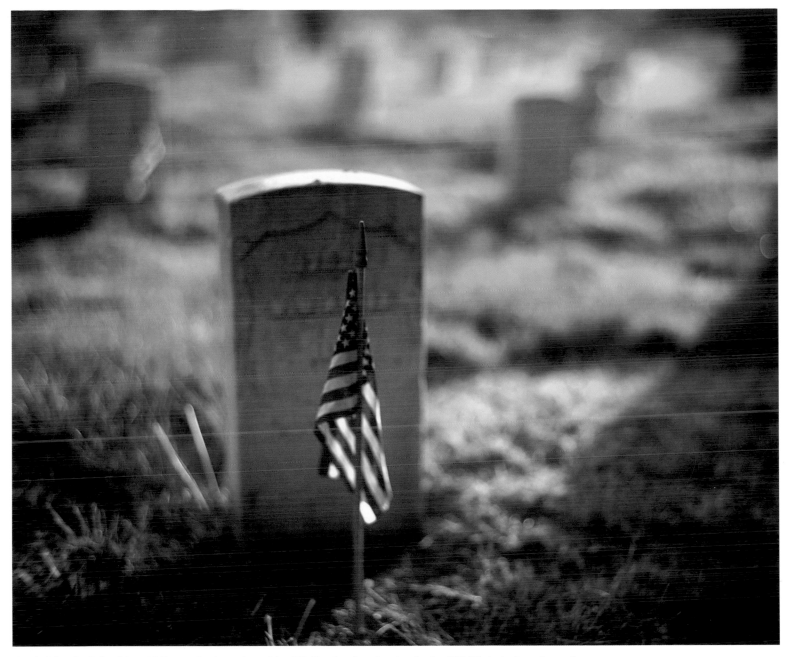

On the Thursday before Memorial Day weekend, members of the Old Guard perform flags-in, planting Old Glories in front of more than 250,000 grave markers, including those in Section 1 (above). Purple-capped Ed Schnug and John Weis, color bearers from the Military Order of the Purple Heart, stand alongside color bearers (opposite) from another veteran's service organization on Memorial Day in 2006.

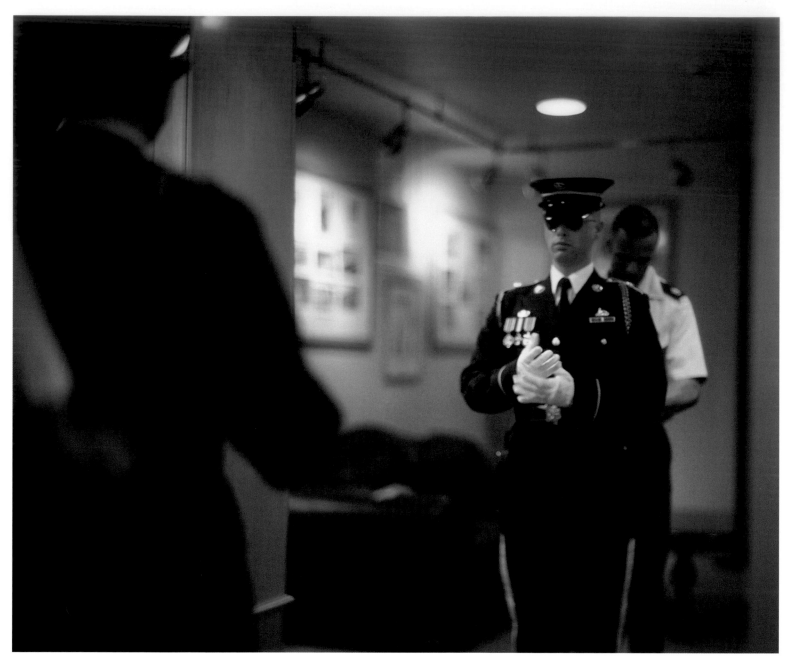

In the quarters beneath the Tomb of the Unknowns known as the "Catacombs," one Tomb Sentinel assists another in the meticulous, hours-long preparation of his uniform before he "walks the mat" in front of the Tomb. On Memorial Day, like every day between April and October, guards change in front of the Tomb (opposite) every half hour on the half hour in a precise ritual.

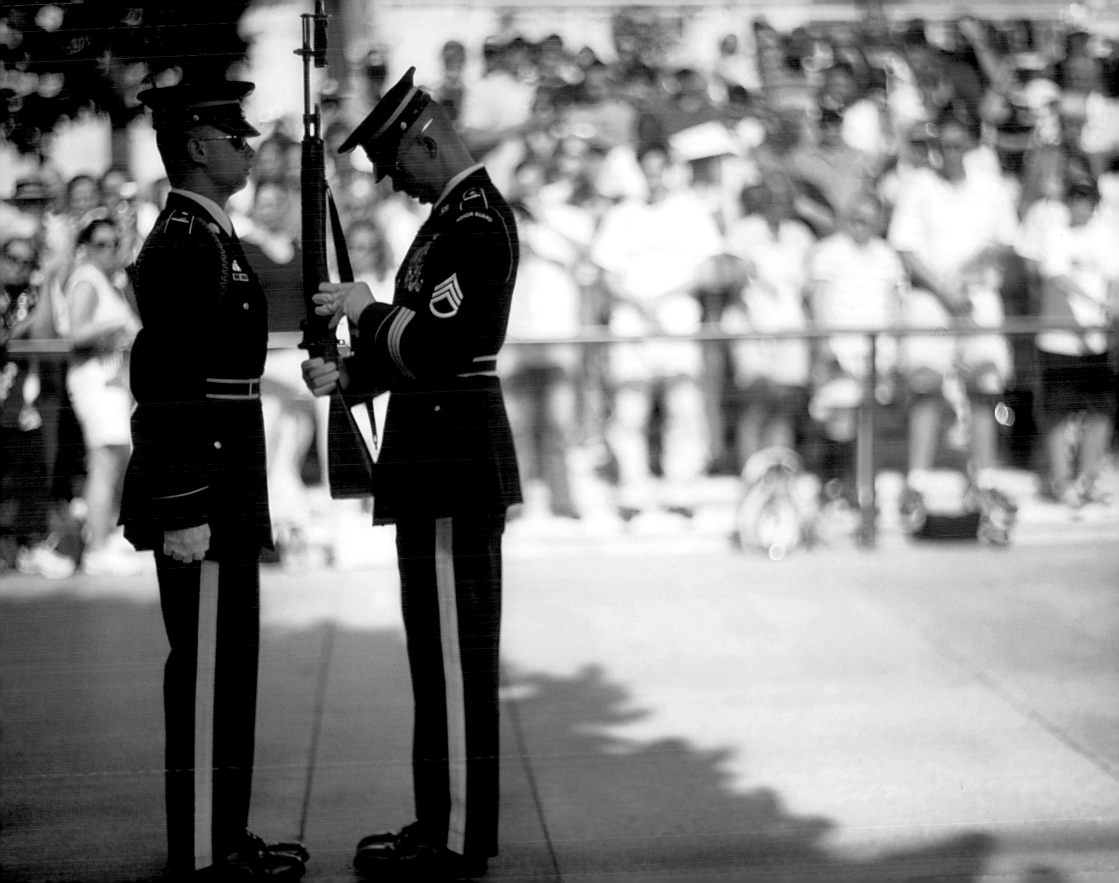

Stones, flowers, and other symbols of remembrance grace the grave of Army Sgt. Michael J. Bordelon (above), a Louisianan who was killed in action, May 2005. Tourists (opposite) crowd the steps of the Memorial Amphitheater, standing quietly to witness the changing of the sentinels in front of the Tomb of the Unknown Soldier, which is protected 24 hours a day, 365 days a year by the elite Tomb Guard.

Bound by a sense of duty and a willingness to fight for timeless ideals, the soldiers buried here never really die; nor do they just fade away. They endure, thanks to the presence of the countless veterans who pay homage to the **SACRIFICE**

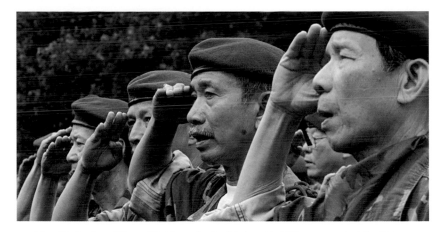

The elite Laotian Airborne Division, who fought alongside U.S. troops against the Vietcong

BENEATH ARLINGTON'S FINELY manicured greenswards lie the remains of men and women of every stripe: colonels and corporals, rich and poor, black and white. In death they know no rank, and throughout the year, and most conspicuously on Memorial Day, veterans of battles fought in Europe, Asia, Africa, and the Middle East arrive to pay homage to their fallen comrades. They come wearing garrison caps and the vestments of their units, of the American Legion, Veterans of Foreign Wars, and numerous other veterans' societies. Witnesses to history, they consecrate those who perished in the shaping of it. To survive is to keep alive memories of the dead, their valor, fidelity, and sacrifice, and the noble ideals of freedom and liberty for which they died. Just as the fallen give silent witness to the price of those ideals, those veterans with whom they fought and the loved ones whose pictures they carried salute them as heroes who put service above self. Honoring their sacrifice is a ritual as old as the cemetery itself. The following photographs, taken during recent ceremonies, movingly portray what the poet Laurence Binyon so eloquently penned from the trenches during World War I: "They shall grow not old, as we that are left grow old / Age shall not weary them, nor the years condemn / At the going down of the sun and in the morning / We will remember them."

Photographs by SELECT PHOTOGRAPHERS

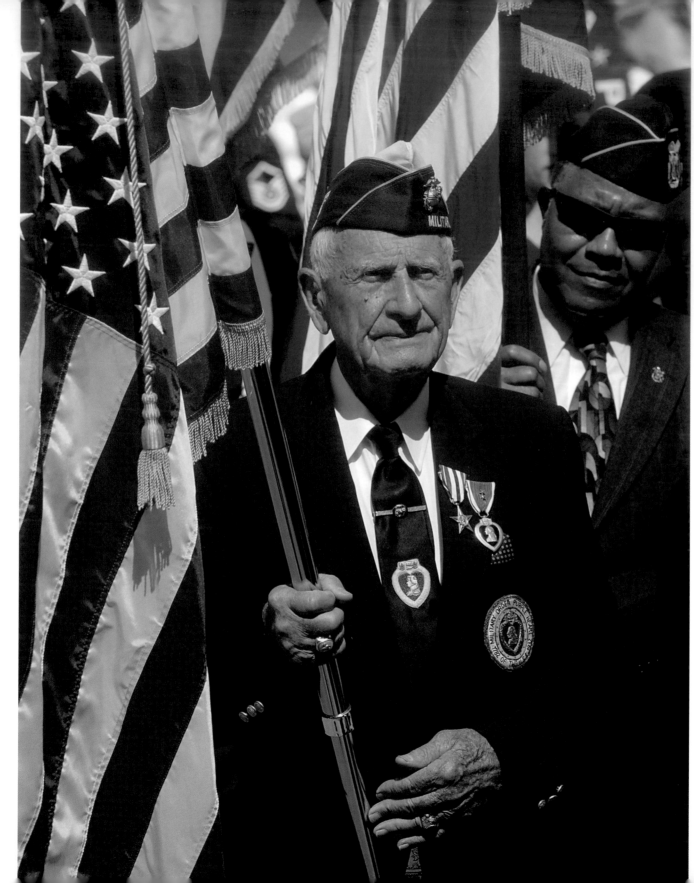

For World War II veterans like Purple Heart and Silver Star Medal recipient Ed Schnug, Memorial Day ceremonies carry heavy emotions. Those who represent the Veterans of Foreign Wars National Honor Guard (opposite) do so with a sense of pride and loss.

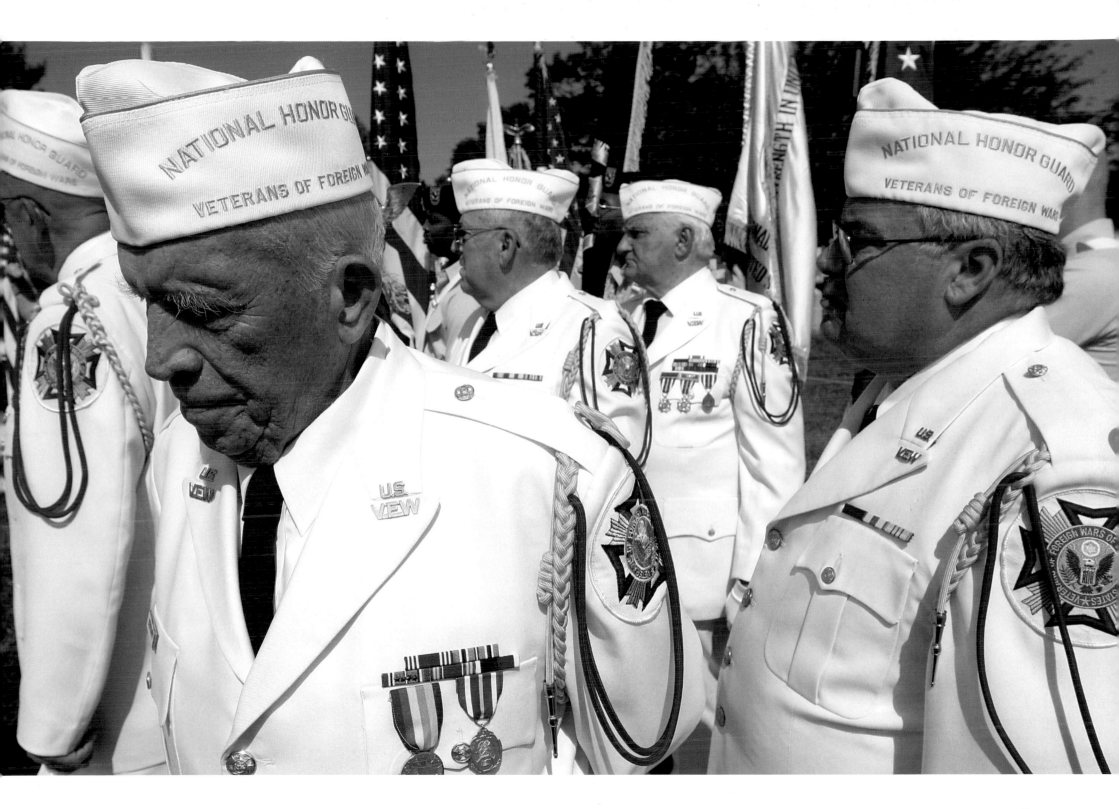

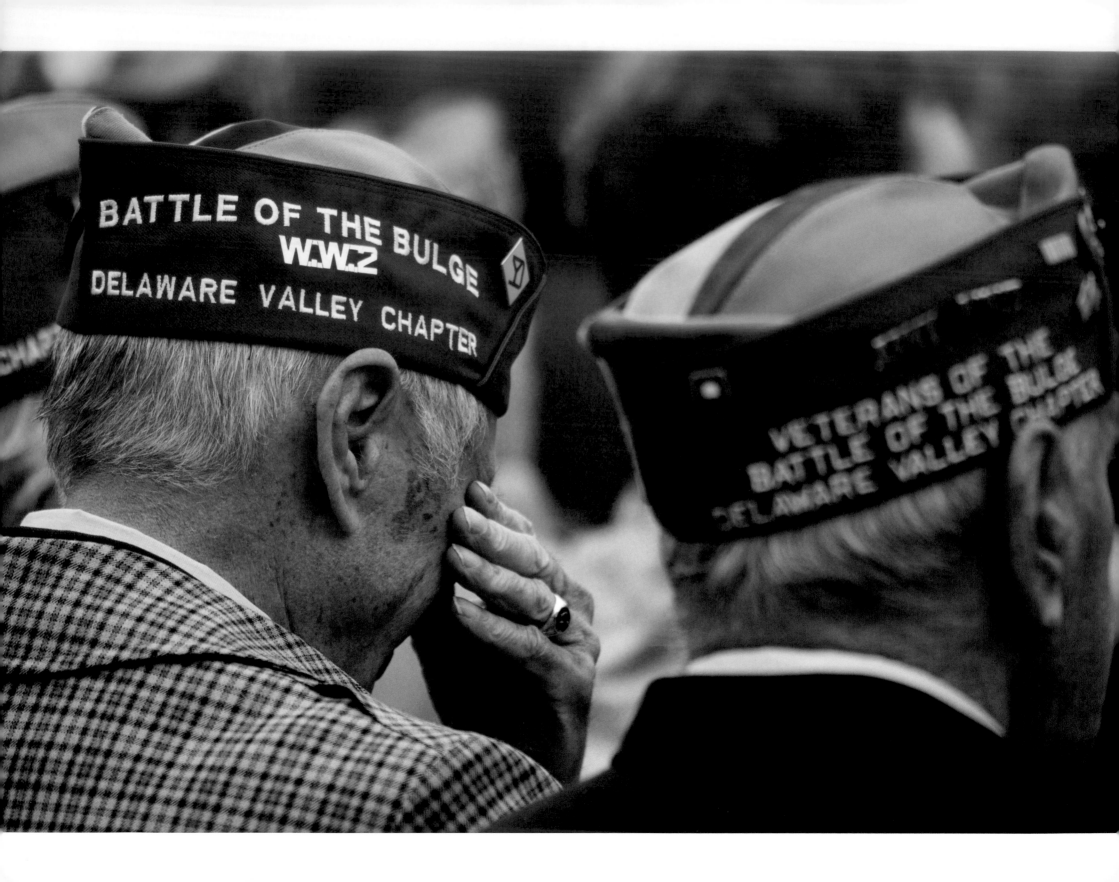

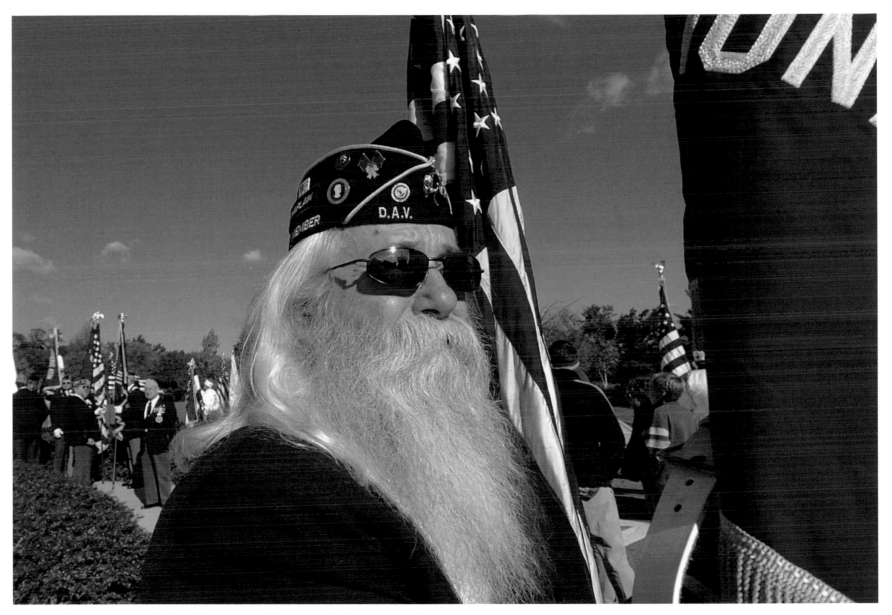

World War II veterans who turned back the Nazis weep openly during the dedication ceremony at Arlington's Battle of the Bulge monument. Virginian Greg Majesky (above) of the Disabled American Veterans Association, Chapter 10, carries the national colors into the Amphitheater during the 2005 Veterans Day ceremonies.

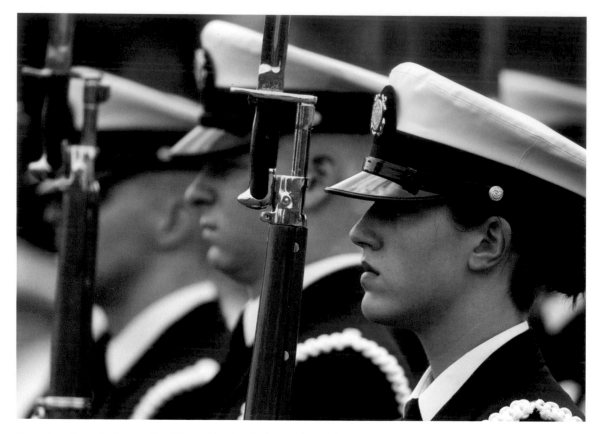

Bayonets at the ready, Seaman Cara Warner (above) and other members of the U.S. Coast Guard Firing Party line up in formation to perform a three-round salute. Alfred Vitali (opposite), an Army corporal during World War II, quietly reflects during the May 8, 2006, dedication of the Battle of the Bulge Memorial.

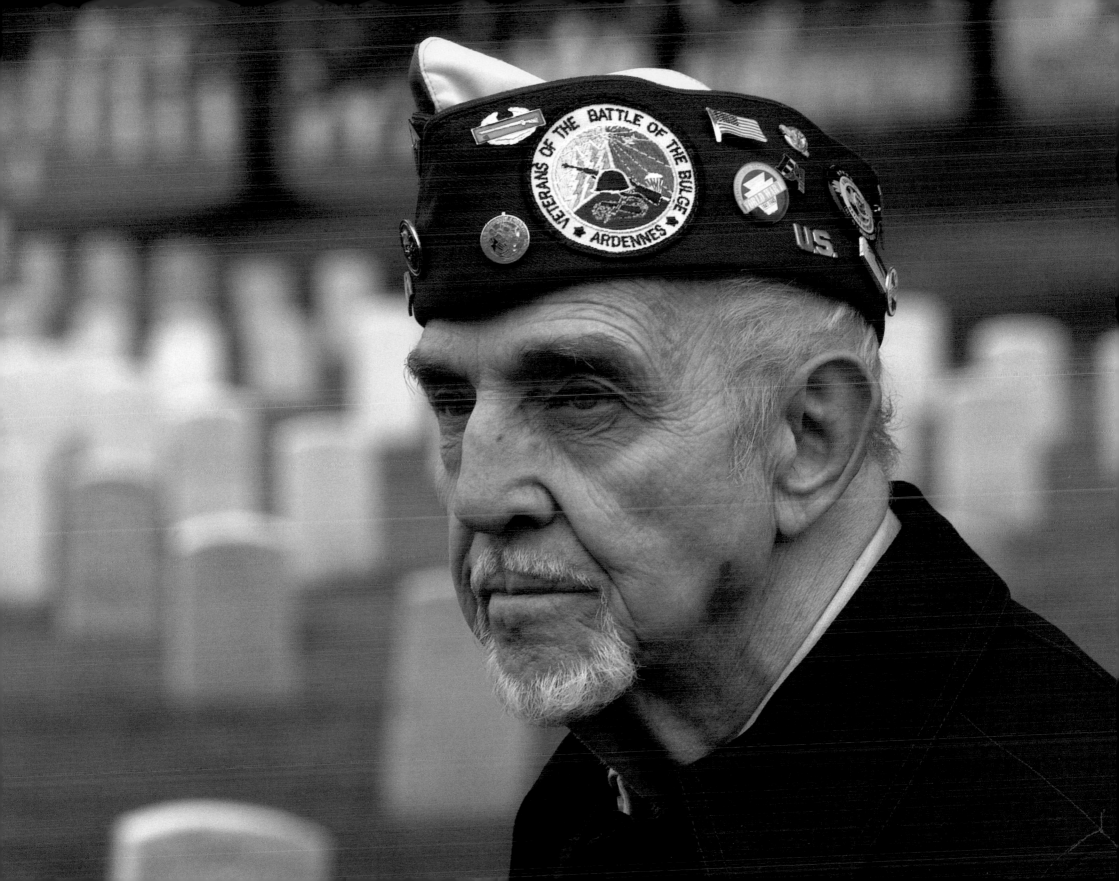

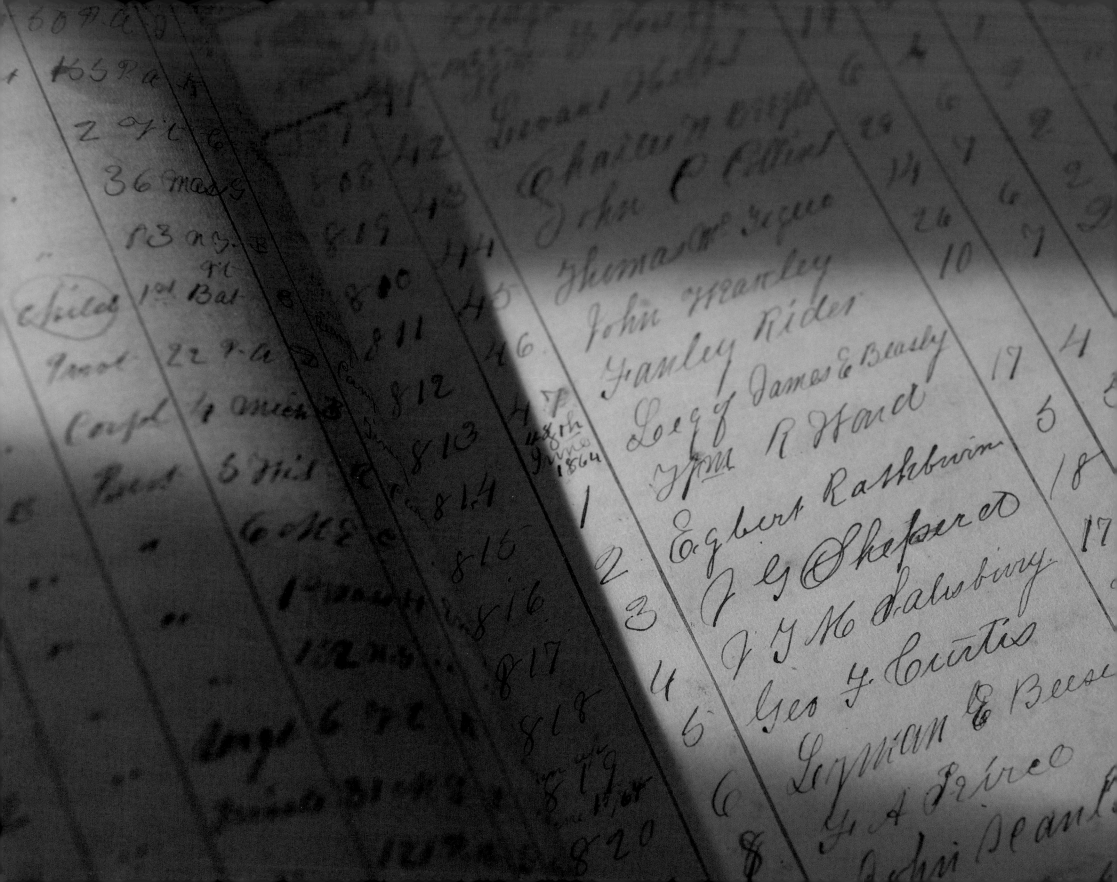

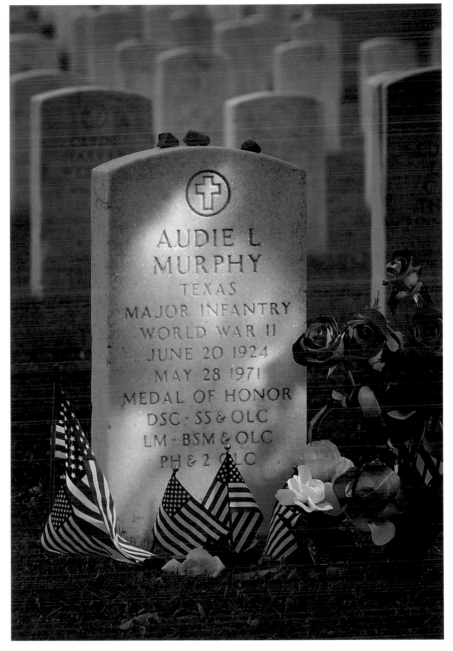

Dating from the Civil War, Arlington's original necrology serves as both artifact and atlas. The grave (above) of America's highly decorated World War II soldier, Audie Murphy, remains as bedecked in death as he was in life.

The Jewish tradition of placing stones atop a grave stone transcends faith at Arlington. Air Force Lt. Col. Robert D. Falkner's grave inscription (right) is one of the cemetery's most elaborate.

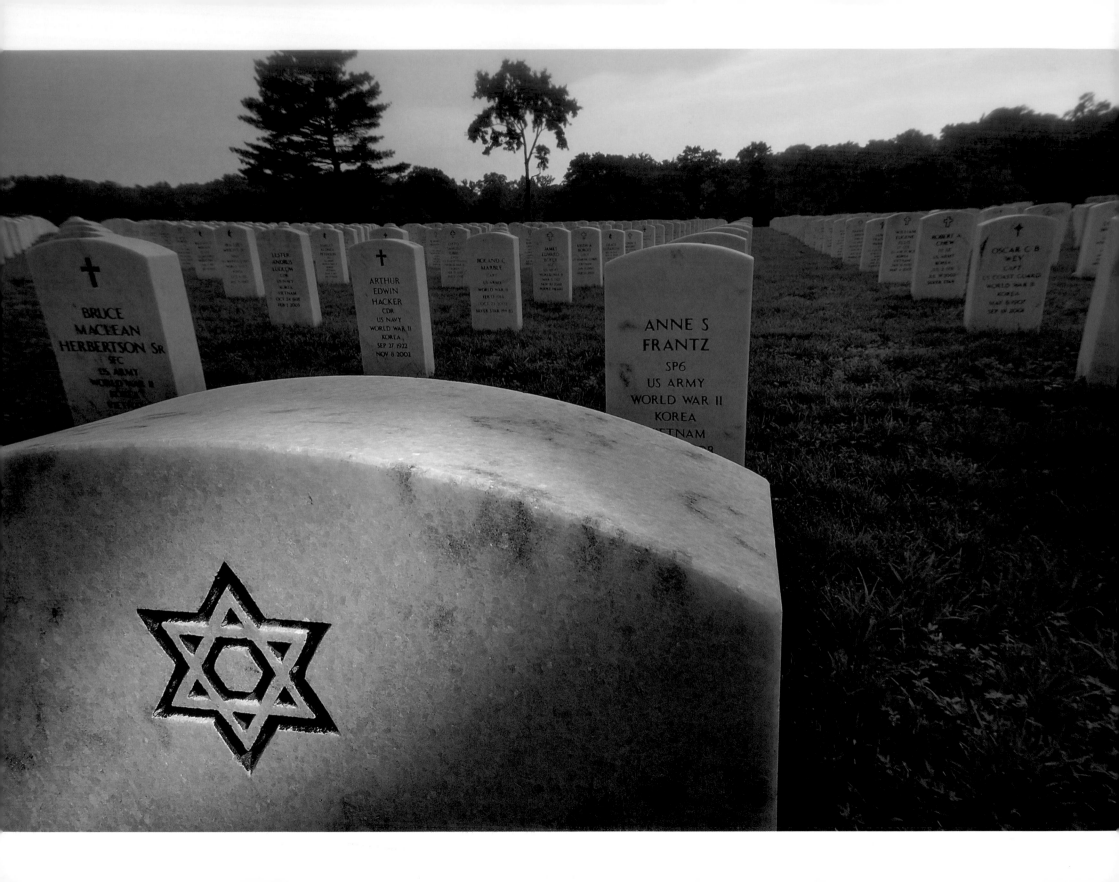

Followers of more than 32 different faiths have died under the same flag—and now lie beneath the same ground. Surviving loved ones leave intimate symbols of love and faith (above).

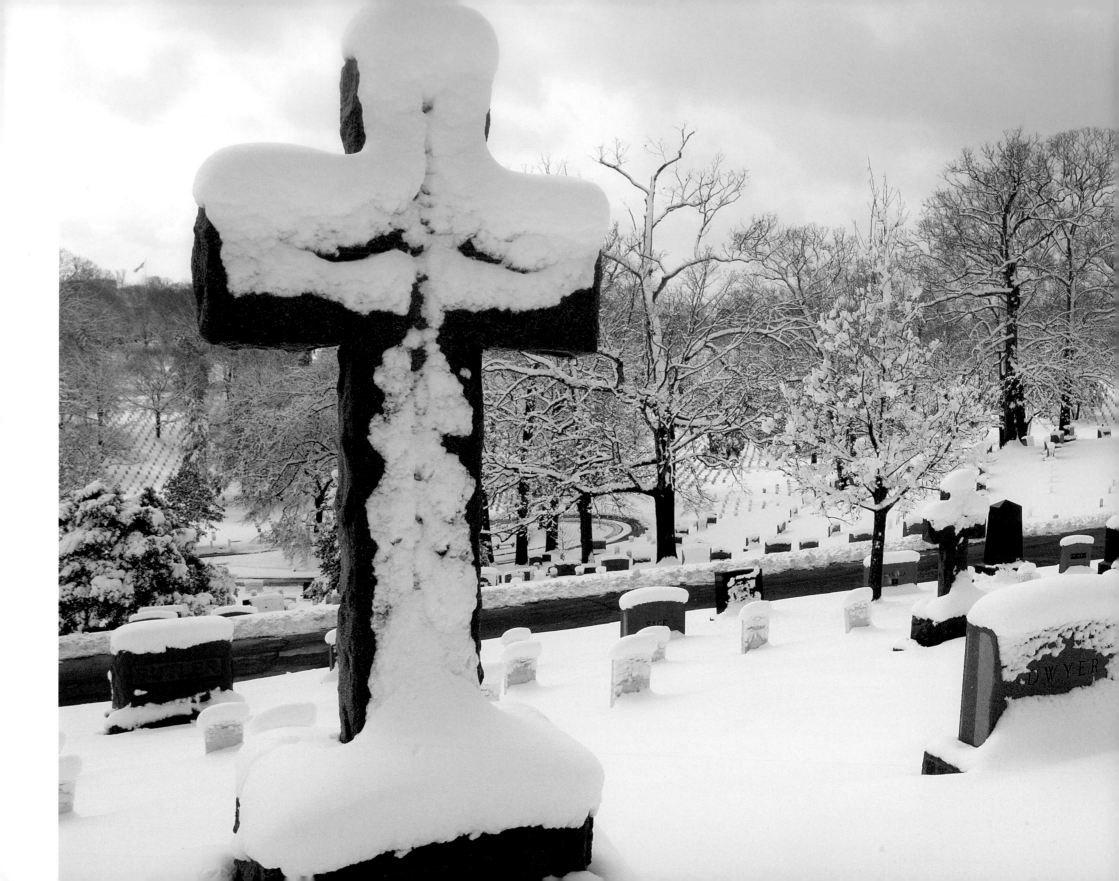

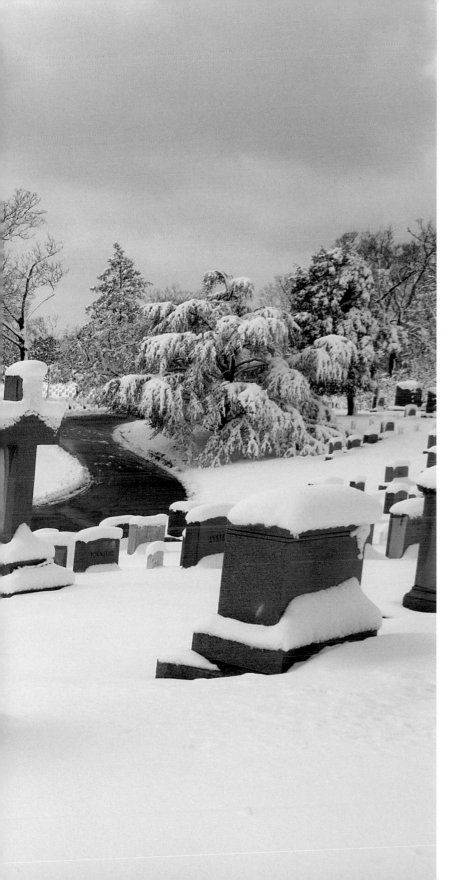

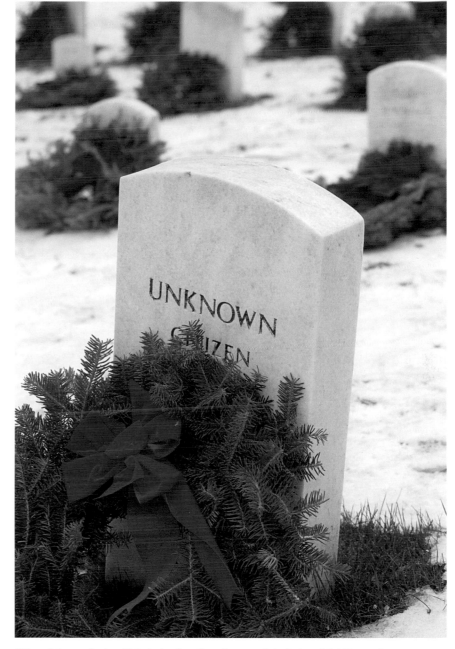

Winter brings to Section 27 both the shrouding of snow and the laying of 5,000 wreaths donated by Morrill Worcester's Worcester Wreath Company. Cloaked in whiteness, the grave of Civil War Brig. Gen. Jacob Kline (left) overlooks the ranks of headstones from Section E.

If you can gauge a nation's character by how it treats its war dead, then the Tomb of the Unknown Soldier and its sentinels embody the height of American pride and dignity. Perfection is the only acceptable standard for **TOMB GUARDS**

The arrangement of Tomb Guard accouterments follows precise organization.

FOR EVERY MINUTE of every day since July 2, 1937, a uniformed sentinel has marched an unvarying, gliding march in front of the Tomb of the Unknown Soldier, a 79-ton marble sarcophagus erected in 1921 to honor all American service members "Known But to God." Made up since 1948 by soldiers in Company E of the Third U.S. Infantry (the Old Guard), Tomb Guard sentinels make up the second most exclusive military group in the U.S. Army. Only the Astronaut Badge has been awarded fewer times than the sterling silver Tomb of the Unknown Soldier Honor Guard Identification Badge, testifying to the rigorous testing criteria used to qualify—and retain—volunteers for the post.

Occurring at regular intervals, the Changing of the Guard is an elaborate ceremony annually viewed by millions. But the spectacle they see—the white-gloved rifle inspection, 21-step march-and-turn, and recitation of orders—is only part of the world of the Tomb Guards. Belowground, in the catacomb-like Tomb Guard Quarters, these dedicated sentinels spend untold hours polishing their brass and boots, pressing their shirts, removing lint and singeing stray threads from their uniforms, and oiling their weapons. Photographed during the chill of early winter, even in "unguarded" moments, the eternal vigilance of these sentinels shines through.

Photographic Essay by DAVID ALAN HARVEY

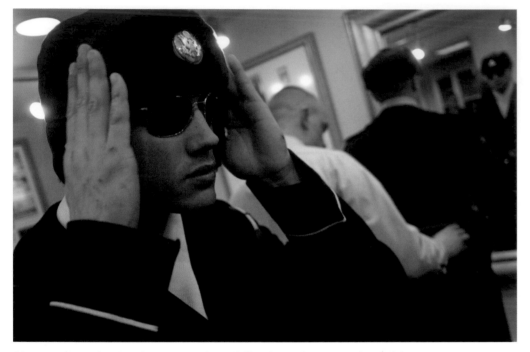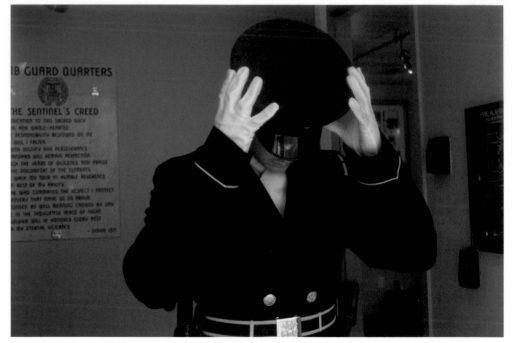

No matter the weather, Specialist James Henderson (left) and Specialist Justin Bickett (right)
meticulously align their caps and every other item on their uniforms. Before donning a wool overcoat,
Staff Sgt. Steve Kuehn (opposite) puts on a white scarf, secured at the chest to prevent movement.

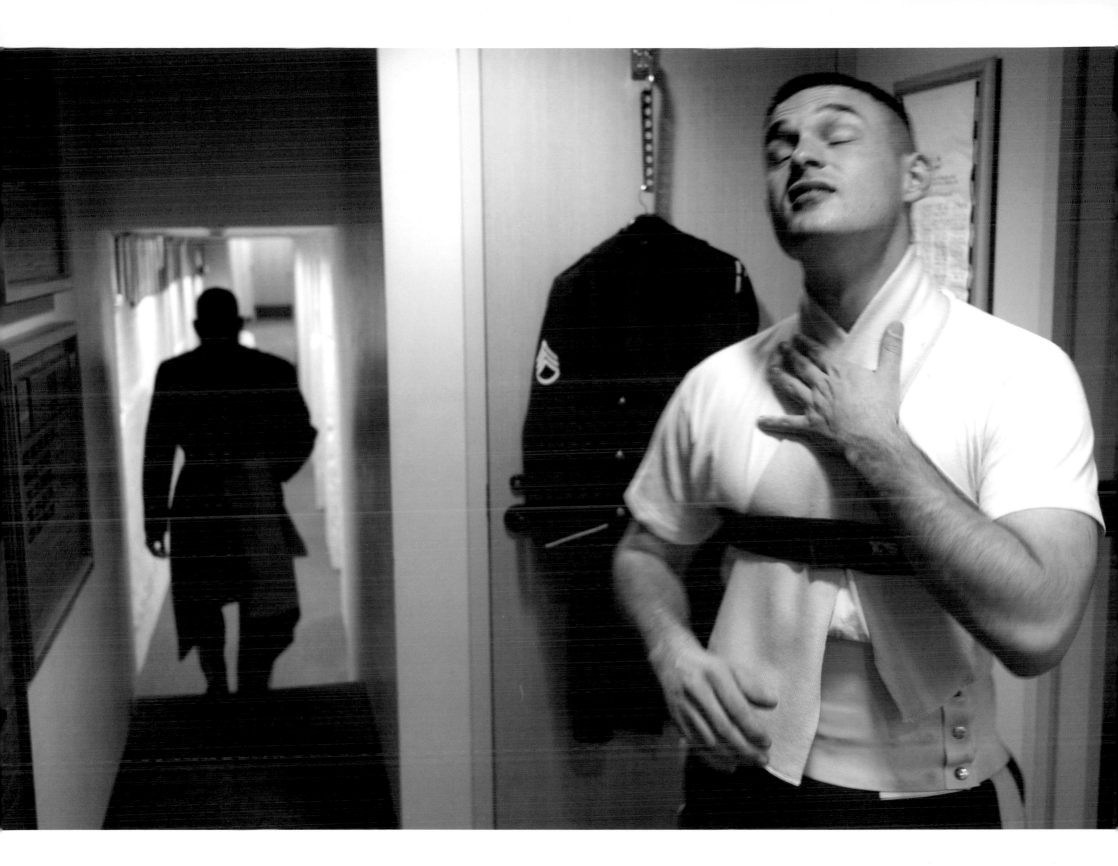

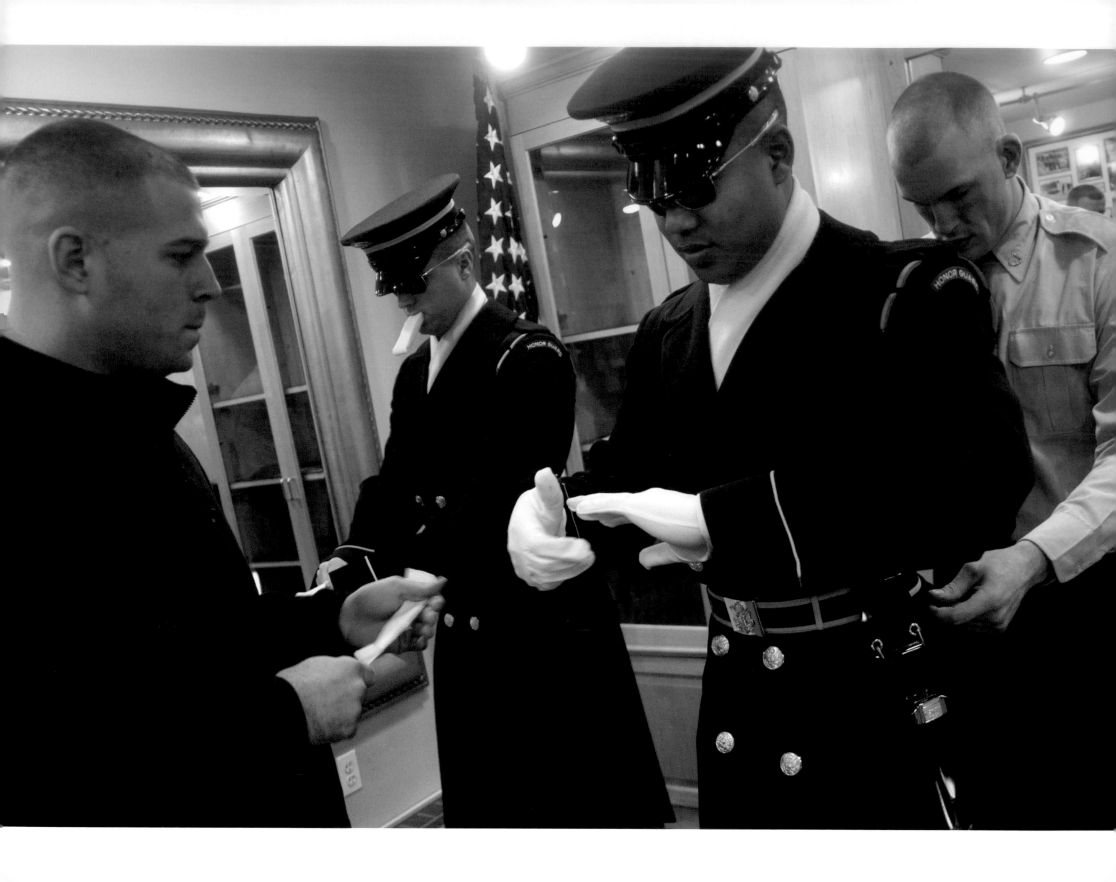

Tomb Guards (opposite), such as Specialist Matt Perovich, Specialist Justin Bickett, Specialist Bruce Bryant, and Pvt. 1st Class Kyle Obrosky, never dress alone and wear moistened gloves for a better grip on their M14 rifles and M6 bayonets. Above, clockwise from left, Capt. Jonathan Murphy, Specialist Adam Cook, Sgt. Chris Moore, Specialist Matt Perovich, Staff Sgt. Steve Kuehn, Sgt. 1st Class Derek Dotson, and Specialist Justin Bickett tend to the details of their station.

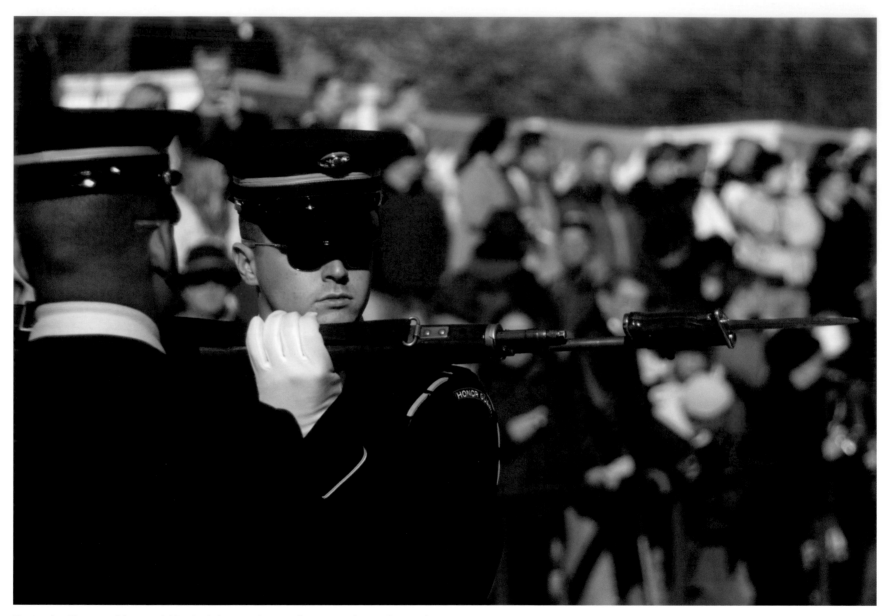

During the Changing of the Guard (above) relief commander Specialist Justin Bickett conducts a white-glove inspection of the relieving sentinel's weapon, checking each part of the M14 once. As two visitors look on, Pvt. 1st Class Kyle Obrosky (opposite) executes his watch with stoic precision.

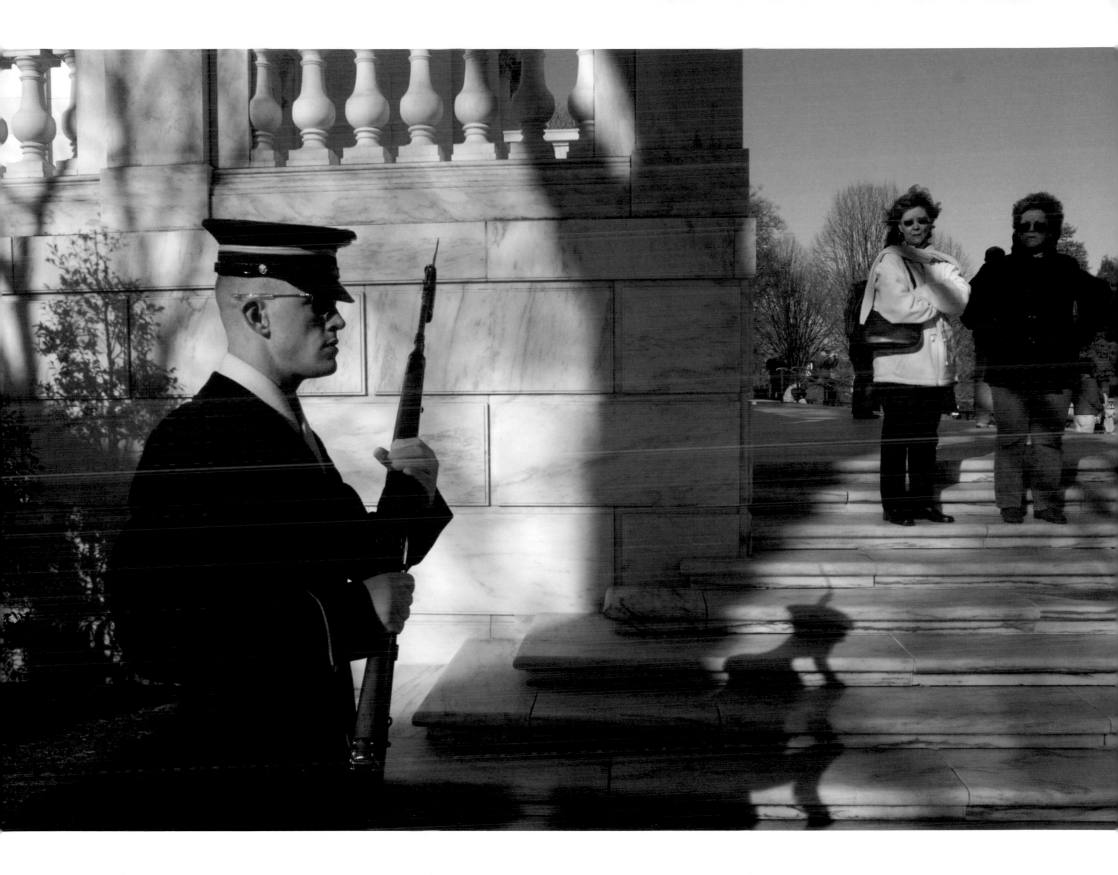

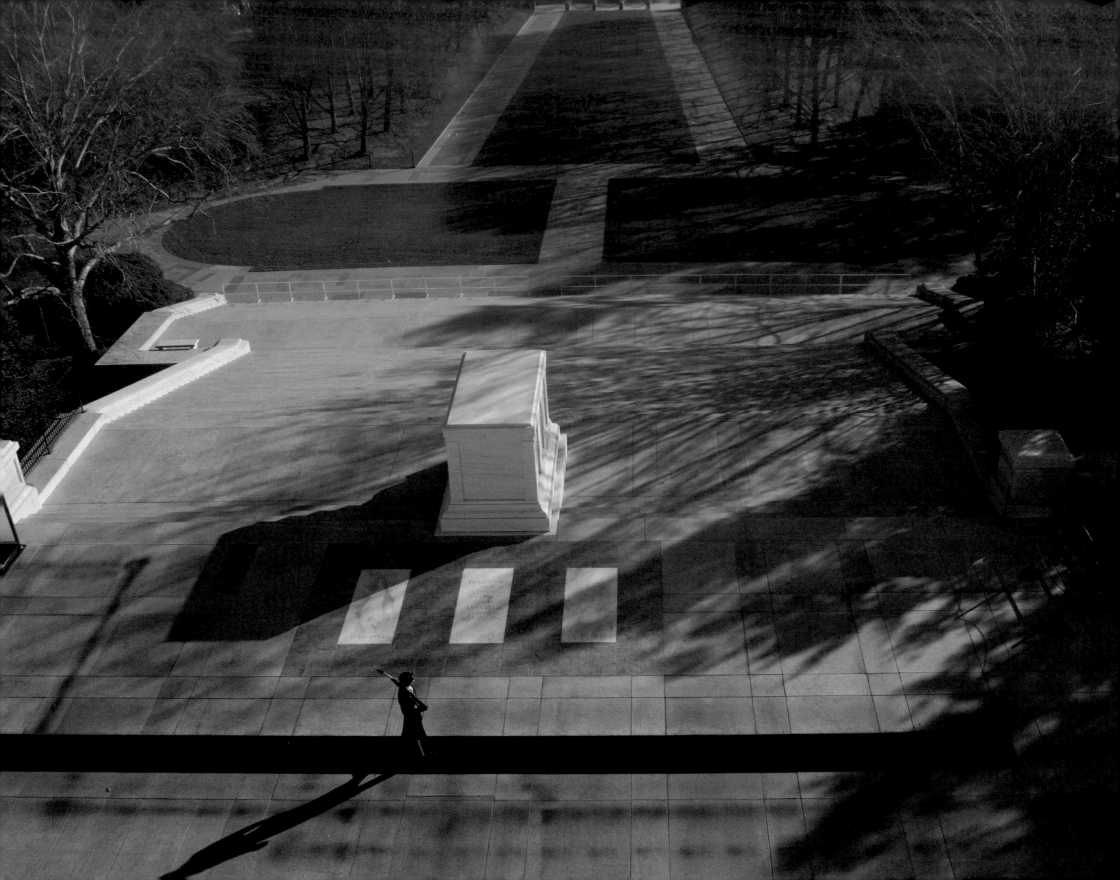

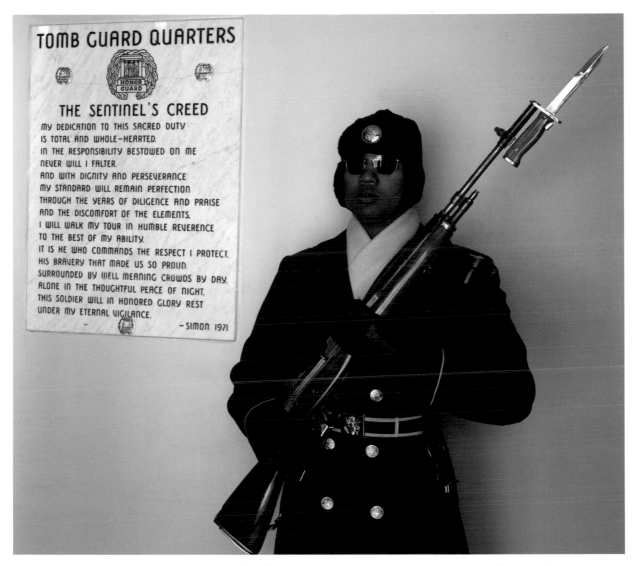

Standing alongside the creed to which he has dedicated himself, Specialist Bruce Bryant (above) prepares to relieve a fellow sentinel. Members of this exclusive detail don't need an audience as they "walk the mat" at the Tomb of the Unknown Soldier (left).

A willingness to make the ultimate patriotic sacrifice ennobles the lives of all military men and women. At Arlington, families know their loved ones belonged not just to them, but also to the nation. They take solace in the **SERVICES**

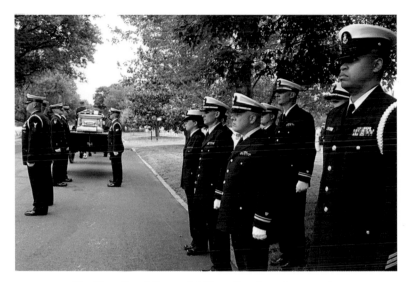

The Coast Guard Ceremonial Honor Guard stands at attention.

SERVICES ARE RENDERED at no cost to families of active or honorably discharged service members. However, the emotional tab is high. For although the Latin inscription over the west entrance to Arlington's Memorial Amphitheater may translate into "It is sweet and honorable to die for one's country," as the photographs on the following pages tearfully show, for the spouses, parents, children, and siblings of those killed in action, the loss is more bitter than sweet, no matter how honorable the purpose. Not every soldier perishes on the battle field, of course, and retired officers receive the same honors as active-duty casualties. But as Army Chaplain Capt. Charles Hamlin, who has presided over thousands of funerals, admits, "Active duty are the toughest services because you see a lot of young people and realize that the soldier didn't get to experience the fullness of life." After the ritualized march to the grave site or columbarium and a brief eulogy, the six body bearers present the next of kin with the flag—folded 13 times into a trim triangle, stars out—that covered the casket. The firing party discharges its salute, followed by the haunting notes of "Taps" and a procession from the grave. What happens next adheres to no script, ritual or protocol; it is when sadness intrudes on ceremony and even the most stoic soldier finds himself struggling to stay strong.

Photographs by SELECT PHOTOGRAPHERS

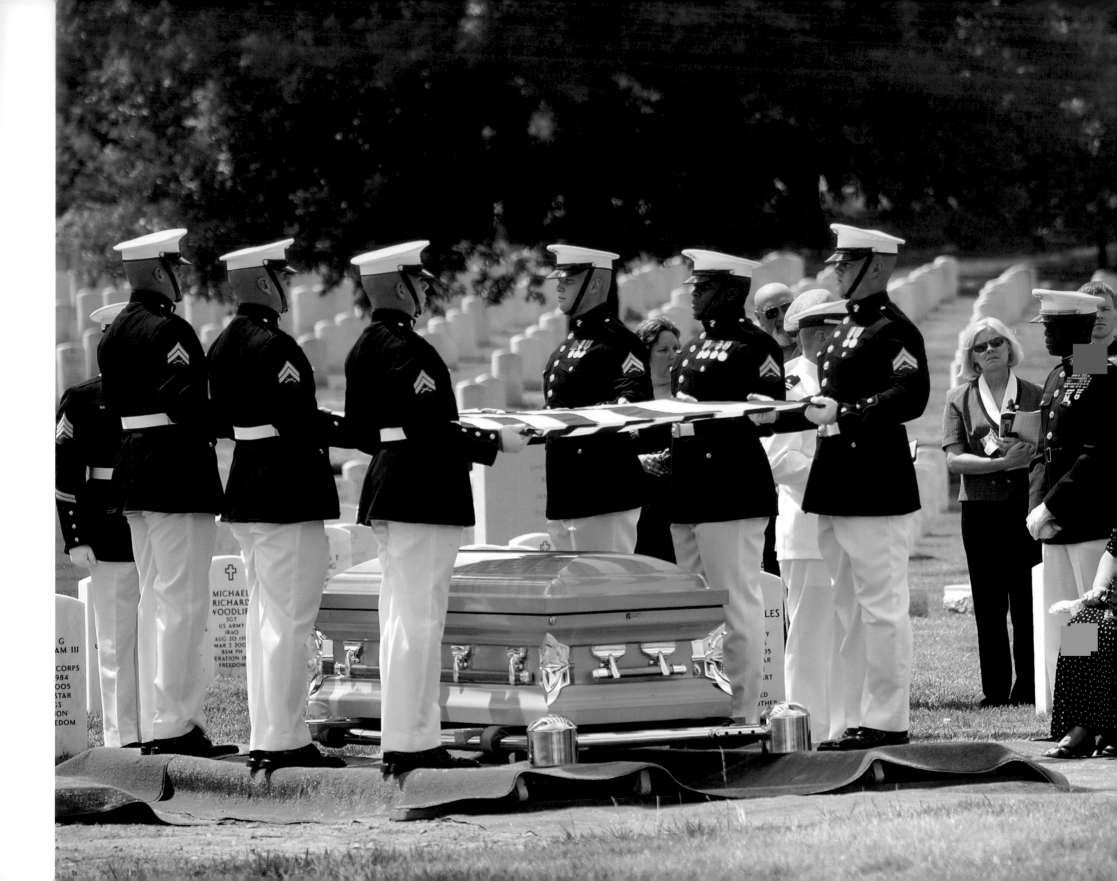

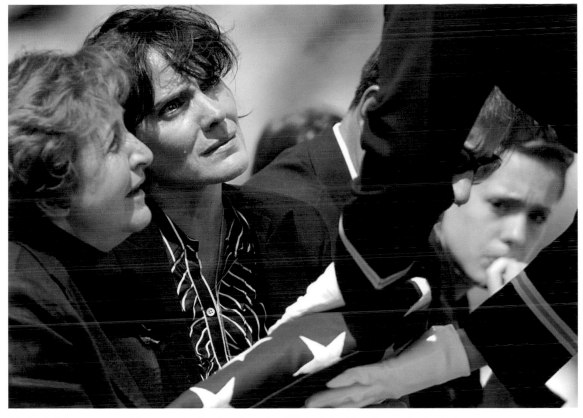

Marine body bearers ceremonially remove the flag from the casket of Cpl. Kevin Adam Lucas, who died in Iraq on May 26, 2006. At the funeral (above) for Chief Warrent Officer José Antonio Suarez, a senior Army officer presents the flag, folded into a taut triangle, to his wife, Margarite, in a ritual that takes place for all service branches.

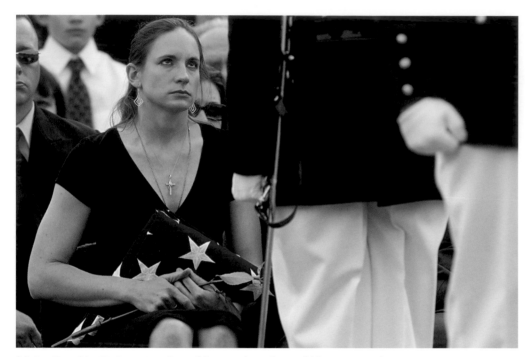
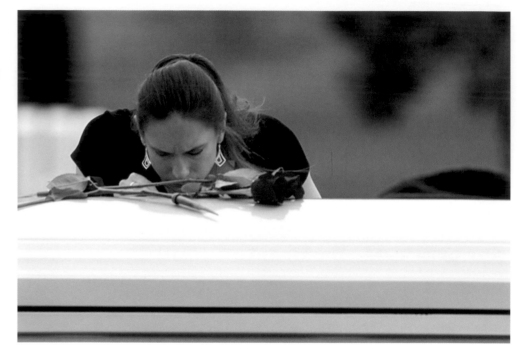

*Marine Capt. Lisa Doring receives the condolences and consolation of fellow corps members
during the memorial for her husband, Marine Capt. Nathanael James Doring, who died in Iraq.*

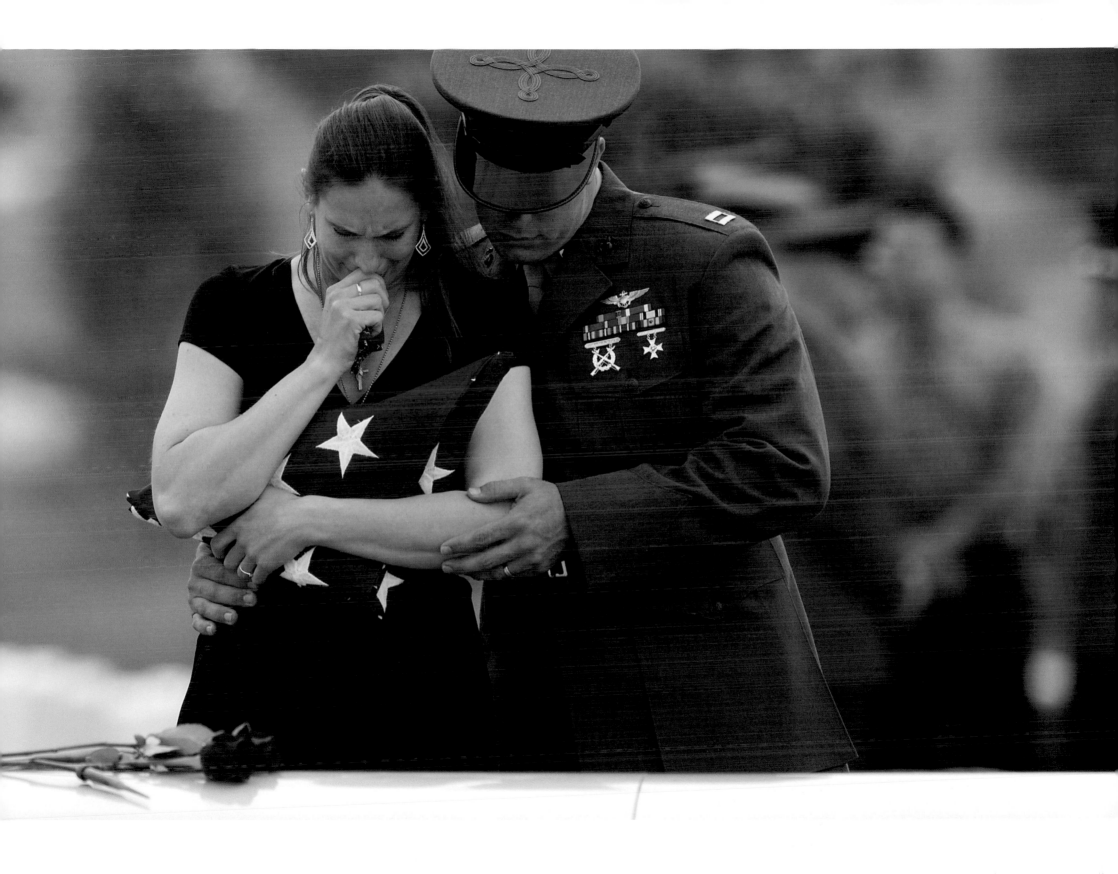

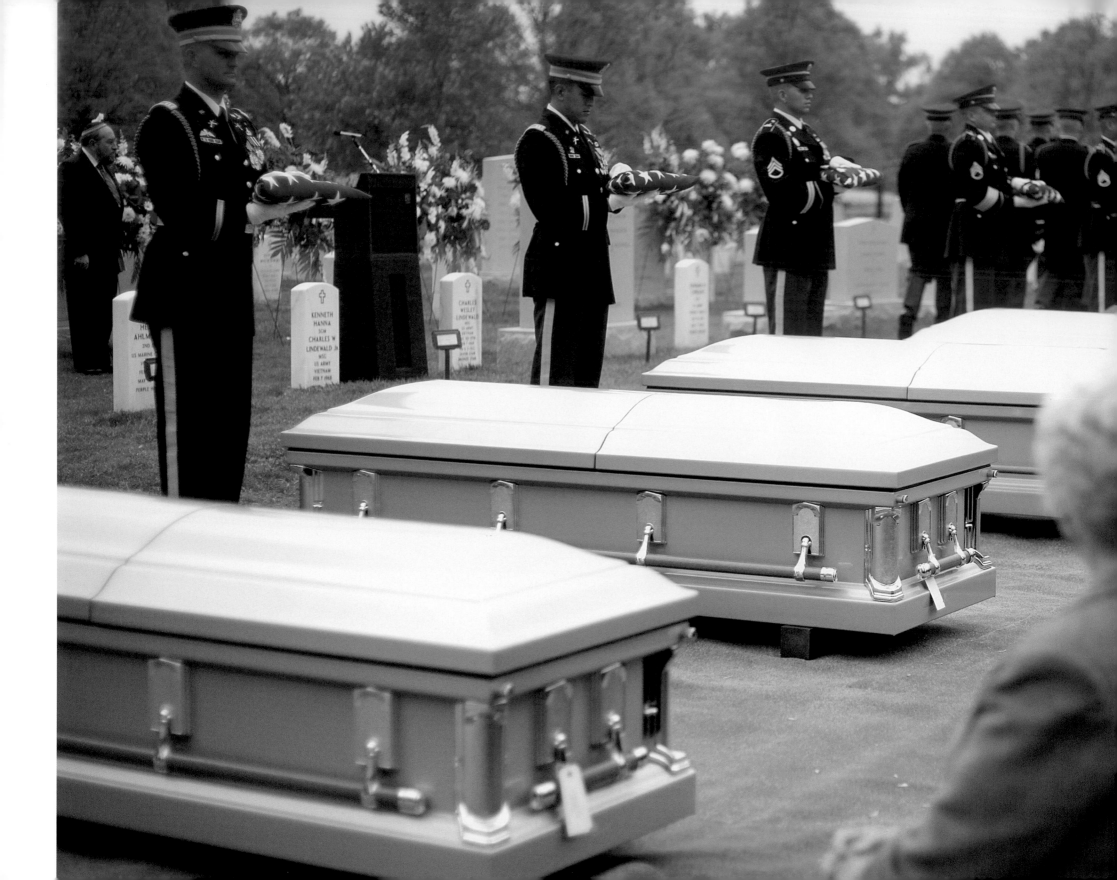

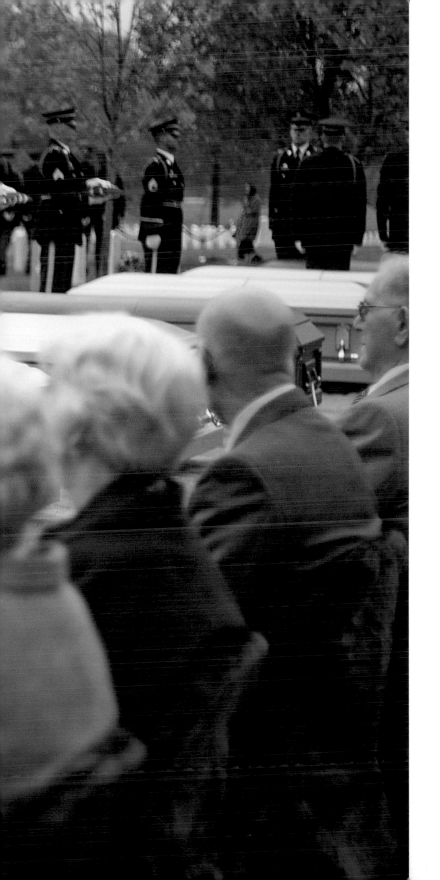

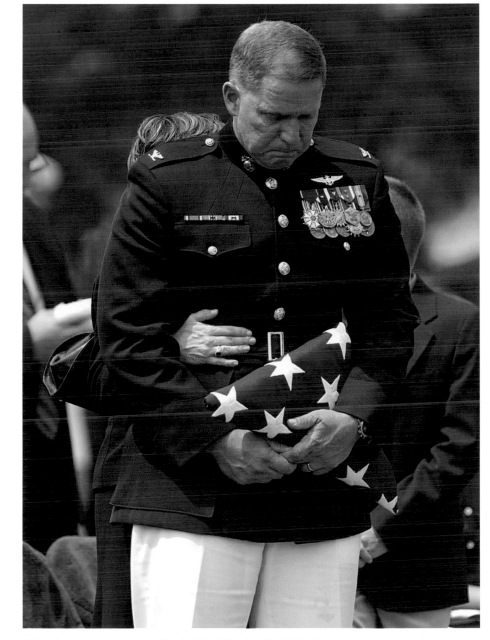

Full military honors are rendered for 7 of 11 MIAs from World War II whose remains had finally been identified. They were 1st Lt. J. P. Gullionn, Sgt. Walter G. Harm, Staff Sgt. William Lowery, Staff Sgt. Elgin J. Luckenbach, Staff Sgt. Marion B. May, Capt. Thomas C. Paschal, and 2nd Lt. Leland A. Rehmet. Marine Col. Robert Deforge (above) grieves as his son, Brian, a Marine first lieutenant, is laid to rest.

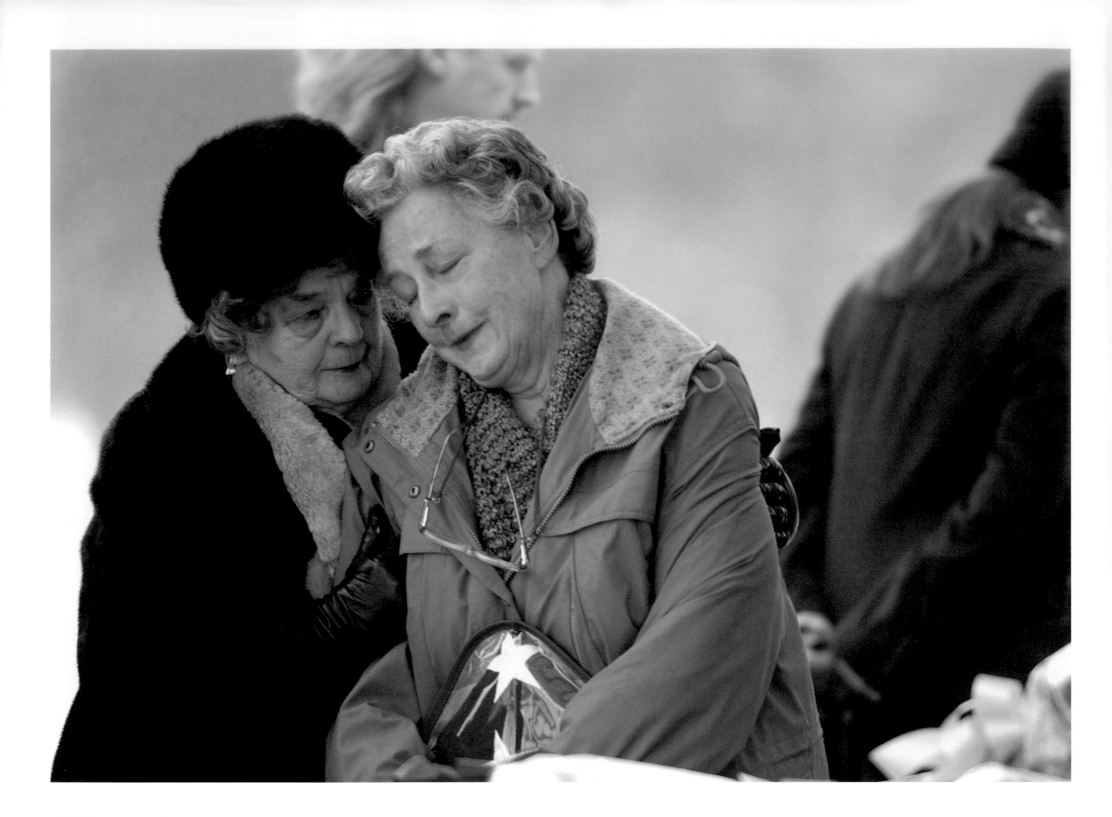

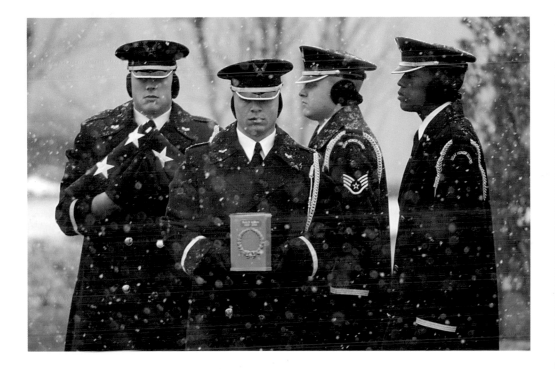

Elsie Eltzroth, widow of retired Air Force Lt.Col. Merlin Eltzroth, receives comfort (opposite) during a January service. Neither cold nor snow (above) deters the rendering of honors for Air Force Master Sgt. Mario R. Aguilera, who, like more than half of Arlington's dead, was cremated. Inurnments receive the same honors and now outnumber interments at Arlington.

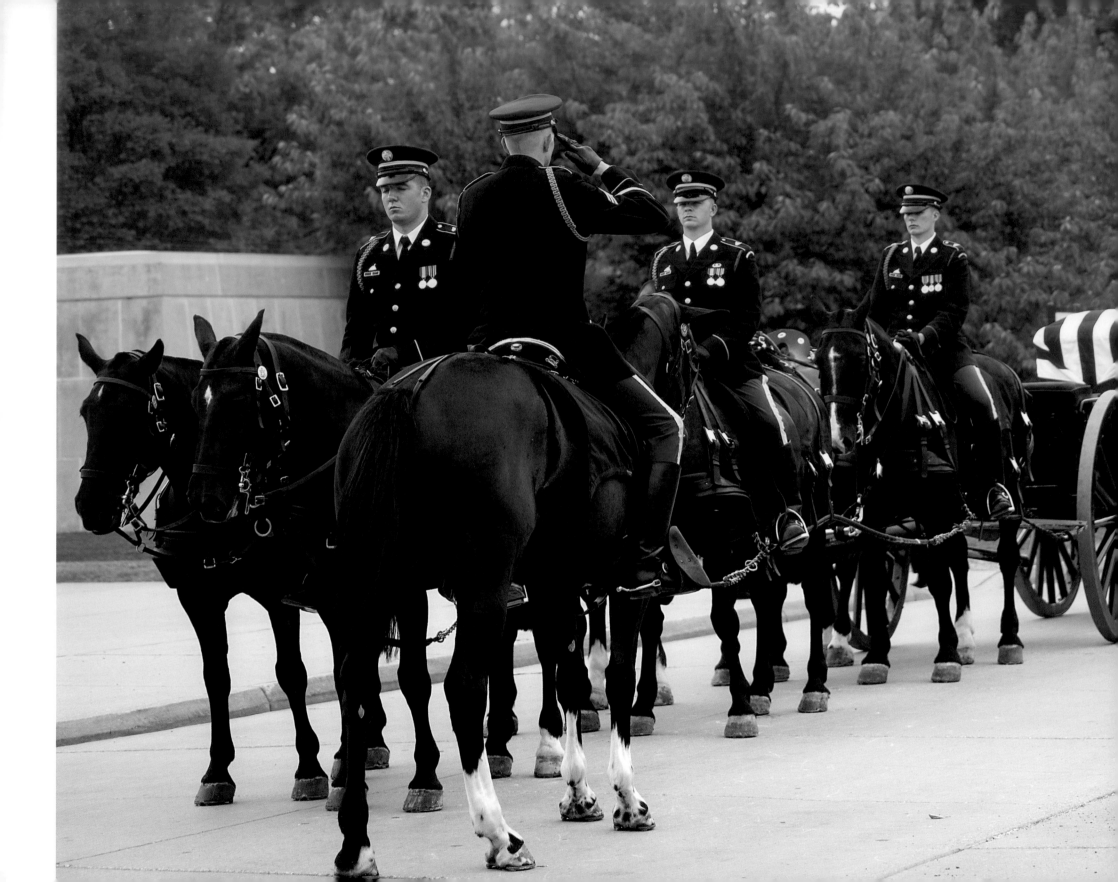

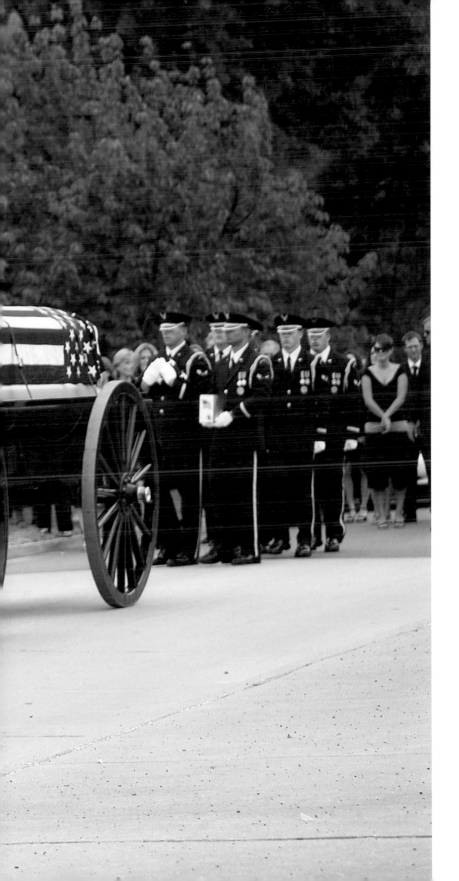

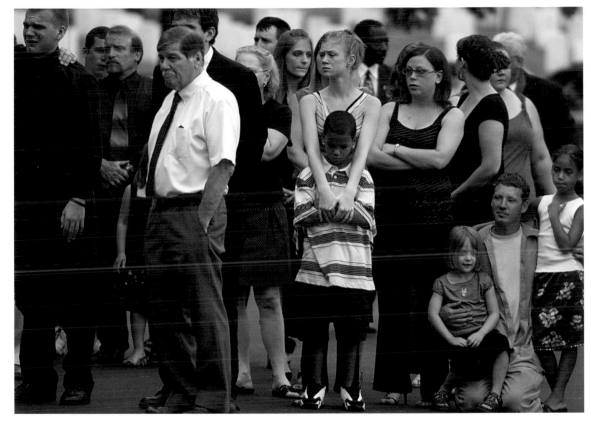

Certain types of full honors funerals bring together ceremonial guards from different service branches, such as the Army and Air Force. A full honors funeral for a soldier killed in action (above) can draw hundreds of mourners to Arlington.

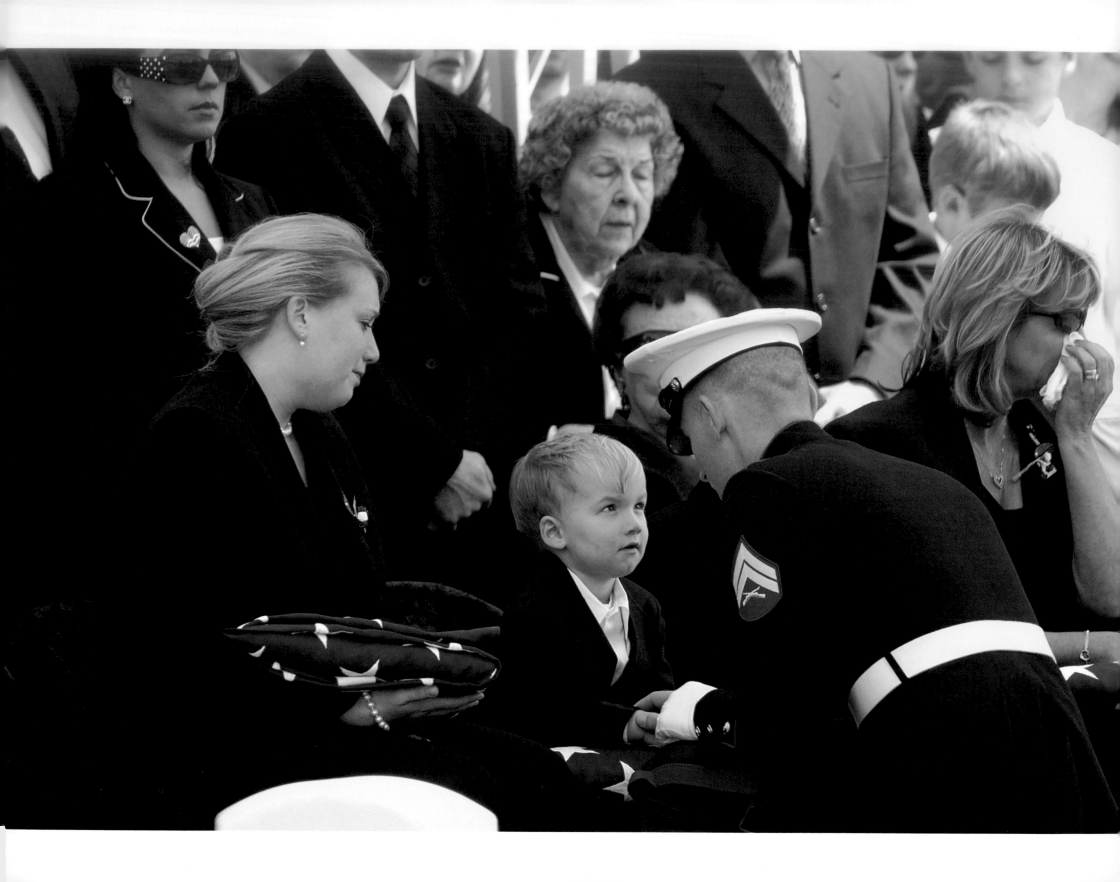

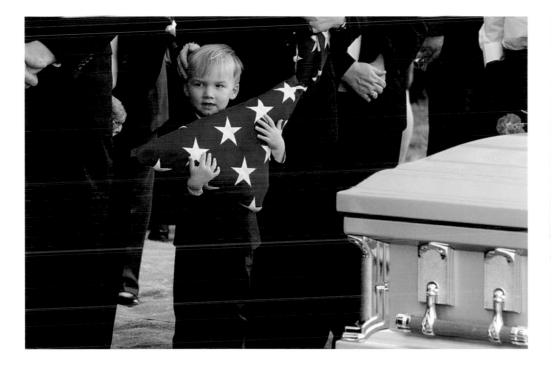

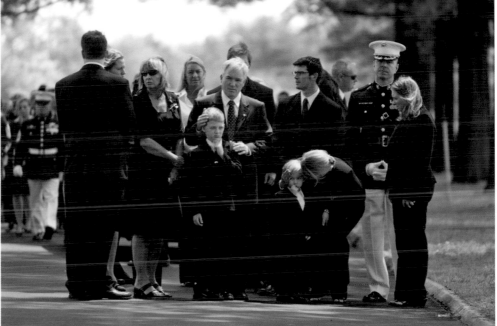

Flanked by his mother, Autumn, and his extended family, three-year-old Dillon Letendre receives consolation from his uncle, Marine Corporal Justin Letendre, after receiving the flag that draped the casket of his father, Marine Capt. Brian S. Letendre, who died in Iraq on May 3, 2006.

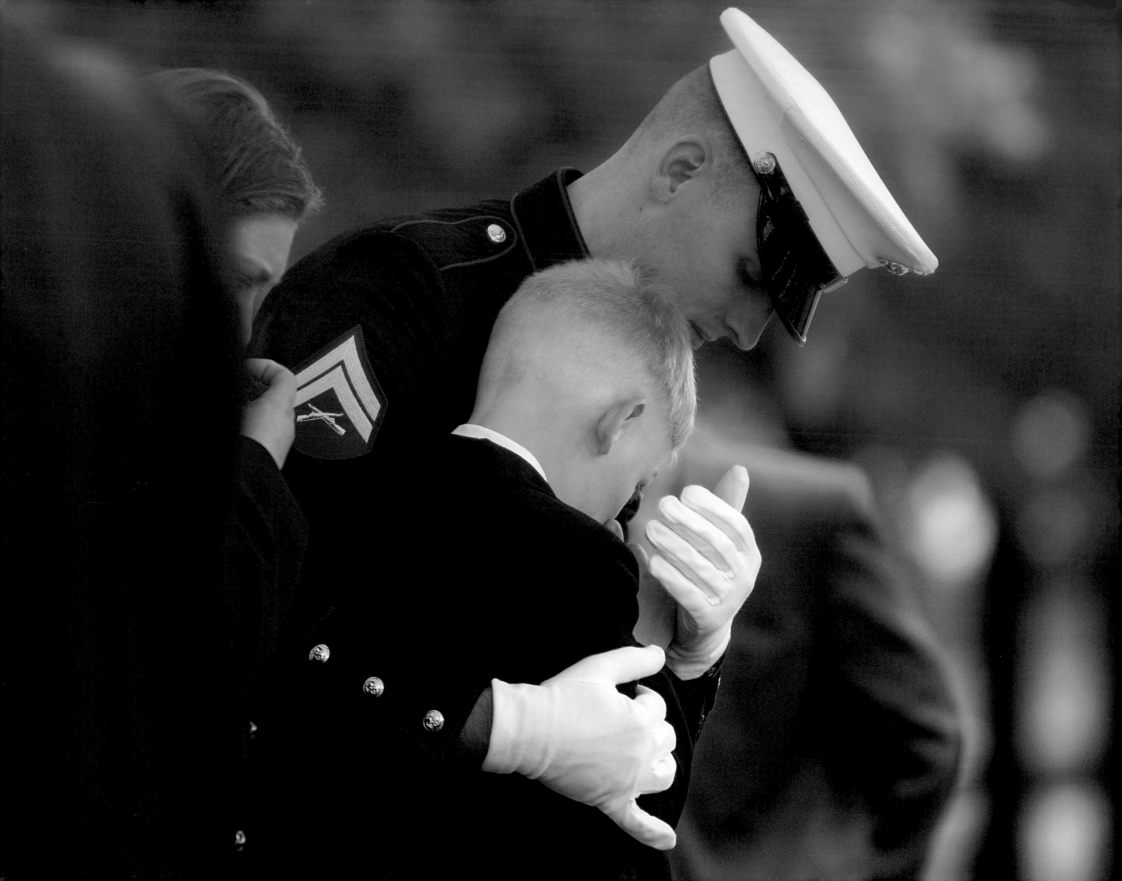

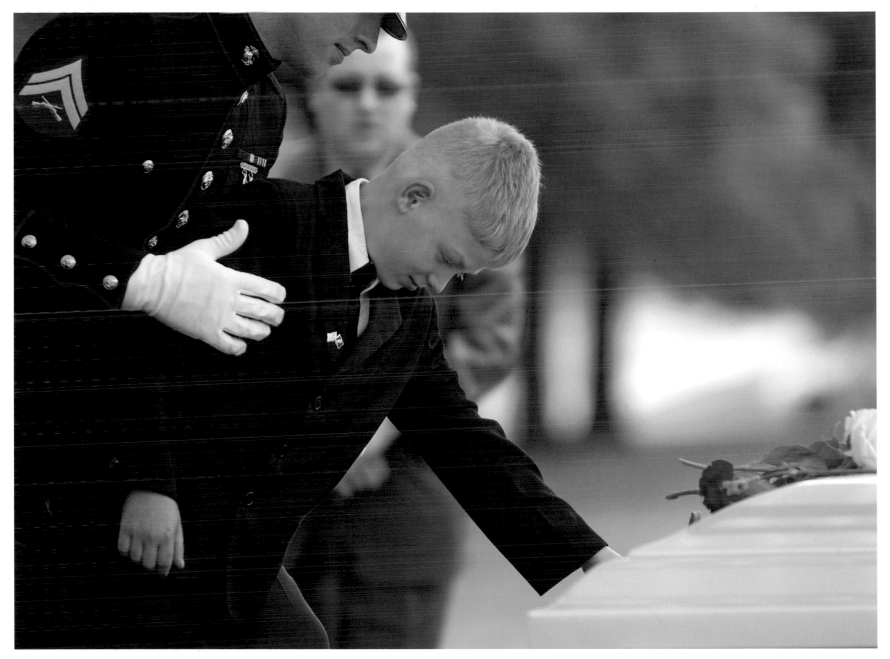

Compassion hits home as Marine Corporal Justin Letendre consoles his son, Tristan, during a service for Marine Captain Brian S. Letendre, Corporal Letendre's brother.

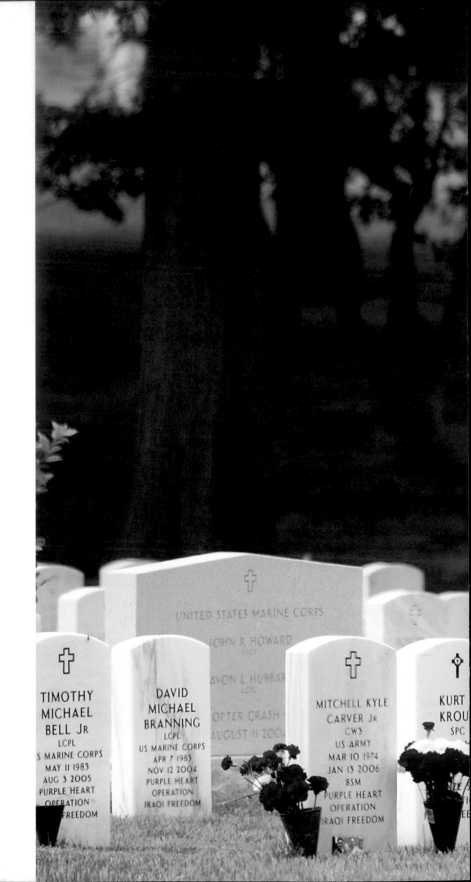

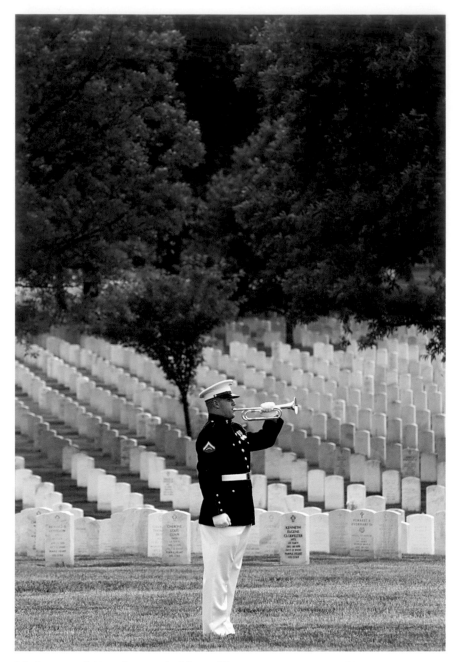

*The last notes of "Taps" float over the fallen. A fellow Marine pays respects (right)
to Gunnery Sgt. Terry W. Ball, Jr., who died in Iraq in 2005.*

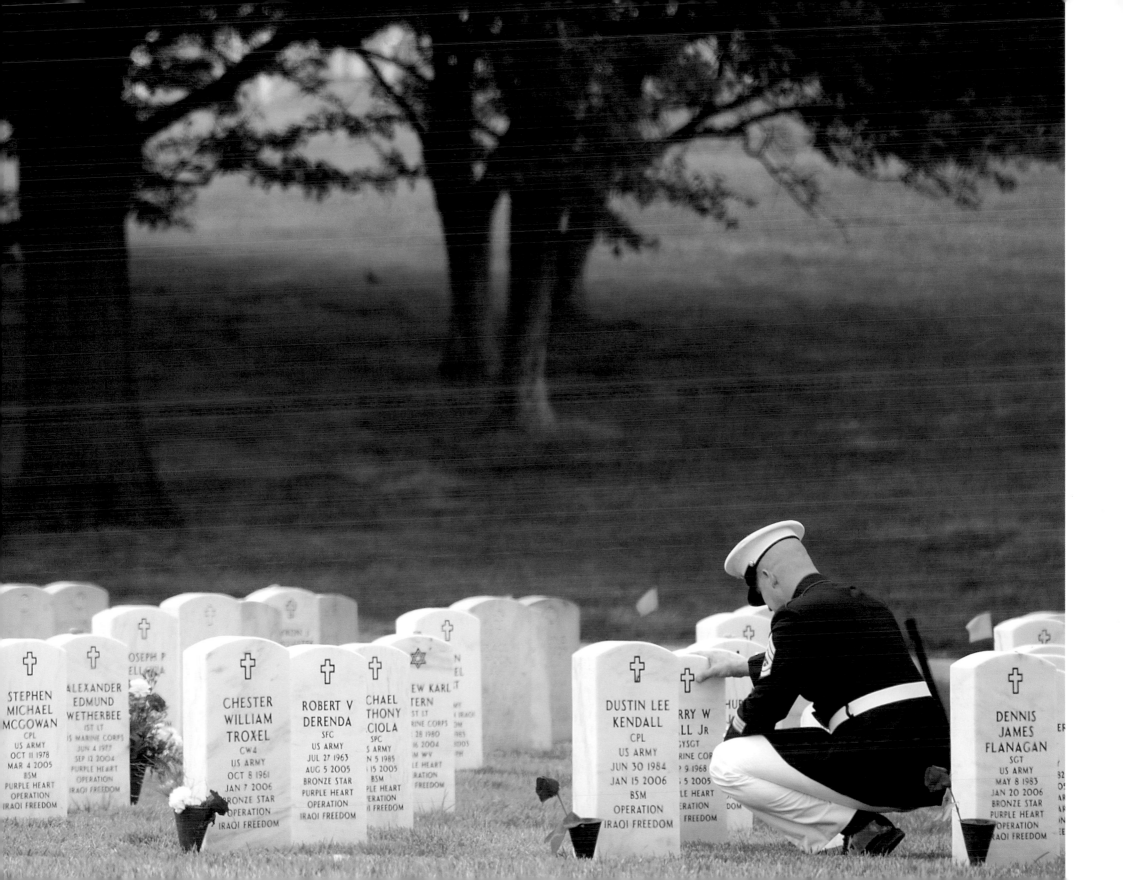

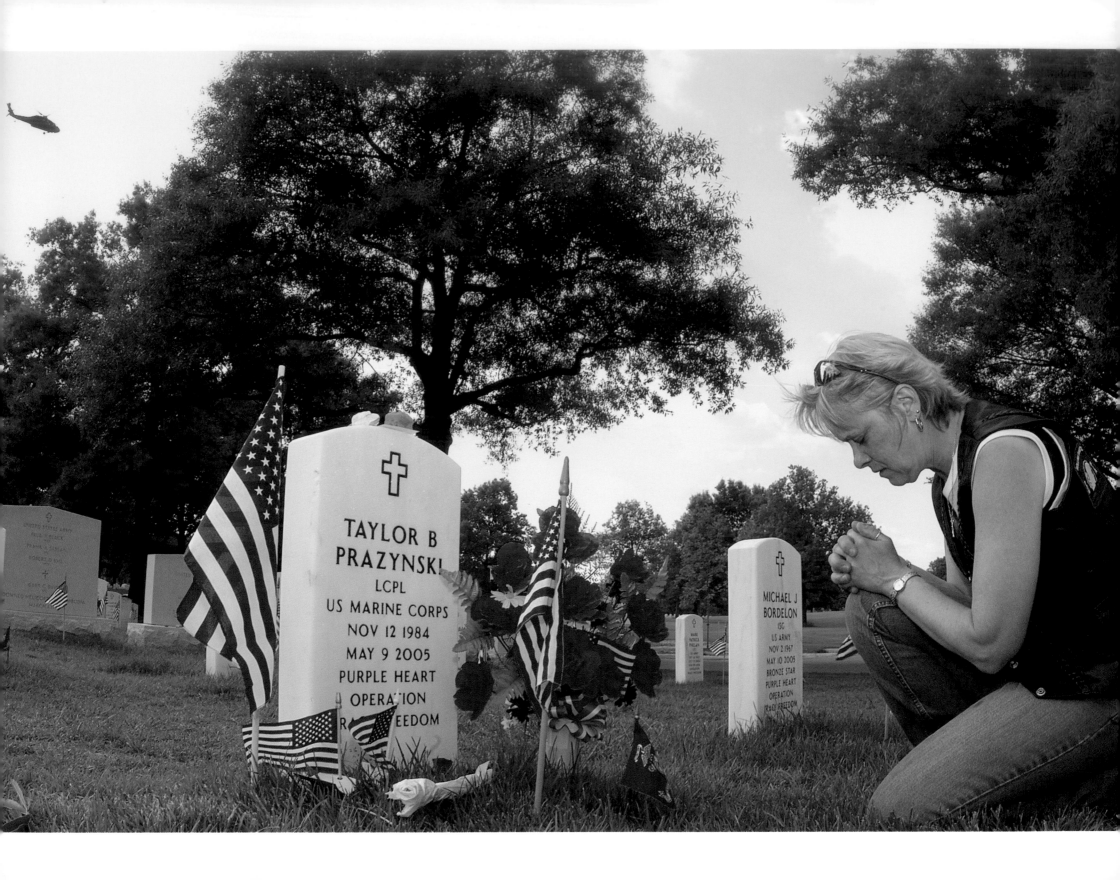

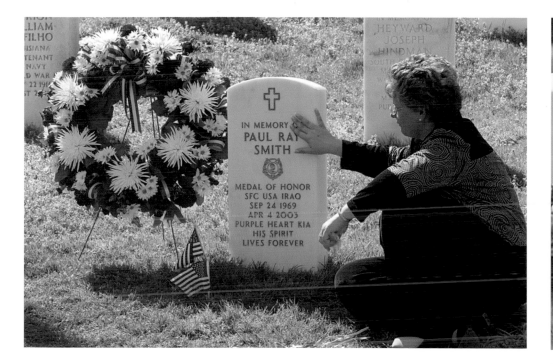

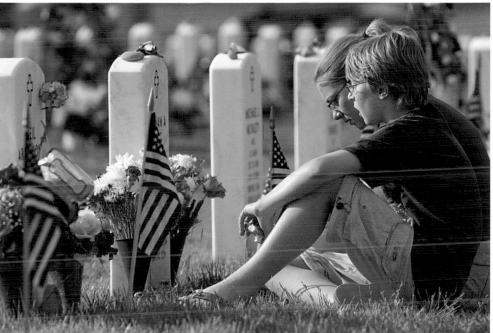

A mourner (opposite) kneels in prayer at the decorated grave of Lance Corporal Taylor Prazynski in Section 60. After posthumously receiving the Medal of Honor, Birgit Smith's husband, Paul, was honored with a headstone (left) in May 2005. Connor and Bryanna Fenton, siblings of Cpl. William A. Long, visit on Memorial Day.

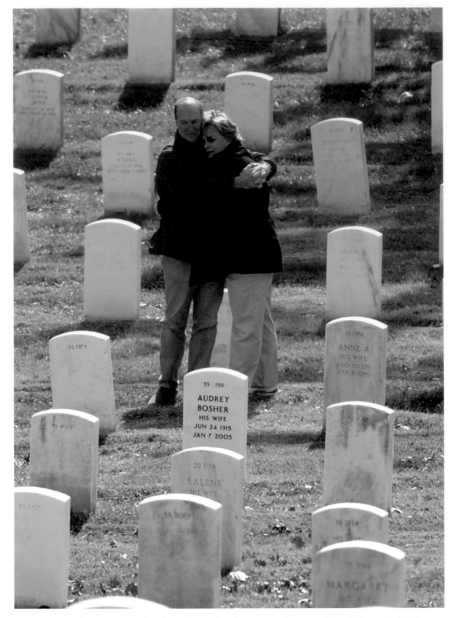

Andrea and Mike Pope (above) embrace during her first visit to the grave of her father, retired U.S. Navy Lt. Cdr. Charles Lang, who died in 1964. Retired Marine Col. Charles Gallina (right) places flowers at the grave of his wife, Caroline Havel.

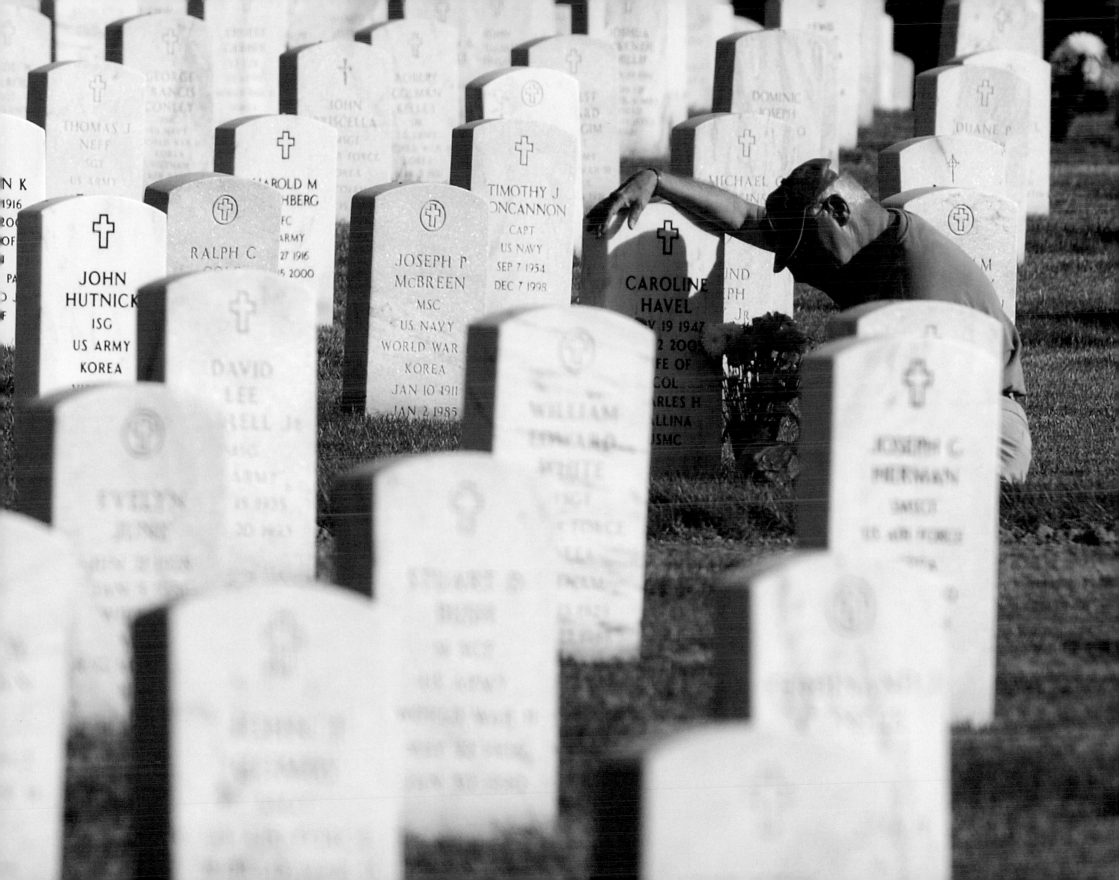

Arlington seldom shows its private, nocturnal side. It is only after the visitors have dispersed and serenity returns that the cemetery's spiritual aura can most profoundly manifest itself, revealing, in the pitch of night, the **AFTERGLOW**

The Washington Monument keeps watch over Arlington.

NIGHT IS WHEN the honored dead have Arlington to themselves. Peace returns. Valor can indeed rest. Only the occasional birdcall and the blare of distant Klaxons crack the silence. Liminal by day, Arlington turns numinous at night, inspiring an abiding curiosity about what transpires amid the graves and ghosts. On a slope just below Arlington House, the eternal flame of the John F. Kennedy Memorial dances unattended in the reflected light of the metropolis he once called home. Soft breezes waft through the thick-limbed trees above the grave markers and swirl around the Memorial Amphitheater. Nearby, the cemetery's lone corporeal presence, an Old Guard sentinel in fatigues, protects the Tomb of the Unknowns, performing a ritual as precise, measured, and invariable as time itself. A sepulchral darkness cloaks the land, but through the photographic technique of light painting, the shroud delicately lifts, unveiling a beauty both haunting and serene. Taken between dusk and dawn, these selectively illuminated images capture the everlasting radiance of the valiant souls whose sacrifice consecrates every acre. They illustrate what the poet Theodore O'Hara meant when he wrote that not even time's remorseless gloom could dim the ray of glory's light that gilds these deathless tombs.

Photographic Essay by DAVE BLACK

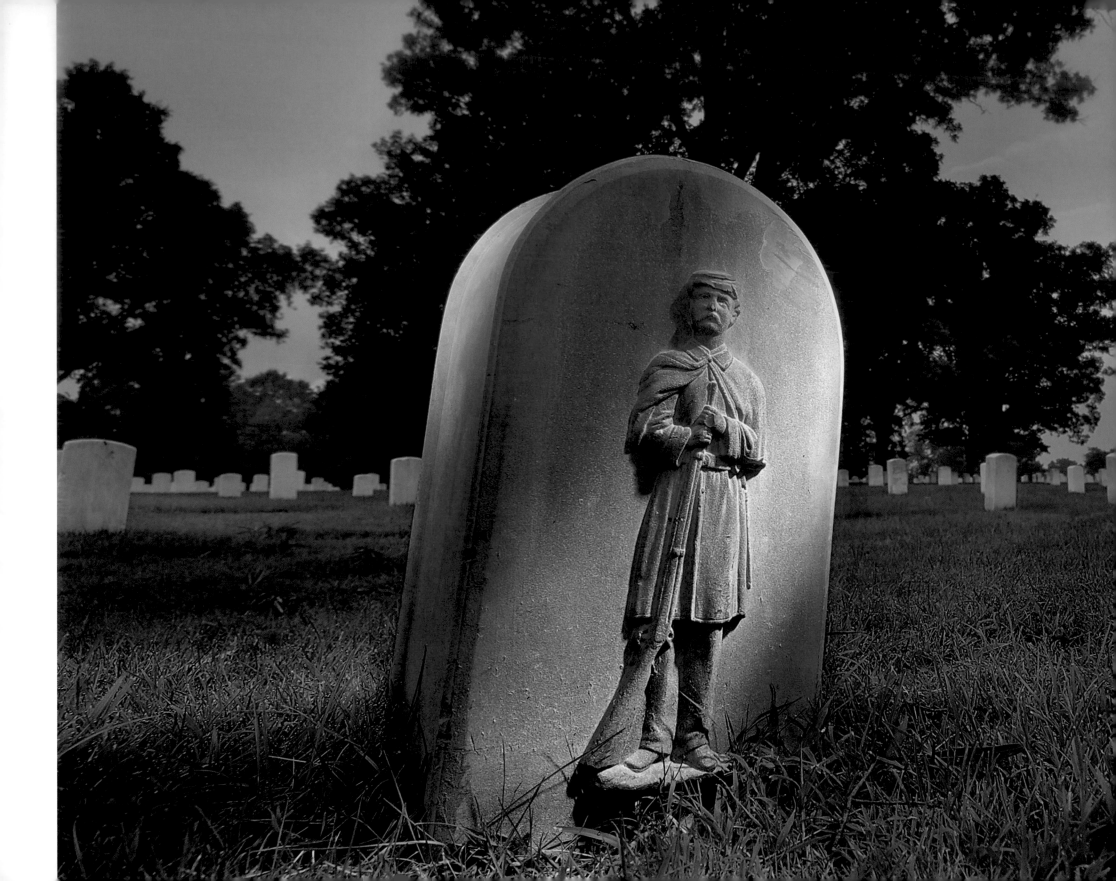

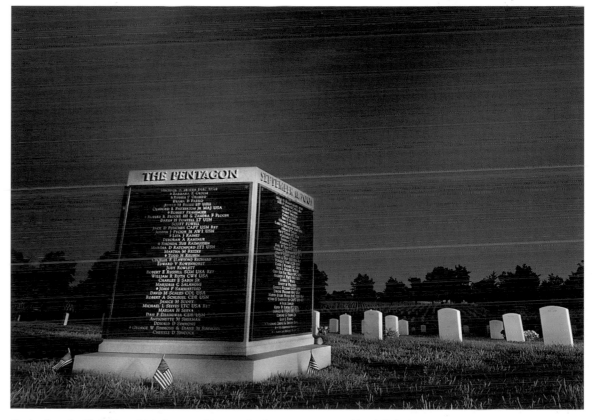

Dating from the Civil War, a 20-inch granite Meigs marker honoring a Union soldier (left) basks in the gloaming. The names of some of the 184 victims who died in the September 11, 2001, crash of American Airlines Flight 77 (above) radiate from the Pentagon Group Burial Marker.

Edged in light and compacted by the use of a long lens, the grave markers of Section 54 suggest an endless sea of soldiers standing in perfect formation for all eternity.

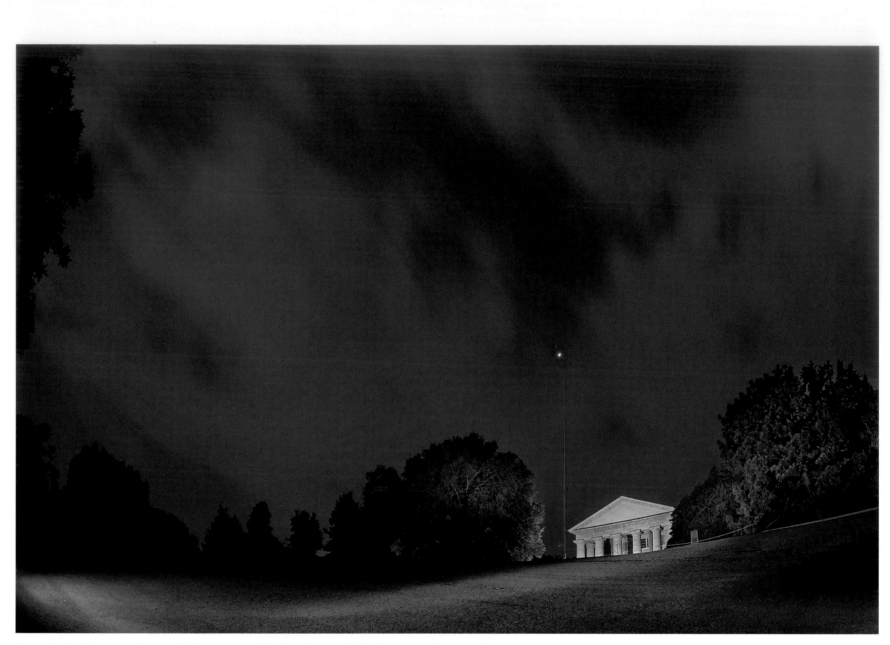

Storm clouds gather over an illuminated Arlington House (above) evoking its turbulent history. A combination of strobes and light-painting (opposite) captures the gliding, rhythmic strides of Specialist Ethan Morse, one of the elite Honor Guard sentinels who provide round-the-clock protection of the Tomb of the Unknown Soldier.

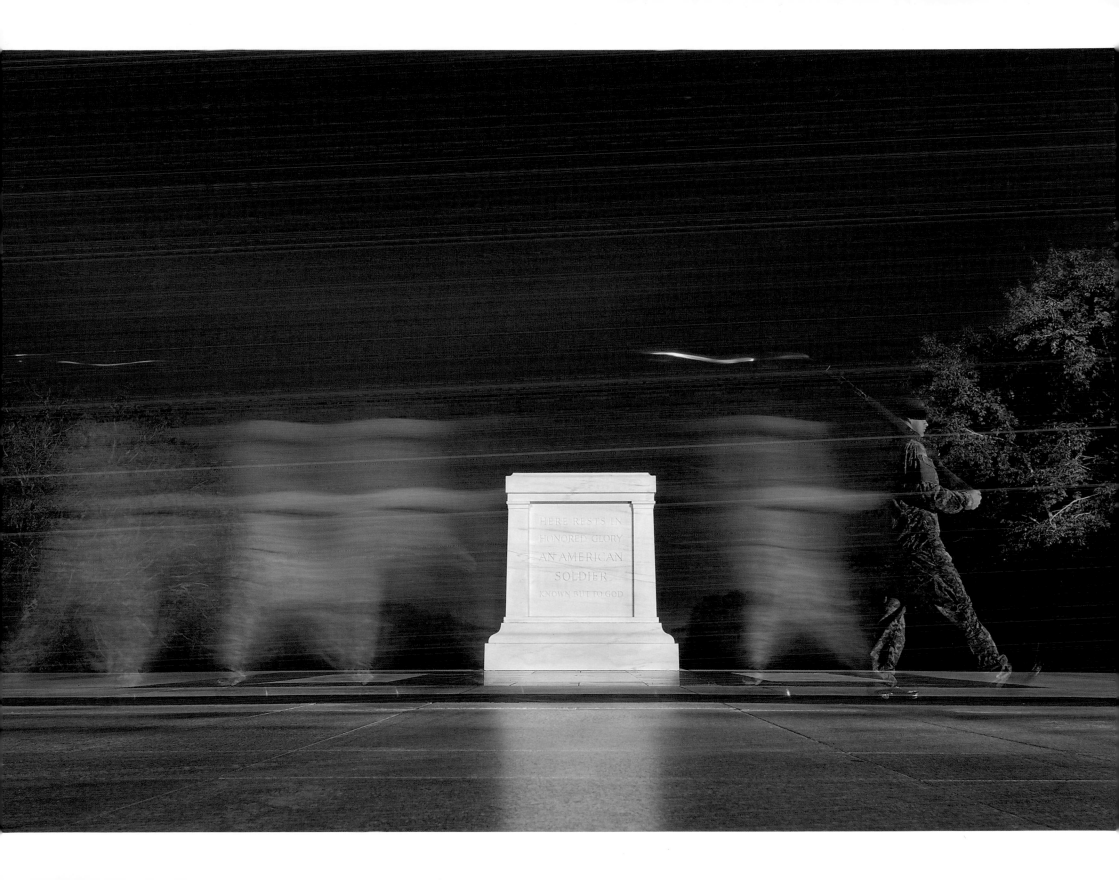

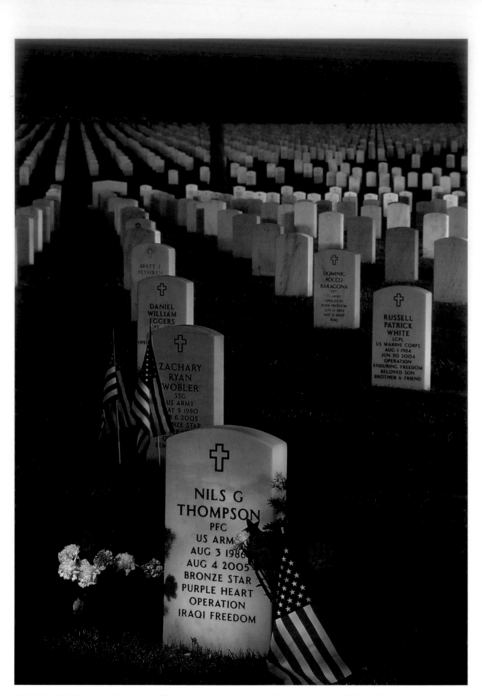

With the Washington Monument illuminated in the distance, the eternal glow of the John F.
Kennedy Memorial (right) symbolizes a historic continuum that carries into Section 60 (above),
where flags and flowers adorn the graves of service members killed in Iraq and Afghanistan.

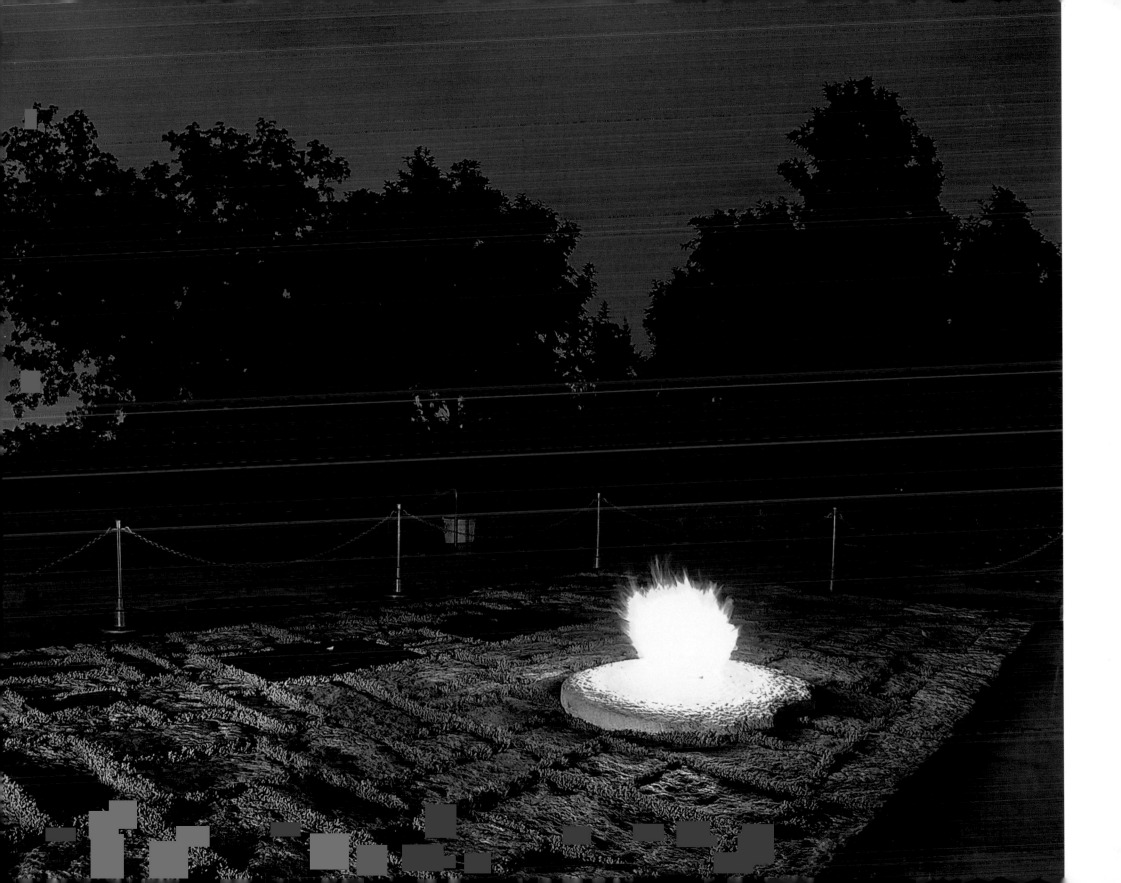

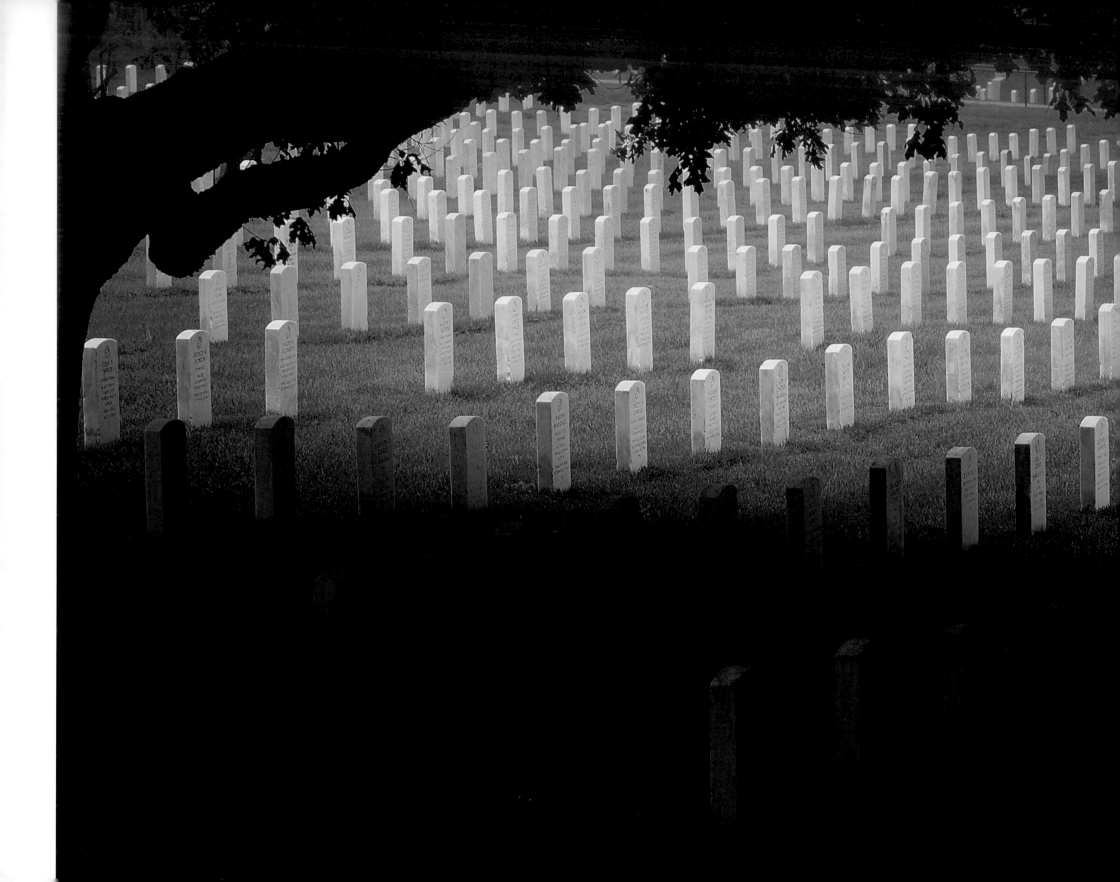

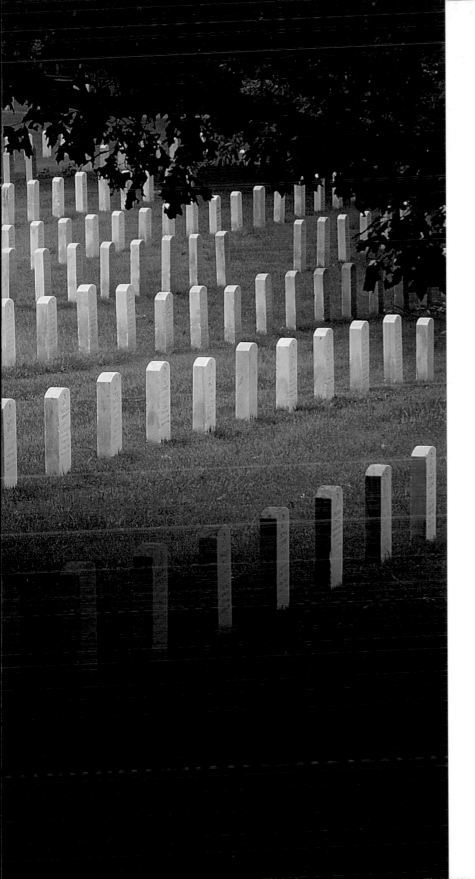

A mighty oak limb (left) shades rows of graves from the dawn's early light. During a sudden summer thunderstorm, a splash of sunshine paints the markers with an appropriately ethereal aura.

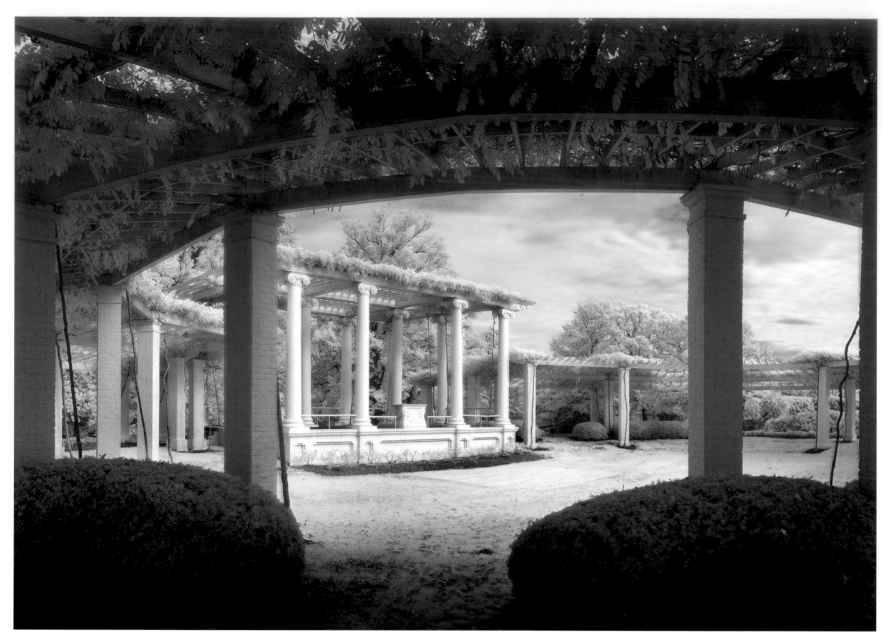

Arlington's old amphitheater glows with an ethereal luminescence.

Afterword JOHN C. METZLER, JR.

A LIVING MONUMENT TO VALOR

I HAVE LIVED, worked, and visited Arlington National Cemetery all my life. I arrived in 1951, at the age of four, when my father became superintendent. It was a calling to which he devoted himself for two decades—and one to which I have devoted myself since assuming this position in 1991. Some might think it peculiar that as superintendent I would also consider myself a "visitor" to our cemetery But every morning I walk out of my home here, with the privilege of stepping out on this hallowed ground, something new presents itself. It may be the way the leaves on one of Arlington's magnificent trees reflect the morning sun, or the simple sight of a robin perching on a headstone. The beauty of this great landscape never fails to amaze and move me.

Arlington is a living monument. It is dedicated not only to the more than 300,000 brave men and women who are interred here as a result of their service and sacrifice, but also to the families, loved ones, and visitors who wander among the monuments and headstones in reflection and reverence and in honor of those who lie beneath. It is with these thoughts and devotion that the magnificent staff at Arlington serve. From the cemetery caretakers and arborists who keep every acre impeccably groomed to our compassionate cemetery representatives who minister to the families during their heaviest times of grief, the individuals who work here attend to every detail so that this shrine to valor called Arlington National Cemetery presents and represents the values of America and of those at rest beneath every headstone.

Each day Arlington conducts four to five funerals per hour with military precision. Our mission is to ensure each family and their fallen loved one is given only the absolute best in final respects. With this in mind, funerals here are in fact zero-defect ceremonies honoring the fallen, whether he or she is a lieutenant or a corporal, a retiree or a soldier lost in battle. With the support of each service branch's ceremonial units, Arlington goes to extraordinary lengths to make certain that members of each family experience the funeral as theirs alone—this is our ultimate goal—for it is that family's day to grieve and to say goodbye.

It gives me enormous pride to have this beautiful book presented to the families who have lost service members while in harm's way. I am also delighted to see this book made available to the millions of people who visit Arlington each year. *Where Valor Rests* represents the beauty and drama of this consecrated land along with the care, concern, and commitment that go into making Arlington National Cemetery one of our country's national treasures. For all who possess it, this impressively assembled collection of words and images will serve as an exquisite reminder that Arlington endures as a living memorial to those who have served and sacrificed in uniform—for Arlington is truly a place where valor rests.

ABOUT THE CONTRIBUTORS

RICK ATKINSON
Three-time Pulitzer Prize winner Rick Atkinson is assistant managing editor at the *Washington Post* and an acclaimed military historian. His four previously published books include the best-selling *The Long Gray Line* and *An Army at Dawn: The War in North Africa, 1942-1943,* for which he won the 2003 Pulitzer for history. This followed a 1982 Pulitzer Prize for national reporting and the 1999 Pulitzer Prize for public service, awarded to the *Post* for a series of investigative articles he conceived, directed, and edited about shootings by the District of Columbia Police Department. Other awards include the 1983 Livingston Award for international reporting, the 1990 George Polk Award for national reporting, and a 1990 PEN special citation for nonfiction. Atkinson has covered the Persian Gulf War, and as the *Post's* Berlin bureau chief filed dispatches from Somalia, Bosnia, and throughout Europe. Before joining the national staff of the *Post* in 1983, Atkinson worked at the *Morning Sun* in Pittsburg, Kansas, and the *Kansas City Star. An Army at Dawn* represents the first volume of his Liberation Trilogy, a narrative history of the American Army in North Africa, Italy, and Western Europe during World War II.

JAMES BALOG
This Colorado-based photographer is as comfortable on a Himalayan peak as he is on a whitewater rapids, the African savanna or a polar ice cap. His six books, each of which concerns the environment, include the highly praised *Survivor: A New Look at the World's Endangered Species* and the more recent *Trees: A New Vision of the American Forest.* Balog has mounted more than 100 exhibitions of his works around the world. He was also the first photographer ever commissioned to create a full plate of stamps for the U.S. Postal Service, the popular 1996 Endangered Species series. A contributing editor to *National Geographic Adventure,* he has also contributed photography to such other magazines as *Vanity Fair, The New Yorker, Life, The New York Times Magazine, Audubon,* and *Outside.*

SUSAN BIDDLE
A staff photographer at the *Washington Post,* Susan Biddle began her photographic career heading the photo unit during the early years of the Peace Corps. She also served as a staff photographer at the *Topeka Capital-Journal* and the *Denver Post,* and spent five years on the White House photographic staff documenting the administrations of Ronald Reagan and George Bush. Biddle's work has appeared in numerous magazines and books.

CHIEF PHOTOGRAPHER'S MATE JOHNNY BIVERA
With more than 20 years of naval service, Chief Petty Officer Bivera has received numerous awards for his documentary photography. He currently serves as the personal photographer to the Chief of Naval Operations.

DAVE BLACK
Known for much of his career as a sports photographer, Black has photographed 12 Olympic games for *Newsweek* and is one of the world's foremost chroniclers of figure skating and gymnastics. He has more recently turned his lens on sporting events such as the Kentucky Derby and the Masters golf tournament. One of the first professional photographers to convert to all-digital cameras and techniques, Black also took the seldom-used photographic technique of light-painting out of the studio and applied it to buildings, landscapes, and panoramic vistas, providing a unique look across Arlington in the twilight and darkness of night. Graduated with a degree in graphic design and studio drawing from Southern Illinois University, Black regularly lectures and teaches at photography workshops and conferences.

DAVID BURNETT
In a career that has spanned more than 40 years, David Burnett has received virtually every major photojournalism prize, including Magazine Photographer of the Year, the Overseas Press Club's Robert Capa Gold Medal, and World Press Photo premier award. The Colorado College graduate earned an internship at *Time*

magazine and, later, a spot as the last *Life* magazine photographer to cover the Vietnam War. He has worked in more than 60 countries, documenting the coup in Chile (1973), revolution in Iran (1979), famine in Ethiopia (1984), the fall of the Berlin Wall (1989), and the U.S. military intervention in Haiti (1994). Based in Washington, D.C., Burnett continues to contribute regularly to *Time.* His memorable photographs include the Ayatollah Khomeini's return to Tehran and Mary Decker's anguished fall during the 1984 Olympics. He co-founded the world-renowned photographic agency Contact Press Images.

BRUCE DALE
Bruce Dale has had more than 2,000 of his photographs appear in NATIONAL GEOGRAPHIC. He was twice named Magazine Photographer of the Year and White House Photographer of the Year. More recently, his innovative work with digital imaging brought him honors from the Smithsonian Institution as well as from NASA, which placed one of his photographs on board the Voyager spacecraft as testimony about planet Earth. Dale has photographed in more than 75 countries throughout the world including ten trips to China. His oeuvre ranges from sensitive people studies of Gypsies and American mountain people to highly technical work with pulsed laser photography that helped produce a hologram of an exploding crystal ball for NATIONAL GEOGRAPHIC's 100th Anniversary cover.

MICHEL DU CILLE
A two-time winner of the Pulitzer Prize in photography, Michel du Cille coordinated and edited the work of the military photographers for this project. Currently associate editor/photography for the *Washington Post,* where he has worked since 1988, du Cille holds a journalism degree from Indiana University and a master's degree in journalism from Ohio University. While at the *Miami Herald* in 1985 he shared the Pulitzer with Carol Guzy for their coverage of the eruption of Colombia's

Nevado Del Ruiz volcano, and won his second award for a 1988 essay on crack cocaine addicts in *Tropic* magazine.

Lt. Col. Michael Edrington
Project director for the Army and Arlington National Cemetery, Lt. Col. Edrington is an accomplished photographer whose 30 years in the military include many command and staff positions relating to photography, publishing, and visual communications. He was commander of the Army's 55th Signal Company (Combat Camera), deputy commander and publisher of *Stars & Stripes Pacific* in Tokyo, and commander of the American Forces Network Europe in Frankfurt. He co-curated the photo exhibit "Desert Storm, A Photographic Diary" at the Smithsonian's American History Museum and has received the National Press Photographers Association Morris Berman Award and the President's Medal for service to photojournalism.

Wendy Galietta
The assistant to the military project director, Wendy Galietta is an accomplished and published photographer. She is a recent graduate of the Corcoran College of Art and Design in photojournalism.

Sgt. Haraz Ghanbari
An Ohio National Guardsman, Sgt. Ghanbari also works as a photojournalist for the Associated Press in Washington. His résumé includes citations as student photographer of the year by both the Ohio Press Photographers Association and the National Press Photographers Association.

David Alan Harvey
A member of the prestigious Magnum group of photographers, David Alan Harvey combines journalistic storytelling with a distinctive artistry that makes him one of the world's most sought-after photographers. He has spent much of his career producing memorable stories for NATIONAL GEOGRAPHIC, where he currently serves as a contributor. His many books include two recent efforts, *Cuba* and *Divided Soul,* both of which have earned inclusion among the best photographic books of the year by *American Photo* magazine. A native Virginian, he entered the graduate program of the University of Missouri School of Journalism and was a staff member of the *Topeka Capital-Journal* before returning to work on a documentary grant in Virginia.

Brian Lanker
One of the nation's most accomplished photographers, Brian Lanker won the Pulitzer Prize in feature photography while at the *Topeka Capital-Journal* in 1973 and is one of only five photographers to have been twice named Newspaper Photographer of the Year by the National Press Photographers Association and the University of Missouri School of Journalism. He was director of photography at the *Register-Guard* in Eugene, Oregon, before leaving to produce major photographic essays for *Life* and *Sports Illustrated* in the 1980s. *I Dream a World,* his award-winning book and traveling exhibition of photographs of great African-American women, sold more copies than any other trade photographic book in American publishing history. He also produced the PBS documentary and accompanying book *They Drew Fire,* which tells the story of the American combat artists of World War II.

Tech. Sgt. Staci McKee
Assigned to the Office of Special Investigations Headquarters at Andrews Air Force Base, Tech. Sgt. McKee is a member of the Air Force Reserve Security Forces. She worked for ten years as a photographer and picture editor for the Associated Press and as a photo editor and homepage editor for washingtonpost.com. She also served as assistant news director for usatoday.com before becoming deputy director of photography for the Army Times Publishing Company. She graduated with a journalism degree from the University of Nebraska at Lincoln.

Jon Rizzi
Jon Rizzi began his two decades in magazine publishing at *Esquire* magazine. He went on to serve as managing editor of six different titles—among them *Town & Country, Woman's Day, ESPN The Magazine,* and *Travel & Leisure Golf*—before founding and editing the award-winning *Colorado AvidGolfer* magazine. His byline has appeared in *The American Lawyer, Popular Science, Luxury Living,* and *Golf.* He graduated from Vassar College with with honors.

Sgt. Ferdinand Thomas
Assigned to the 214th Mobile Public Affairs Detachment of the Virginia National Guard, Sergeant Thomas is currently attending Thomas Nelson Community College in Hampton, Virginia, where he is majoring in photography. He also works as a freelance photographer.

Master Sgt. James Varhegyi
Currently assigned to the Pentagon Air Force Image Center, where he makes still and video images available to the news media, Master Sgt. Varhegyi has served in various photographic capacities for two decades. A graduate of the Military Photojournalism Program at the S. I. Newhouse School of Communications of Syracuse University, he also served with the Air Force's First Combat Camera Squadron.

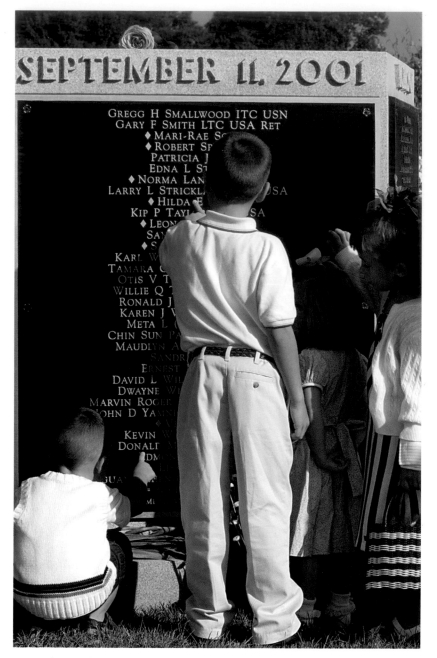

During the annual ceremony honoring the victims of the September 11 attack on the Pentagon, Liam and Megahan Vauk and Patrick and Saoirse Deboy remember their father and uncle, Lt. Cmdr. Ronald J. Vauk USN, who perished that day.

ADDITIONAL READING

OWEN ANDREWS
Arlington National Cemetery: A Moment of Silence
Washington, D.C.: Preservation Press, 1994

PETER ANDREWS
In Honored Glory: The Story of Arlington
New York: G.P. Putnam's Sons, 1966

PHILIP BIGLER
In Honored Glory: Arlington National Cemetery the Final Post
St. Petersburg, Florida: Vandamere Press, 2005

JOHN VINCENT HINKEL
Arlington: Monument to Heroes
Englewood Cliffs, New Jersey: Prentice-Hall, 1965

JAMES EDWARD PETERS
Arlington National Cemetery: Shrine to America's Heroes
Bethesda, Maryland: Woodbine House, 2000

TIM WARREN
"Halloweed Ground,"
Washingtonian 34, no. 9 (June 1999)

National Park Service website: *http://www.nps.gov/archive/arho/tour/history.html*
Arlington National Cemetery website: *http://www.arlingtoncemetery.org/*
Buglers website: *http://www.tapsbugler.com/24NotesExcerpt/Page1.html*

PHOTOGRAPHY CREDITS

ACKNOWLEDGMENT OF SPONSORS

The publication of this book was made possible by the Arlington National Cemetery Commemorative Project, Inc., a nonprofit corporation. Its board of directors comprises distinguished volunteers, with Major General Carl H. McNair, Jr., as its chairman and president. The support of all those who contributed to the project is deeply appreciated.

PLATINUM

Veterans of Foreign Wars
National Funeral Directors Association *
 Alabama Funeral Directors Association
 Brintlinger and Earl Funeral Homes
 Carmon Community Funeral Homes
 Connecticut Funeral Directors Association
 Dodd and Reed Funeral Home
 Eagle Burial Vault Association
 Eannace Funeral Home
 Fogarty Funeral Home
 Funeral Directors Association of Kentucky
 Georgia Funeral Directors Association
 Gilligan Law Offices
 Handley Funeral Home
 Heritage Club
 Illinois Funeral Directors Association
 Indiana Funeral Directors Association
 Integrity Burial Boxes
 Iowa Funeral Directors Association
 Kansas Funeral Directors Association
 Lynch & Sons Funeral Directors
 Magoun-Biggins Funeral Home
 Messenger Corporation
 Michigan Funeral Directors Association
 Mountcastle Funeral Home
 Myers Mortuary
 New Hampshire Funeral Directors Association
 New Jersey Funeral Directors Association
 New York State Funeral Directors Association
 NFDA Executive Board
 NFDA Policy Board
 North Carolina Funeral Directors Association
 Ohio Funeral Directors Association
 Pennsylvania Funeral Directors Association
 Rhode Island Funeral Directors Association
 Rogers Family Mortuary
 John N. Santeiu and Son Funeral Home
 Starrett-Rose Funeral Home
 Utah Funeral Directors Association
 Wappner Funeral Directors
 West Virginia Funeral Directors Association
 Wilson-St. Pierre Funeral Service and Crematory

GOLD

Army Aviation Association of America (AAAA)
Association of the U.S. Army (AUSA)
Booz Allen Hamilton
Dorene and Lee Butler Family Foundation
Computer Sciences Corporation (CSC)
Dignity Memorial Providers—Funeral and
 Cremation Services
DynCorp International
L-3 Communications Services Group
Major General and Mrs. Carl H. McNair, Jr.

Military Order of the Purple Heart
National Defense Industrial Association (NDIA)
Non Commissioned Officers Association of the USA
 (NCOA)
Prudential Financial
 Wilbert Funeral Services *
 Akron Burial Vault
 The American Wilbert Vault Corp. of Forest Park, IL
 Arnold-Wilbert Corporation
 Automatic Wilbert Vault Company, Inc., Tacoma, WA
 Baxter Burial Vault Service, Inc., Cincinnati, OH
 Bell Vault and Monument Co., Miamisburg, OH
 Bickes, Inc
 Binghamton Burial Vault Co., Inc.
 Blairsville Wilbert Vault Co., Inc.
 Burlington Iowa Wilbert Vault
 Combs Wilbert, Inc.
 Detroit Wilbert Vault Corporation
 Elm Cap Industries, Inc of West Hartford, CT
 The Fort Miller Service Corporation
 Hicks Industries, Inc.
 Josten Wilbert Burial Vault Co.
 Omaha Wilbert Vaults, Inc., Omaha, NE
 Richards Wilbert, Inc.
 Richards-Wilbert, Inc., Roanoke Valley, Salem, VA
 S. M. Bush Enterprises
 Saginaw Wilbert Vault Corporation
 Sexton Wilbert Corporation
 SI Funeral Services
 SI Veteran Memorials
 Smith/Scranton Wilbert Vault
 Turner Vault Company of Ohio
 Washington Wilbert Vault Works, Inc., Laurel, MD
 Wilbert Funeral Services, Inc.
 Wilbert of Greenville, SC
 Wilbert of Pittsburgh, Inc.
 Wilbert Vault Company, Milan, IL
 Wilbert Vaults of Houston, Inc.
 Yates Wilbert Vault Company
 Zeiser Wilbert Vault, Inc.

SILVER

AM General, LLC / James Armour
American Helicopter Society
AMVETS
Army Women Veterans' Association of Northern Virginia
Brigadier General Mildred "Inez" Caroon Bailey, USA (Ret.)
 and First Sergeant Roy Carson Bailey, U.S. Marine Corps
Dan and Sondra Bannister
EDS
Fleet Reserve Association
Colonel and Mrs. Wilbur W. Hiehle, MD, USA (Ret.)
John Paul and Joyce A. B. Ketels
Military Officers Association of America (MOAA)
The MITRE Corporation

Reserve Officers Association of the United States
Joseph C. Ryan Family
Tom and Dorothy Shull

BRONZE

A & T Systems, Inc.
AFBA
Air Force Association
Air Force Sergeants Association
Armed Forces Communications and Electronics Association
 (AFCEA) International
Armed Forces Insurance
Armed Forces Services Corporation
Army Arlington Ladies
Army Women's Foundation
Board of Directors, Arlington National Cemetery
 Commemorative Project, Inc.
Burdeshaw Associates, Ltd. (BAL)
Capitre Planning Solutions
John and Linda Cannon
Chief Warrant and Warrant Officers Association, USCG
Coast Guard Combat Veterans Association
Timothy and Suzanne Campen
Richard O. Duvall
Kathy, Michael, Lindsay, and Jackson Edrington
Donald, Susie, Elisabeth, and Kristina Edrington
Flight Safety International, Inc.
Fresco Mulitmedia Productions
Gold Star Wives of America, Inc.
Greenberg Traurig, LLP
Interstate Van Lines
Jewish War Veterans of USA, Inc.
Marine Corps League
Marine Corps Reserve Association
Lieutenant General James H. Merryman Family
Military Chaplains Association of the USA
Military Order of the World Wars
National Military Family Association
Naval Reserve Association
Navy League of the United States
Oshkosh Truck Corporation
Peduzzi Associates, Ltd.
Pentagon Federal Credit Union
Professional Services Council, Inc.
Max D. Putnam, Sr., and Phyllis W. Putnam
Joe R. Reeder
Silver Eagle Consulting, Inc.
SRA International, Inc.
Staubach Retail Services
U.S. Army Warrant Officers Association
U.S. Military Academy—Class of 1955
Wilbert Manufacturers Association
Colonel and Mrs. Stephen P. Williams, USAF (Ret.)
 and son David
Brigadier General Myrna H. Williamson, USA (Ret.)
Wise Foods, Inc.
Christopher and Brenda Woods
Betsy and Glenn Yarborough

* Donation level is achieved through the combined contributions of the listed members.

A special acknowledgment goes to the law firm Clifford Chance US LLP for its services in contribution to this project.

A special edition of this book has been prepared by the Arlington National Cemetery Commemorative Project, Inc., to be respectfully presented to the family of each service member newly interred at Arlington National Cemetery who died while serving on active duty since September 11, 2001.

The superintendent of Arlington National Cemetery will personally emboss a seal, inscribe a serial number, and sign each book presented, making *Where Valor Rests* a truly commemorative treasure for each family to whom it is given in appreciation of their loved one.

Royalties from the sale of this hardcover trade edition by the National Geographic Society will be paid to the Commemorative Project.

ARLINGTON NATIONAL CEMETERY COMMEMORATIVE PROJECT, INC.

Major General Carl H. McNair, Jr., USA
 (Ret.) Chairman / President
Timothy A. Campen, Director / Vice President
Richard V. Doud, Jr., Director / Treasurer
Roger R. Rapp, Director / Secretary
Chris Johns, Director
John Paul Ketels, Counsel
Lieutenant Colonel Michael G. Edrington, U.S.
 Army Liaison / Project Director

WHERE VALOR RESTS
Arlington National Cemetery

Published by the NATIONAL GEOGRAPHIC SOCIETY

John M. Fahey, Jr., *President and Chief Executive Officer*

Gilbert M. Grosvenor, *Chairman of the Board*

Nina D. Hoffman, *Executive Vice President;
 President, Book Publishing Group*

Prepared by the Book Division

Kevin Mulroy, *Senior Vice President and Publisher*

Leah Bendavid-Val, *Director of Photography Publishing
 and Illustrations*

Marianne R. Koszorus, *Director of Design*

Barbara Brownell Grogan, *Executive Editor*

Carl Mehler, *Director of Maps*

Staff for this Book

Garrett W. Brown, *Acquiring Editor*

Judith Klein, *Proofreader*

Gary Colbert, *Production Director*

Thomas L. Gray, Nicholas P. Rosenbach, Tibor G. Tóth, Gregory Ugiansky, and
 NGM Maps, *Map Research and Production*

Lewis Bassford, *Production Project Manager*

Manufacturing and Quality Management

Christopher A. Liedel, *Chief Financial Officer*

Phillip L. Schlosser, *Vice President*

John T. Dunn, *Technical Director*

Vincent P. Ryan, *Director*

Chris Brown, *Director*

Maryclare Tracy, *Manager*

Staff at Rich Clarkson and Associates

Rich Clarkson, *Editor*

Kate Glassner Brainerd, *Art Director*

Jon Rizzi, *Contributing Writer*

Trevor Brown, Jr., *Photo Editor*

Steve Nowland, *Copy Editor, Researcher*

Jennifer Finch, *Imaging*

Charles M. Garofalo, *Project Manager*

Staff for Arlington National Cemetery and the U.S. Army

Lieutenant Colonel Michael Edrington, *Project Director*

Wendy Galietta, *Coordinating Manager / Editor*

Michel du Cille, *Photo Editor*

Thomas L. Sherlock, *Project Advisor, History*

Erik Dihle, *Project Advisor, Horticulture*

Colonel Nelson McCouch, *Project Advisor, Public Relations*

Lieutenant Colonel Lisiane Valentine, *Project Advisor, Administration*

Airman 1st Class Rusti M. Caraker, *Contributor*

Master Sergeant Scott Ash, *Contributor*

Master Sergeant Mark Subin, *Contributor*

Technical Sergeant Jennifer Gangemi, *Contributor*

Airman First Class Rusti Caraker, *Contributor*

Founded in 1888, the National Geographic Society is one of the largest nonprofit scientific and educational organizations in the world. It reaches more than 285 million people worldwide each month through its official journal, NATIONAL GEOGRAPHIC, and its four other magazines; the National Geographic Channel; television documentaries; radio programs; films; books; videos and DVDs; maps; and interactive media. National Geographic has funded more than 8,000 scientific research projects and supports an education program combating geographic illiteracy.

For more information, please call
1-800-NGS LINE (647-5463)
or write to the following address:

NATIONAL GEOGRAPHIC SOCIETY
1145 17th Street N.W.
Washington, D.C. 20036-4688
U.S.A.

Visit us online at www.nationalgeographic.com

For information about special discounts for bulk purchases, please contact
National Geographic Books Special Sales: ngspecsales@ngs.org

For rights or permissions inquiries, please contact
National Geographic Books Subsidiary Rights: ngbookrights@ngs.org

First paperback printing 2009
ISBN: 978-1-4262-0456-2

A Rich Clarkson Book
Produced for The Arlington National Cemetery Commemorative Project
by Rich Clarkson and Associates, LLC
1099 18th Street, Suite 1840, Denver, CO 80202
www.richclarkson.com

The Library of Congress has cataloged the hardcover edition as follows:

Where Valor Rests : Arlington National Cemetery.
 p. cm.
 Includes essay by Rick Atkinson.
 Includes bibliographical references.
 ISBN 978-1-4262-0089-2 (hardcover : alk. paper)
 1. Arlington National Cemetery (Arlington, Va.)—Pictorial works. 2. Arlington National Cemetery
(Arlington, Va.)—History. 3. Seasons—Virginia—Arlington—Pictorial works.
4. Arlington (Va.)—Biography. I. Atkinson, Rick. II. National Geographic Society (U.S.).
 F234.A7W48 2007
 973'.099—dc22
 2006038340

PRINTED IN CHINA